DINNER WITH JACKSON POLLOCK

RECIPES, ART & NATURE

SENIOR PRODUCER AND RESEARCH DIRECTOR
Marina Cukeric

SPECIAL THANKS
Francesca Pollock, Jacqueline Pollock de Souza Costa, Helen A. Harrison,
Francile Downs, James ("Ford") Huniford

PRINCIPAL RECIPE TESTING, FOOD STYLING, PREPARATION, AND CONSULTING
Kylie Balharrie and Kate Mizrahi
Chef Michael Rozzi
Chef Kira Jacobs

ADDITIONAL RECIPE PREPARATION AND CONSULTING
Catherine Malady, Heather Chontos, Jackie McKay, Michael Ferran

PROPS STYLING
Barbara Marsiletti, Shane Klein, Michelle James

Front cover, from top: A rainbow of carrots; detail of
Jackson Pollock's studio floor. Photos © Robyn Lea.
Back cover: Lee Krasner and Jackson Pollock in
the kitchen of their home in Springs, New York,
April 1949. Photo © Martha Holmes/The LIFE
Picture Collection/Getty Images.
Endpapers: Handwritten recipes from the
collection of Stella Pollock, courtesy of
Jacqueline Pollock de Souza Costa, Sacramento,
California, July 2014. Photos © Robyn Lea.

All text and photographs
(excluding artworks and historical images)
© 2014 Robyn Lea

© 2015 Assouline Publishing
601 West 26th Street, 18th floor
New York, NY 10001, USA
Tel.: 212-989-6769 Fax: 212-647-0005
www.assouline.com

ISBN: 9781614284321
10 9 8 7 6 5 4 3 2
Editor: Amy L. Slingerland
Art director: Jihyun Kim
Photo editor: Hannah Hayden

Preface by Francesca Pollock

DINNER WITH JACKSON POLLOCK

RECIPES, ART & NATURE

BY ROBYN LEA

Foreword by Helen A. Harrison,
Eugene V. and Clare E. Thaw Director,
Pollock-Krasner House and Study Center

ASSOULINE

TABLE OF CONTENTS

Jackson's studio in high summer, Springs.

PREFACE: KEEPING THE RECORD STRAIGHT

" YOU ARE A REAL CRAFTSMAN, MOTHER. NO WONDER THERE ARE SO MANY ARTISTS IN THE FAMILY. "

From an unpublished letter from Frank Pollock to Stella Pollock, 1937

Charles Pollock, the eldest of the five Pollock brothers, was my father, and Jackson Pollock, the youngest of the brothers, my uncle. They were both artists.

When I was born, my father was sixty-four years old. Born so late in his life, I only got to know two other Pollock brothers, Frank and Jay. Still, Jackson, who died eleven years before I was born—his presence, his fame, his art, his name, the stories about him, his letters—has always been a big part of my life. But I have always seen him either through the proud and attentive eyes of my father or through the mystification of others. Because of our family ties and our common heritage, I have seen him more as a man than as a famous artist, more as a human being than as a celebrity.

Until I saw this book, I never knew how much Jackson and Lee liked to cook and entertain, but somehow I am not surprised. That way of life—that simplicity, that taste for nature—evokes perfectly my image of my grandparents. The father I knew was different. I don't think he liked cooking in a formal way or from recipes. What he liked to do with food was to play with leftovers. The only times I ever heard him talk about cooking was when, after a day painting in his studio, he would come home and announce, "I think something is cooking!" Indeed, he painted the same way he cooked: Endlessly using leftovers; keeping and re-using; trying one color or shape and then another. There was never ever any waste. Painting, like cooking, was a way of living.

What he had inherited from his parents, and maybe most especially from his mother, was an interest in man-made things more than in things found in nature. And in those things, she had high standards; she didn't like "shoddy."

Looking at these elegant and beautiful photographs, I feel, like Alice in Wonderland, that I am peeking through the looking glass into a world that is familiar but that I have never really known. It is a world I only approached briefly, and in some ways too late. The closest I ever got

to that atmosphere (or to what was left of it) was in 1982, when my father took me on a long journey. First we went to Mexico to see his dear friend the artist Mathias Goeritz. I was fifteen, and seeing our picture on the front of the national daily newspaper was quite a thrill. Then we joined my mother, Sylvia Winter Pollock, in Los Angeles, where we spent time with the family. Then, after a few days in New York City, we went to East Hampton, where we visited with Reuben and Barbara Kadish, Jeffrey Potter, Herman and Regina Cherry, Willem de Kooning, and Alfonso Ossorio. Ossorio's studio at The Creeks was the most amazing place I had ever seen; his mixed media and his charisma were anarchic and unforgettable. I think it is the only time in my life that I entertained the idea of becoming an artist!

The way Robyn Lea discovered the recipes for this book reminds me of my own experience of discovering the family letters in the Charles Pollock Archives. My father had kept all those letters out of a highly developed sense of responsibility. Not only was he a key figure in carving a path for his siblings, but all his life people came to him with questions about the family and his famous brother. Often the story he told was too simple, and not romantic or glamorous enough for them. There was no mystification in his accounts. Charles cared deeply about transmission, always insisting that we had to do our best to "keep the record straight." Now, more than twenty-five years after his death, that phrase still resonates, and influences my own approach to family matters. When I discovered those letters, I realized at once how precious they were, since they tell an unabridged story.[1] One of a simple, modest family with very high moral standards and expectations—and no taste for convention.

I am delighted to be able to contribute to this wonderful project, because I know it is honest material and provides another way—unexpected, like a gift—of keeping the record straight!

FRANCESCA POLLOCK

[1] *American Letters, 1927–1947: Jackson Pollock & Family*. Sylvia Winter Pollock, ed., Polity Press, 2011.

FOREWORD

Jackson Pollock (1912–56) is world-famous as a genius of abstract painting, but how many people are aware that he also had culinary talent? The eastern Long Island home that he shared with his wife, Lee Krasner (1908–84), is now the Pollock-Krasner House and Study Center, a museum devoted to their lives, where their recipes and cookbooks are preserved. I was delighted when Robyn Lea proposed mining them for this book, which also amplifies the material in our collection. Robyn's extensive research and beautiful photographs, many using Jackson and Lee's own cookware and tableware, open a fascinating window on their world.

Until he was eighteen, Jackson lived at home, moving around the Southwest with his family, finally settling in Los Angeles. His mother, Stella Mae McClure Pollock, raised her five sons to appreciate good cooking, and her bountiful meals are legendary. In 1930 Jackson went east to attend the Art Students League in New York City. For the next few years he probably survived on what he could scrounge from the League cafeteria, where his teacher, Thomas Hart Benton, got him a job to help pay for his classes. And he was always welcome at Benton family dinners, presided over by Benton's wife, Rita.

In the depths of the Great Depression, Jackson shared living quarters with his brother Sanford, known as Sande, and theirs was a hand-to-mouth existence. Sande later recalled that they were so poor they stole produce off pushcarts. The only mention of what they actually ate is in a letter Jackson wrote to their father in 1932, which he closed with, "Well Dad I took time out to eat about two pounds of fresh cooked spinach—shure [sic] like it."

When Sande married his sweetheart, Arloie, she moved into their apartment on East 8th Street in Greenwich Village and prepared the meals for the two brothers. By that time they were both getting modest but regular paychecks from the Works Progress Administration's Federal Art Project, a New Deal employment program, which began in 1935. The WPA supported many artists, including Lee Krasner, throughout the economic crisis.

Before Lee met Jackson in late 1941, she didn't know how to boil water. There's an amusing scene in the motion picture *Pollock,* starring Ed Harris as Jackson and Marcia Gay Harden as Lee, that dramatizes her lack of culinary skill. Jackson visits Lee's studio, and she asks if he'd like some coffee. When he answers yes, she puts on her coat, and says, "You don't think I make it here?" Out they go to the coffee shop. After Sande and Arloie moved to Connecticut in 1942, Lee began living with Jackson and she had to learn to cook or they both would have starved.

With their move to the country in November 1945, they apparently thought they could live off the land. Not long after arriving in Springs, Jackson wrote to one of his brothers that they

had "a boat and a goat." Evidently he planned to fish off the boat and milk the goat. But he soon ran up a tab at the Springs General Store, where he once settled the grocery bill with a painting. Getting through that first winter must have been tough, since they had only a coal range to cook on. Their first major purchase for the house was a gas stove.

One of the advantages of country living was the availability of excellent fresh ingredients. Seafood was always on the menu. Lee's big enamel lobster cooker is still in the pantry. Martha Holmes, the photographer who took the wonderful pictures of Jackson at work for *Life* magazine in April 1949, told me that after the day's shoot—which included pictures of the couple entertaining friends around Lee's mosaic coffee table in the living room—Jackson and Lee invited her and her boyfriend to stay for dinner. They dined on local fish, and fifty years later Martha fondly remembered the delicious meal and the artists' warm hospitality.

After Jackson's untimely death in an automobile accident in August 1956, Lee understood that, just as his lifetime career required a certain amount of cultivation, maintaining his posthumous reputation would involve entertaining influential people. And she had her own career to consider. Within a couple of years she acquired a magnificent circular dining table that was the locus of many a memorable meal and is now the museum's centerpiece. The mid-nineteenth-century mahogany table is a marvel of Victorian engineering. When fully extended it is eight feet in diameter, seating a dozen guests, but for more intimate dinners it can be reduced to six feet across by means of rotating hinges attached to its wedge-shaped leaves. For the next two decades, Lee wined and dined the collectors, critics, curators, art historians, and art dealers who ensured Jackson's status in the art world and ultimately elevated her own.

Jackson and Lee's gastronomic history is well documented in their Springs home. You're welcome to visit the kitchen where the couple prepared their favorite dishes, and the living-dining room where they entertained friends and family.

HELEN A. HARRISON
Eugene V. and Clare E. Thaw Director,
Pollock-Krasner House and Study Center

INTRODUCTION

"...I ALWAYS THINK OF HIM LIKE A FARMER, PART OF THE EARTH, THE TREES, THE WHOLE LANDSCAPE OUT THERE." *Herbert Matter*[1]

Alone on the banks of Accabonac Creek on Long Island with my camera on a cool and quiet post-winter evening, I tried to imagine how Jackson Pollock might have perceived the scene when he stood there sixty years before. The view back toward his studio and house was carpeted with marshland grasses that made a dancing pattern, still half-frozen in poetic formation from the heavy snow that had melted just a week or so before. Naked trees appeared like dark, sharpened fingers reaching to the dusk sky, framing Jackson's studio off to the right and the shingled house at center, and forming a demarcation line around the property. It was here, in the East Hampton hamlet of Springs, that Jackson lived with his wife, artist Lee Krasner, from 1945 until his premature death in 1956. This is where he created the masterpieces of modern art that propelled him into the global spotlight. It is also where I found Jackson and Lee's collection of handwritten, unpublished recipes and a side of the artists that I never knew existed.

I learned of the recipes only after I had visited the house and studio many times to photograph the interiors and surrounding landscapes. History has imbued their simple personal objects with weight and meaning—Jackson's monogrammed suitcase, a dial telephone on the bedside table, and Lee's lone wicker chair on the front porch. The multicolored lattice of paint on the studio floor documented the works Jackson created there. I made still-life studies of their art materials, including cigar boxes full of pastels or charcoal, sticks used for mixing or flinging paint into the air, color pigments in jars from the Works Progress Administration art projects, sharpened pencils, rusty tools, handmade paper, and even a human skull.

With each visit there was another angle or object to shoot, or simply the same subject in the light of a different season. Drawn to their kitchen and pantry, I photographed pots and pans, a delicate rattan basket, Lee's beloved cut-glass jugs and wine goblets, and a white ceramic dove on the windowsill. The evidence of daily life was everywhere—the stove, a family of wooden spoons, an eggbeater, tarnished silver cutlery, and even the kitchen sink.

In October 2012 the director of the Pollock-Krasner House and Study Center, Helen Harrison, told me they had some of Lee and Jackson's handwritten recipes, sixteen in total, including recipes

Lee Krasner and Jackson Pollock in the kitchen of their home in Springs, New York, April 1949.

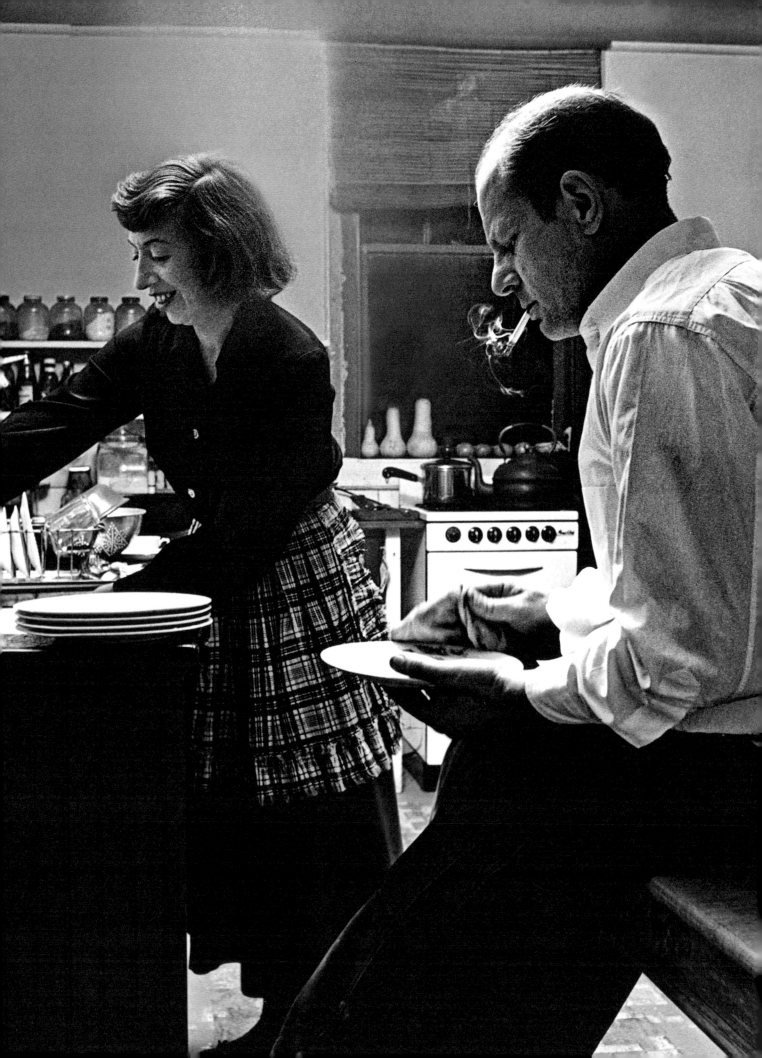

Lemon Pudding

3 egg yolks juice of
1 lemon 1 scant cup
sugar creamed with
1 tables. butter pinch
of salt 1/3 cup flour
1 cup milk
Beat eggs seperately
mix yolks juice flour
+ milk in creamed
butter & sugar. Fold
in beaten egg whites

1 - mix sugar into butter
& alternate milk & flour
slowly into creamed mix.
3 Add beaten yolks &
l. juice

Pat

Lois

(You can make this in morning and heat
up at night.)

(I a a little more liquid)

mix graham - butter & . . .
Pan - . . . of the egg yo. . .

for potato pancakes, lemon pudding, and Jackson's bread. On further investigation we found dozens more, stuffed inside the front and back covers of their recipe books and inside the pockets of a small *New York Times* recipe file from 1942. Along with the handwritten recipes were other favorites marked with pencil in their recipe books. *The Art of Fish Cookery* and *The Mystery Chef's Own Cook Book* had pages caked with flour and butter, and the recipe for Chocolate Butterscotch Cake was splattered with chocolate blobs in *The Pocket Cookbook*. Important pages were dog-eared, and favorite dishes were bookmarked with pieces of torn paper wedged in the spine.

Among Lee and Jackson's handwritten recipes were those by artist and collector Alfonso Ossorio, socialite and writer June Platt, and other friends in their circle, along with family favorites by Jackson's mother, Stella Pollock, and his sister-in-law, Arloie McCoy. There were recipe cards saved from the luxury dining cars of the Union Pacific Railway, and others written on scraps of paper, used envelopes, and even on notepaper from Jackson's psychiatrist's office. Many were written by Lee in a small spiral-bound notebook then torn out and filed in their recipe folder. Jackson wrote his recipes in almost perfect script on unlined paper, with ingredients and methods clearly noted. Many of Lee's seemed written in haste, perhaps at a dinner party, sometimes noting just the essential details for a delicious dish.

Fastened with a rusty paper clip inside *The Boston Cookbook* was a nine-page diet prescribed to Jackson in the early 1950s by pharmacist Grant Mark, who thought he could cure Jackson's alcoholism through a strict diet, daily doses of a soy-based emulsion, and a regimen of salt baths and minerals. Friends rallied to encourage Jackson's cure through food, and for Christmas 1953 they were given a recipe book titled *Raw Vegetable Juices: What's Missing in Your Body?* which included recipes for brussels sprout and dandelion juice. Their book *Constructive Meal Planning* spoke of "nutrition in action" and the importance of using raw seasonal ingredients, and they purchased a blender in order to make healthy smoothies and fruit drinks from their "Pick Ups and Cheer Ups" recipes. Jackson's interest in the power of raw foods was perhaps inspired by his own mother, who wrote something of a motto inside her own recipe book in the first pages: "Raw Food and Dynamic Breath Control for Health, Success, and Happiness." The heading preceded almost four pages of her notes detailing a juice fast diet that included doses of black cherry juice, grape juice, and sauerkraut juice.

The recipes help us see beyond the image of Jackson as a narcissistic action-painter fueled to alcoholic self-destruction, to a quieter domestic portrait, informed by the rhythms of the day-to-day. Inside their private domestic world, Jackson loved nothing more than to make a batch of fluffy pancakes for his friends, open fresh clams at high speed to share with guests who came up from the city, or bake an apple pie for the annual local fair competition. When his pie won first prize, he taught his friend Josephine Little how to make it. Jackson's love of food was evident in the childlike joy he experienced in the color of his homegrown eggplants and his rapture at the bounty of the sea, the forest, and the simple pleasures of his own vegetable garden.

A selection of original handwritten recipes discovered in Lee and Jackson's pantry.

Food preparation for Jackson and Lee was not a tiresome daily chore but an extension of their creative outlook, an interest that stemmed from childhood and blossomed into a shared passion beginning in 1942, when they began living together in New York City. But what was the origin of each recipe? Who were the guests at Lee and Jackson's table? And what fueled their passion for good food?

Jackson's interest originated on the family ranch in Phoenix, Arizona, where his father, LeRoy Pollock, farmed vast fields of vegetables and fruit to sell at market. Jackson's eldest brother, Charles, remembered their father as a "craftsman on the soil…I think my father was a very sensitive man. He was very good on the farm. He knew how to make things grow."[2] Among other things, LeRoy grew squash, beans, yams, alfalfa, okra, tomatoes, corn, cucumbers, various melons, strawberries, and apricots. His enormous watermelons won the blue ribbon at the local fair in 1914 and the family was photographed holding the prize fruit. The photo captures the beaming smiles of his oldest boys, which reflect LeRoy's infectious pride, while two-year-old Jackson holds his massive slice of melon with an expression of full concentration. In the selling season, Charles would help LeRoy load up the wagon in the evening, then wake around four in the morning and hitch up a horse team to the wagon and accompany him to market.

Like LeRoy, Jackson's mother, Stella, was industrious and hardworking. While LeRoy was happiest working the land, Stella's domain was the kitchen. Her culinary talents extended beyond the preparation of exceptional meals for her family to working at times as a professional cook to supplement the family income, and her handwritten recipe book shows that even during the war and Depression years, she brought beauty and art to her table. She fed her husband and five boys meals that often included recipes cut out of the latest magazines at the end of a long day of work. In her collection were dishes with titles such as Delicious Cream Fudge, Frozen Apple Snow, A Perfect Shortcake, Cranberry Fluff, Apple Eggnog Pie, Rhubarb Wine, Lady Baltimore, Italian Chocolate Pudding, and Heavenly Hash. Despite the many hardships of life in her time, Stella was driven to create not just utilitarian meals but magnificent, creative meals, as though her life depended on it.

As a toddler and young boy, Jackson would often shadow his mother in the kitchen, where she baked fresh bread, whipped cream, churned butter, roasted, bottled, pickled, and poached. Her daily routine also included feeding their pigs and chickens and milking their herd of Holstein and Jersey cows, while Jackson was placed in charge of collecting eggs from the chicken pen and helping to feed their baby ducklings. Stella liked to have first pick from LeRoy's fruit and vegetable cart before it disappeared to market, and she loved buying exotic food ingredients, despite their often difficult financial circumstances. Then the family would "eat like Roman banqueteers for three days…she had to buy the very best there was. Whatever was the finest and rarest food…and if she couldn't get that, she took nothing!"[3]

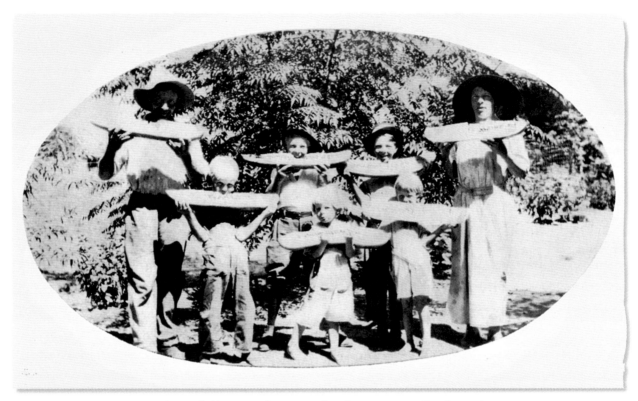

Penned note beneath image: "In the good old 'watermelon' time." Identification on verso (handwritten): "The Pollock Family in Arizona, ca. 1914; L to R: Le Roy, Frank, Charles, Jackson, Jay, Sanford, Stella."

LeRoy Pollock (second from left) with sons Sanford, Jackson, and Frank, exploring cliff dwellings, Tonto National Forest, Arizona, 1924.

In 1957, the year after Jackson died and the year before her own death, Stella was still collecting and writing up her favorite recipes. Reflecting her love of trying the newest dishes, she cut out a recipe from *The Tribune* for a French-style dessert, Savarin in Apricot Syrup, which was served to Queen Elizabeth when she dined at the Waldorf-Astoria in New York City in the fall of 1957 on her first official visit to the United States. The accompanying story declares, "You will feel like a queen serving and eating it."

For Jackson, food was a defining characteristic of his relationship not only with his parents but also with many other key people in his life. In 1930, at age eighteen, he left the family nest in California, following his brothers Charles and Frank to live in New York City, and began studying art with Thomas Hart Benton. Thomas's wife, Rita, practically adopted Charles and Jackson as extended members of the family and fed them regular Italian-style meals inspired by her upbringing in a small village about ten miles south of Lake Como in northern Italy. She served Jackson his first-ever spaghetti and, charmed by his bewildered response, gave him a lesson in how to eat it. When he was sick she would send a batch of cookies with cream to his apartment, and when he was unhappy or anxious she wrote encouraging letters and helped with ideas for selling his work or generating income. During the Depression years Jackson sometimes joined the Bentons on vacation at Martha's Vineyard and would forage with Rita for wild ingredients. Each night Rita would cook from the bounty of the seasonal produce they found and the freshest fish from the fishermen at Menemsha Bay.

Later, food also became a key element of Jackson's relationship with Lee. When she moved into his Greenwich Village apartment she essentially took over where Rita and Stella had left off. As well as providing an important emotional anchor, she stepped into the role of homemaker, which compelled her to learn to cook for the first time. Lee took her new role seriously, and having met Stella she realized she had big shoes to fill. "I was overpowered by her cooking. I had never seen such a spread as she put on. She had cooked all the dinner, baked the bread. The abundance of it was fabulous."[4]

Like Jackson's, Lee's upbringing also revolved around food and was governed by the rhythms of the market. After moving to America, Lee's parents ran a fish, fruit, and vegetable stall in Brooklyn's Blake Avenue market, and Lee grew up on the Jewish recipes her mother learned in her hometown near the former Russian city of Odessa. This early education informed her insistence on top-quality ingredients throughout her life, and she was "capable of giving the butcher hell who gave her a poor cut of beef; Lee did not reserve her rage."[5] By the time Lee moved in with Jackson she had renounced many of the traditions of her religion and cultural heritage, including most of the recipes of her childhood. Instead she sought out Jackson's favorite recipes from Stella and Arloie, from artist friends in their circle, as well as French-style recipes that were popular in New York at the time. Many of the Pollock family recipes were the classics of Midwestern cuisine, as well as wonderful New England and Southern-style dishes.

Lee's confidence in the kitchen grew rapidly; she soon combined her culinary skills with her determination to promote Jackson's art, and she began hosting dinner parties in their apartment. She quickly understood the power of the dinner party to capture the attention of important people in the art world. Lee invited Peggy Guggenheim's assistant Howard Putzel to one of their first dinner parties, determined to introduce him to Jackson's work. In an early display of her natural flair, she served a sophisticated menu, and Howard's thank-you note to Jackson included compliments to his "Cordon Bleu Chef."

No doubt inspired by the flavors and aromas of his mother's kitchen as well as Rita Benton's many tasty dishes, Jackson had also developed an interest in cooking and would soon be sharing his signature dishes with friends in their new home in Springs. Their property had ample space for Jackson to follow in the footsteps of his father and both his paternal and maternal grandfathers, and plant a garden of vegetables and fruit. Jackson had an acute sensitivity for the land, and the garden produce delighted him. He felt an enormous sense of pride in gifting friends with his vegetables, and even offered his produce to his friend Dr. Frank Seixas, who remembered, "We didn't do any bartering, as some did for services, and he didn't give us a painting. What he did give us was an eggplant—the best, most glorious purple shiny eggplant. That was our memento from Jackson."[6]

For Lee a bigger home meant the possibility of hosting influential weekend houseguests, ensuring their connection with art-world contacts in New York. Having observed the sophisticated salon of friends Mercedes and Herbert Matter in their apartment on 42nd Street in New York, and the style of Lucia Wilcox, who entertained the surrealists with her fine Syrian cuisine, Lee was soon issuing invitations to Peggy Guggenheim (whose loan helped them buy the house), art critic Clement Greenberg, and artist and collector Alfonso Ossorio and his partner Ted Dragon. A trail of other friends followed. Keen to introduce their city friends to the wonders of Springs and its magnificent bounty, Jackson would often baptize them with a clamming expedition, urging them to follow him across their back lawn to the salt marshes lining the creek and Gardiner's Bay beyond to help gather clams for dinner. Soon afterward Lee would be found in the kitchen cooking up a chowder or clams with garlic and dry vermouth, followed perhaps by raspberry-poached pears or brandied peaches.

It was in the kitchen and around the table that Lee groomed clients and journalists, and both Jackson and Lee were active in the meal preparations. Lee later described the division of roles in the kitchen: "He loved to bake. I did the cooking but he did the baking...he was very fastidious about his baking—marvelous bread, cake, and apple pies. He also made a great spaghetti sauce."[7]

After the privations of World War II rationing in New York City, Springs seemed like a veritable Garden of Eden. In the spring and summer months there was an extraordinary cornucopia of fresh and wild produce that was available at little or no cost. There was a great variety of seafood, wild duck and game, the freshest wild strawberries, cranberries, raspberries, rose hips, elderberries, grapes, and beach plums. The forest offered still more wild ingredients,

"JACKSON SPENT HOURS, SOMETIMES WHOLE DAYS, WALKING AROUND, THE FIRST SPRING WE WERE THERE. HE WAS LIKE A KID EXPLORING EVERYTHING... HE LOVED TO GO OUT AND LOOK AT THE DUNES."

Lee Krasner[8]

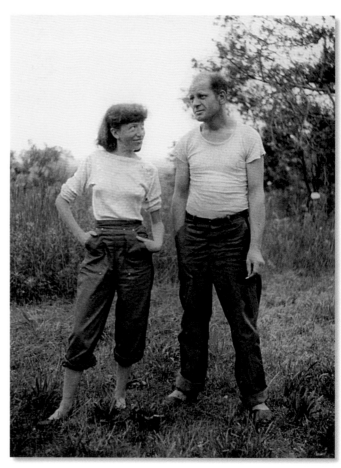

Lee and Jackson in Springs, c. 1946.

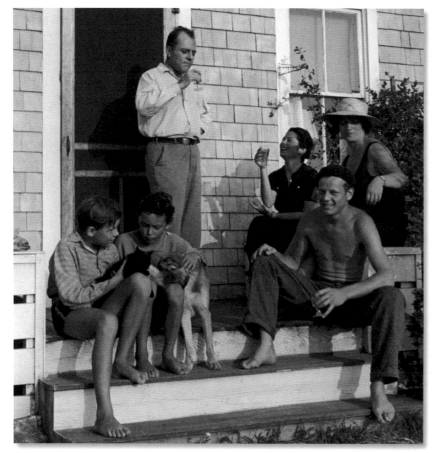

Jackson Pollock (seated at right) on the steps of painter Thomas Hart Benton's summer home with Rita Benton (in hat) and author Coburn Gilman (standing), 1937.

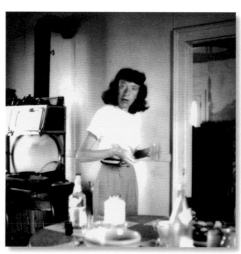

Lee Krasner in the kitchen, Springs, c. 1947.

including mushrooms, leeks (ramps), and fiddlehead ferns, while lambs' quarters, purslane, and wild lettuces sprouted in the spring and summer. Around the sandy riverbanks, wild groundnuts were plentiful and local farm stands sold vegetables and fruit, such as Long Island potatoes, cauliflower, brussels sprouts, pumpkins, peaches, and apples.

For other supplies, cream-topped morning milk and hand-churned butter were available from neighborhood vendors, and Iacono Farm sold free-range chickens and turkeys, while Taber's Seafood Market down the road sold huge lobsters, soft-shell crabs, and the results of the Bonac fishermen's daily catch. The local windmill in East Hampton was still grinding wheat and corn for the tastiest loaves of home-baked bread. Community festivals centered around prized ingredients such as strawberries and clams, with bake-offs and cook-offs and prizes awarded for the best in show. When they could afford to, Lee and Jackson bought porterhouse steaks from Dreesen's butcher shop and grocery store in East Hampton, which was also famous for cinnamon-dusted donuts.

Lee and Jackson shared their culinary interests with many of their closest friends, including artists or writers whom Jackson and Lee had convinced to relocate to Springs. Not surprisingly, many of the artists shared their interest in food, a heightened appreciation for the color, form, and beauty of the natural ingredients, and a pronounced interest in the presentation of the final dish. Artist friends John and Josephine Little loved to share the produce they grew at their nearby property, Duck Creek Farm, which Lee and Jackson had urged John to buy and Jackson had helped to renovate.

The Littles' garden included peaches, arugula, mustard greens, and fresh basil. They made green grape jelly and wine from their own grapes, served globe artichokes with melted butter and chestnuts when in season, made eggnog, peach brandy, and hot buttered rum for dinner parties, and candied orange peel, butter mints, and meringue cookie kisses for gifts. They also raised their own turkeys and chickens, and John built a smokehouse in the woods behind the main flower garden and used hickory to smoke whiting that he and Jackson caught at Montauk. With Jackson and Lee they shared cornmeal pancakes, bacon, and maple syrup, and for dinner they grilled steaks over an open fire. Both couples entertained often and loved to prepare dishes from their garden-picked produce, and enjoyed salads such as peeled grapefruit with young mustard greens and garlic vinaigrette, or endive salad sprinkled with crumbled Roquefort and walnuts. One of John's favorite recipes was Chicken Renoir, while Josephine's Hominy Puffs became Lee's all-time favorite recipe.

In nearby East Hampton, Lee and Jackson were among Alfonso and Ted's most regular dinner guests at their extraordinary Italianate mansion, The Creeks, on Georgica Pond. Drawn together through a love of art and appreciation for food and nature, the two couples shared a strong bond. Dinner at The Creeks often involved five or more courses, often beginning with Bollinger or Dom Pérignon Champagne and crudités. One menu included creamed smoked capon in pastry shells, a clear herb consommé with sliced raw mushrooms, and duck à l'orange

served with wild rice and buttered asparagus. For dessert, nut roll was served along with peeled grapes and melon balls, and all courses were accompanied by French wine. Other favorites at The Creeks included eel stew Normandy; *saucissons* borghese; stuffed clams, fish, and lobsters; and pork loin roast. Ted was in charge of table settings and liked to decorate to a theme, or create beautiful centerpieces of fresh flowers including sweet peas and roses.[9]

Jackson was thrilled when his friends relocated to Springs, but he was also focused on connecting with his new neighbors, known as Bonackers, many of whom worked as tradesmen, fishermen, and farmers. It was, however, a private and self-contained community, with many descendants of the English sailors who arrived on the first settlers' ships in the late 1630s. Some of the Bonackers were bemused by the New York art couple in their midst, but Jackson persisted. Chatting with Dan Miller at the Springs General Store, or sitting side by side with locals at Jungle Pete's tavern, conversations flowed about the day's catch or what hearty dishes were served on the tavern menu. "Clam-talk" was a favorite subject, including debates about the best clam pie and chowder recipes, many of which were handed down by the locals' ancestors. Nina Federico, who owned the establishment with her husband, was a quiet-spoken woman with a huge heart, and she loved to create tasty meals for the locals. If regulars appeared with game after a hunt, they knew to take it through the kitchen's back door and she would have it prepared and served to them.

Jackson's fascination with and love of nature—the seasons, the colors, the moods, the produce, and the magic—was absolute. Josephine Little remembered Jackson's excitement as he burst into their kitchen with a box of farm-picked strawberries from Amagansett, while on another occasion he called for the whole family to come out to see the aurora borealis, "which was a spectacular 'bolts of silk' display, pinks and greens in pendant shimmering folds draped across the dark sky."[10]

Planting, gathering, fishing, and clamming for fresh seasonal ingredients connected Jackson to nature, which fed his inner creative terrain and in turn inspired many of his greatest works. From his paintings *Enchanted Forest* and *The Nest* to the Accabonac Creek series and the Sounds in the Grass series, there was a fluid interconnection between art, food, and nature—the three pillars of their lives in Springs, and the three subjects celebrated in this book. Inside these pages you will find over fifty of these recipes, and eating them is like experiencing a slice of history.

NOTES

[1] *To a Violent Grave: An Oral Biography of Jackson Pollock,* by Jeffrey Potter, 1987, p. 129.

[2] Interview with Charles Pollock conducted by Jeffrey Potter, 1982, from the Jeffrey Potter tapes in the Oral History Collection, Pollock-Krasner House and Study Center, East Hampton.

[3] Interview with Elizabeth Pollock conducted by Jeffrey Potter, 1982, from the Jeffrey Potter tapes in the Oral History Collection, Pollock-Krasner House and Study Center, East Hampton.

[4] "Who Was Jackson Pollock?" by Francine du Plessix and Cleve Gray, *Art in America,* May–June 1967, pp. 33–34.

[5] *To a Violent Grave: An Oral Biography of Jackson Pollock,* by Jeffrey Potter, 1987, p. 209.

[6] *To a Violent Grave: An Oral Biography of Jackson Pollock,* by Jeffrey Potter, 1987, p. 141.

[7] "Who Was Jackson Pollock?" by Francine du Plessix and Cleve Gray, *Art in America,* May–June 1967, p. 51.

[8] *Jackson Pollock: An American Saga,* by Steven Naifeh and Gregory White Smith, 1989, pp. 516–17.

[9] Information about dinners at The Creeks sourced from the Alfonso Ossorio and Edward Dragon Young Papers (SC 15), file 982, Harvard Art Museums Archives, Harvard University, Cambridge, MA.

[10] Interview with Abigail Tooker conducted by Robyn Lea, April 15, 2014, and subsequent letters and documents provided to Robyn Lea by Abigail Tooker.

Jackson and Lee's kitchen.

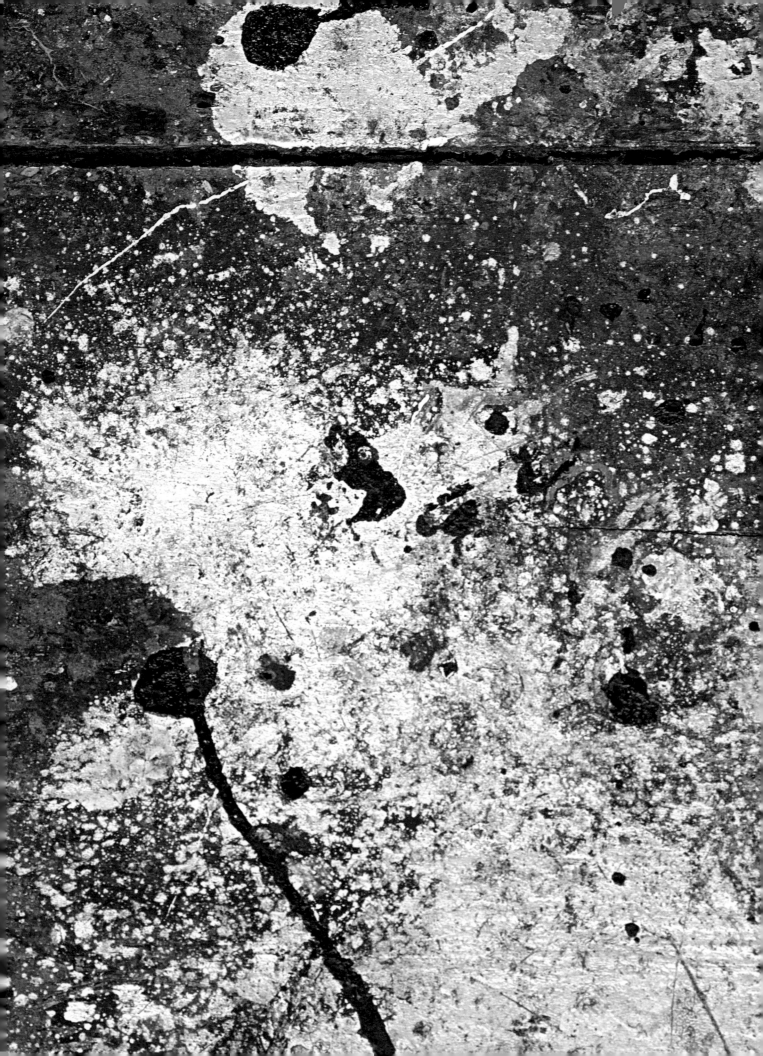

SOUPS
&
STARTERS

BORSCHT

This beet soup was inspired by a favorite recipe of Jackson and Lee's from a small cookbook that came with their purchase of a Waring blender in the late 1940s. In an earnest attempt to cure Jackson of his alcoholism, the couple followed dietary advice from various people, some of whom emphasized vast quantities of certain fresh fruits and vegetables. Lee prepared nutrient-packed smoothies, soups, and healthy dressings for Jackson's consumption and coaxed him to eat fresh vegetables and fruit. They might have prepared this dish, of a bright magenta hue, using beets from Jackson's garden or from roadside vendors whose seasonal produce thrived in the fertile Bridgehampton loam soil.

Serves 4

1 lb raw beets

1 cup beef broth

½ cup sour cream,
 plus more for serving

½ lemon, juice and zest

½ tsp salt

2 pinches freshly ground
 black pepper

¼ cup dill and/or chives,
 finely chopped,
 for garnish

○ Wash and scrub beets thoroughly, then place in a saucepan and cover with lightly salted cold water. Bring to a boil then reduce heat to low and cook until tender, about 40 minutes depending on the size of the beets. Allow to cool, then strain and reserve liquid.

○ Peel then chop beets into quarters, then place them in a blender with 1 cup reserved beet liquid, beef broth, sour cream, lemon juice and zest, salt, and pepper; blend until smooth. Garnish with a swirl of sour cream and sprinkle with finely chopped dill and/or chives.

○ Serve warm or cold.

"ABSTRACT PAINTING IS ABSTRACT. IT CONFRONTS YOU. THERE WAS A REVIEWER A WHILE BACK WHO WROTE THAT MY PICTURES DIDN'T HAVE ANY BEGINNING OR ANY END. HE DIDN'T MEAN IT AS A COMPLIMENT, BUT IT WAS."

Jackson Pollock[1]

[1] "Unframed Space," by Berton Roueché, *The New Yorker*, August 5, 1950.

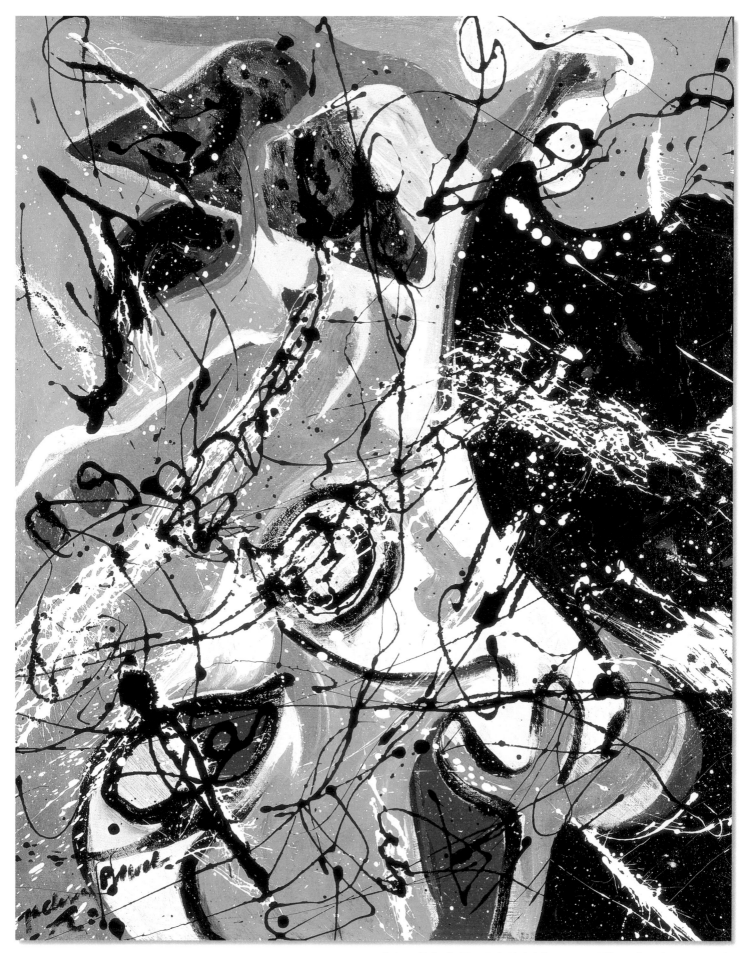

Jackson Pollock, *Water Birds*, 1943. Oil on canvas, 26¹/₈ x 21¼ in. (66.4 x 53.9 cm).
Opposite: Borscht. *Previous pages:* Detail of Jackson's studio floor.

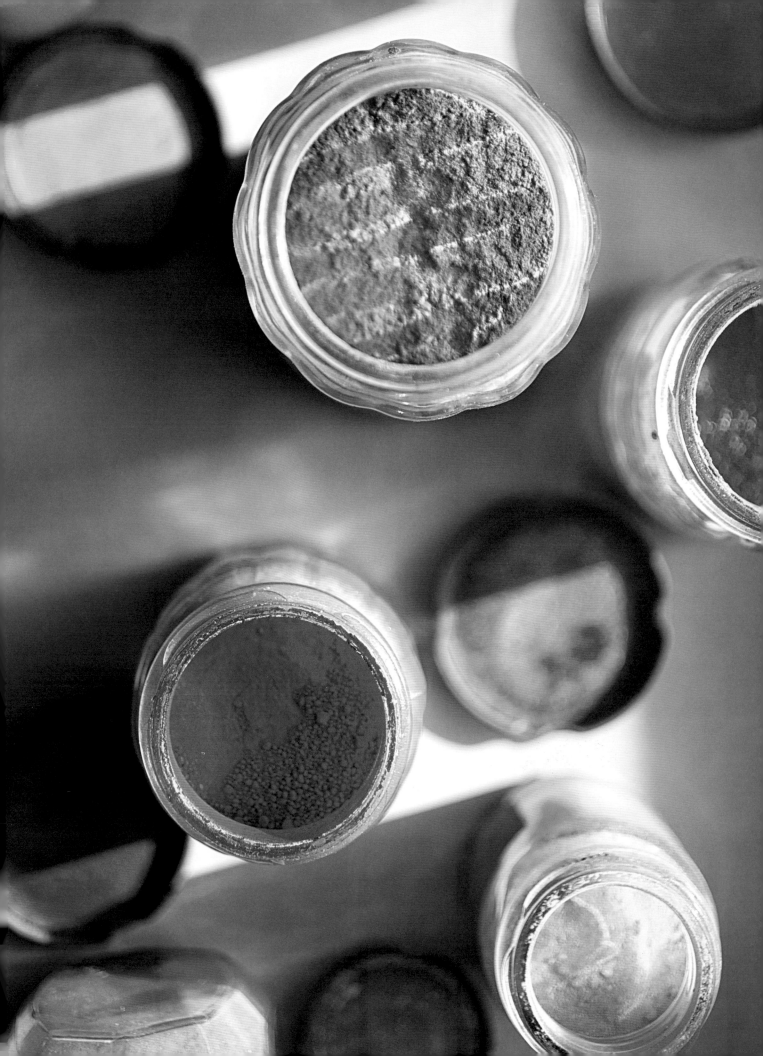

CREAMY ONION SOUP

Classic cream of onion soup was a favorite dish of Jackson's mother, Stella, who described it in her notes alongside this recipe as a "refreshing dish."[1] On the family ranch in Phoenix, Arizona, the ingredients for this soup were readily available to Stella, as they had chickens for fresh eggs, and dairy cows for milk, cream, and butter. It is an easy-to-prepare French-inspired soup and has a smooth, rich taste due to the milk as well as the egg yolks, which are stirred in at the end.

Serves 4-6 as a starter

3 Tbsp butter

6 large onions, sliced thinly

1 cup vegetable broth,
 plus more asif needed

1 quart milk

1 Tbsp flour

4 egg yolks

1 cup cream

salt and pepper

crispy roasted shallots,
 cut in thin slices,
 for garnish

olive oil and toast,
 for serving

- In a fry pan, melt butter; add sliced onions and stir until they begin to cook, then cover tightly and simmer for half an hour, checking and stirring regularly, adding a little vegetable broth as needed to make sure the onions don't burn.

- In a saucepan, bring milk to a boil. Into the onions, add flour and stir constantly for 3 minutes over the heat, then pour the onion mixture into the milk and cook for 15 minutes. Pass the soup through a strainer, return it to the heat, and season with salt and pepper. Beat egg yolks well; add the cream to the egg yolks and stir mixture into soup. Cook 3 minutes stirring constantly. Add more broth as needed to adjust to desired consistency.

- Garnish with fresh herbs, roasted or pan-fried shallots, and a few drops of olive oil on top.

- Serve with toast.

Creamy Onion Soup. *Opposite:* Jackson and Lee's collection of paint pigments that they kept from their WPA art projects.

[1] Stella Pollock's original recipe book, courtesy of Jacqueline Pollock de Souza Costa, in Sacramento, California, July 2014.

EGGPLANT CONSTANTINOPLE

This delicious dish was a family favorite, handwritten in Stella's recipe book. Jackson inherited his mother's love of eggplant and he grew them in his garden in Springs. He liked to present friends with his home-grown vegetables "as though they were being presented with the crown jewels."[1]

Serves 4

1 medium-size eggplant,
 sliced in ½-inch rounds
2 onions, sliced
2 Tbsp butter, plus more
 as needed
1 cup ground lamb
2 cups tomato juice
1 egg, lightly beaten
½ cup bread crumbs
salt and pepper
fresh herbs from the garden,
 chopped

○ Soak eggplant slices in salted water for one hour.

○ Preheat oven to 350°F. Rinse eggplant slices and pat dry. In a sauté pan, brown sliced onions in butter, stirring often. Set aside.

○ In another pan, brown the eggplant slices in butter, keeping covered and checking regularly, adding more butter as needed. Set aside.

○ In another pan, brown the ground lamb, add the cooked onion, and season with pepper, salt, and fresh herbs to taste.

○ Line a rectangular baking tin or cast-iron or enamel baking dish with baking paper. Place a layer of eggplant slices, then a layer of ground lamb and onion mixture, then a generous drizzle of tomato juice, then a layer of bread crumbs, then a layer of eggplant, and so on. Pour remaining tomato juice over the top and around the edges, top with bread crumbs, and drizzle the beaten egg over the top.

○ Bake about 1 hour until all the eggplant is soft and the top is brown and crispy.

○ Sprinkle with more chopped fresh herbs to garnish.

[1] Interview with Helen Harrison conducted by Robyn Lea at the Pollock-Krasner House and Study Center, April 2014.

Baby eggplants, similar to what Jackson proudly grew and gifted from his vegetable garden.

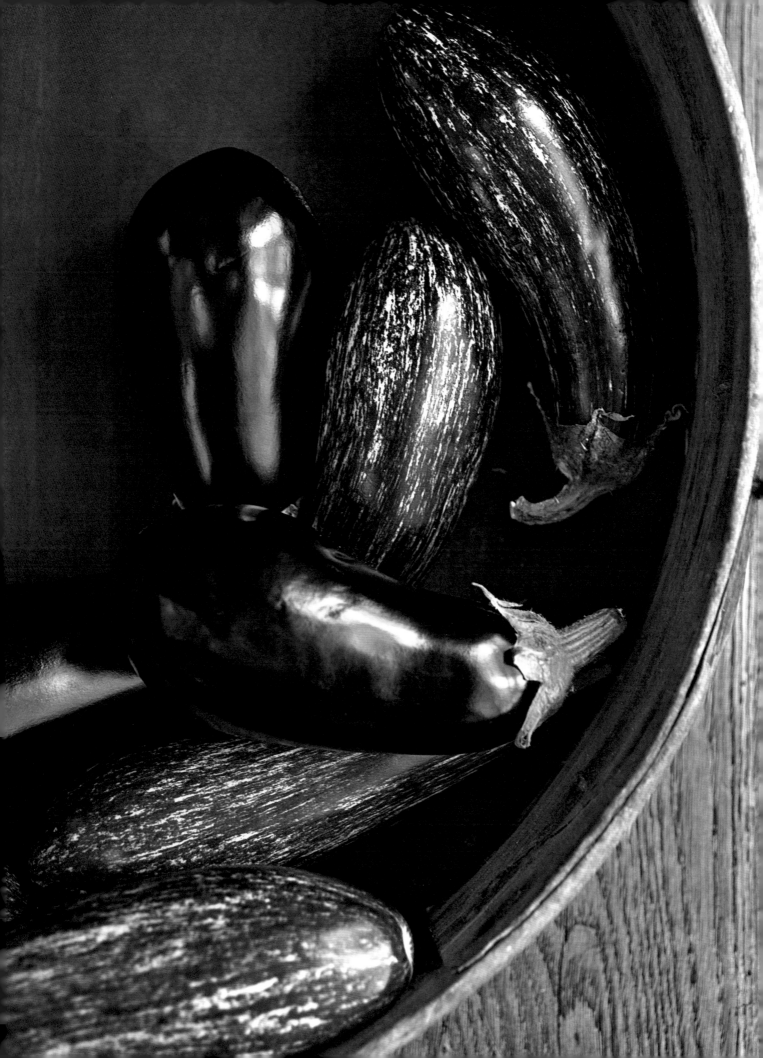

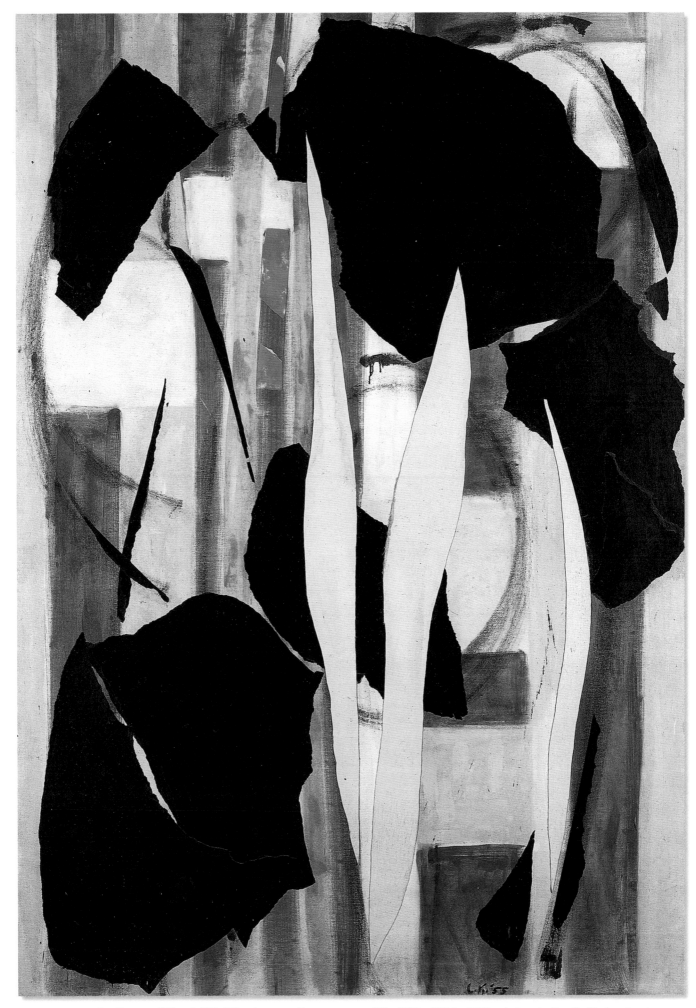

Lee Krasner, *Milkweed,* 1955. Oil and paper collage on canvas, 82½ x 57¾ in. (209.6 x 146.7 cm). *Opposite:* Detail of Jackson's paint cans.

JOSEPHINE LITTLE'S HOMINY PUFFS

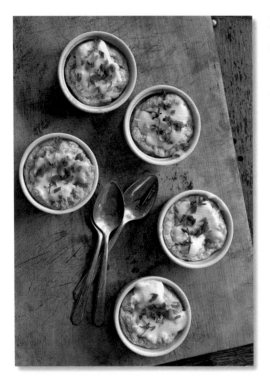

Lee's female friends provided her with emotional support and comfort and often also great practical assistance. She relied heavily on friends in Springs such as stencil artist Francile "Cile" Downs, writer Patsy Southgate, and artist Josephine Little. They shared ingredients and recipes and helped each other with cooking and grocery shopping. Patsy, appalled at Lee's inability to drive, even gave her driving lessons, enabling Lee to go into town unaccompanied to buy ingredients from Dreesen's butcher and grocery store, the Maidstone Market, or the A&P Tea Company. This recipe was given to Lee by Josephine, and Lee provided it for publication on several occasions when asked about her favorite recipe. A tasty starter, it also makes a great side dish to Southern-style meals.

Serves 8

FOR THE GRITS

5 cups boiling water

1 cup white hominy grits
 or white semolina or
 fine white polenta

1 tsp salt

FOR THE CHEESE SAUCE

3 Tbsp butter

3 Tbsp plain flour

1½ cups hot milk

1½ cups freshly grated sharp
 cheddar cheese, such as
 Vermont white cheddar

○ To make the grits: In a pot, boil water then reduce heat to a simmer and add grits slowly, to avoid lumps. Return to a boil then reduce heat again, add salt, and cook slowly for about 25 minutes, stirring with a wooden spoon in one direction to ensure a smooth mixture. Cool completely over a bowl of cold water. When hominy mixture has cooled, preheat oven to 400°F and butter 8 ramekins, 3 inches in diameter and 3 inches tall.

○ To make the cheese sauce: In a saucepan, melt butter and stir in flour with a wooden spoon. Cook for a minute until well mixed, but do not allow to brown. Slowly beat in milk until the sauce is thick and smooth. Remove mixture from heat and add cheese, salt, and pepper. Set aside ½ cup of cheese sauce to dress the puffs for serving.

1 cup scallions or chives,
　　chopped
3 egg yolks
5 egg whites
salt and pepper
sprigs of thyme, for garnish

○ Add scallions or chives to the main cheese mixture (not the portion set aside for dressing). Whisk egg yolks until smooth, add to cheese sauce, and mix thoroughly. Once mixed, add the cheese to the cooled hominy and work it through, breaking up any lumps with a spoon.

○ In a separate bowl, beat 5 egg whites until stiff. Fold one third of the whites into hominy and cheese mixture until well combined, then gently fold in the remaining two thirds.

○ Pour mixture into buttered ramekins, filling to the brim. Place ramekins on a tray in the middle of the oven. Lower oven temperature to 325°F and bake for 1 hour and 15 minutes, or until puffed and golden. Gently warm the reserved cheese sauce and drizzle over the puffs; garnish with thyme. Serve immediately.

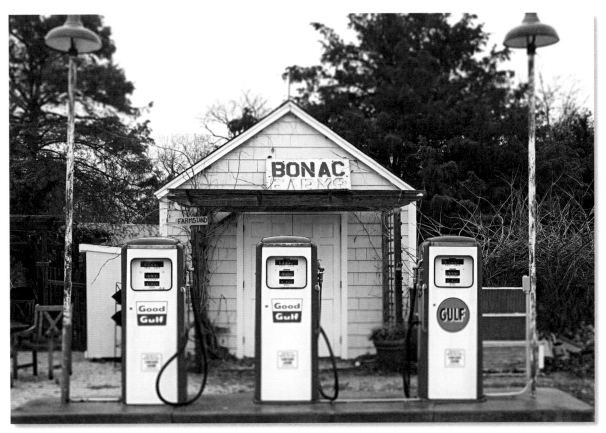

The gas station at the Springs General Store, where Jackson spent many hours talking with his friend and store owner Dan Miller.
Opposite: Josephine Little's Hominy Puffs.

OVEN-BAKED STUFFED ONIONS

Obviously one of Stella Pollock's favorites, this stuffed onion recipe comes from her handwritten recipe book. She noted next to the recipe that these "stuffed onions are delicious."[1] It can be served as a starter or, given the inclusion of chicken in the stuffing, could also be served as a more substantial main course alongside roasted potatoes and green vegetables.

Serves 4-6 as a starter

6 medium red onions

2 medium chicken breasts, roasted with skin on, meat pulled into small pieces

1 cup celery, plus several celery leaves, finely chopped

2 Tbsp heavy cream

¼ cup melted butter, plus more butter to rub the onions

¾ cup buttered bread crumbs

½ cup chicken stock or water

salt and pepper

○ Preheat oven to 325°F. Remove skins from onions and boil in salted water for 10 minutes. Drain and cool. Cut off the tops of the onions and remove the onion centers, without destroying the outer shape, and set aside. Finely chop the onion centers.

○ To make the stuffing: Combine equal parts cold pulled chicken, chopped celery, and chopped onion. Season with salt and pepper and moisten with a little cream and melted butter.

○ Fill hollowed onions with stuffing and top with buttered bread crumbs. Rub the outside of the onions with butter.

○ Place stuffed onions in a greased baking dish with a little chicken stock or water; bake uncovered until onions are soft and cooked through, and brown on the outside, about 20-30 minutes depending on onion size.

[1] Stella Pollock's original recipe book, courtesy of Jacqueline Pollock de Souza Costa, Sacramento, California, July 2014.

Oven-Baked Stuffed Onions.
Opposite: Detail of Jackson's studio floor.

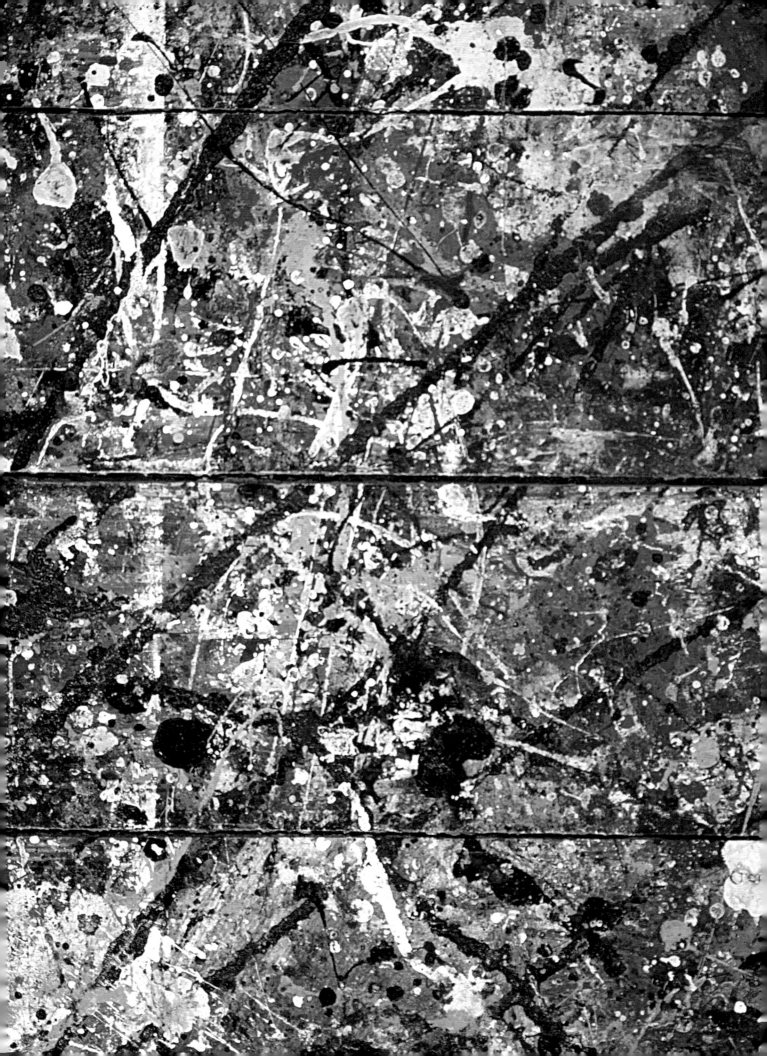

MIRROL
QUICK-DRYING EN

SPINACH MUFFINS & SPRING GREENS WITH TOMATO CHUTNEY

In 1946 Jackson finally had land in Springs to enable him to follow in his grandfather's and father's footsteps and plant his own vegetables. Spinach was a favorite ingredient in both Stella Pollock's and Lee and Jackson's recipes.

This recipe from Lee and Jackson's collection works as a spinach loaf, though it is also lovely baked as individual spinach muffins and served warm for a delicious springtime lunch accompanied by a salad of wild or seasonal greens and tomato chutney.

Makes 8 small muffins

FOR THE MUFFINS

2 cups raw baby spinach, chopped

2 cups cream cheese

1 cup bread crumbs

½ tsp cayenne pepper

2 eggs, beaten

¼ cup melted butter

1 tsp salt

Makes 6 cups

FOR THE TOMATO CHUTNEY

1 cup seedless raisins or sultanas

4 cups fresh tomatoes, diced

2 cloves garlic, chopped

1½ Tbsp powdered ginger

1 tsp salt

¼ tsp cayenne pepper

½ cup white wine vinegar

1 tsp black peppercorns

¼ tsp ground cloves

½ cup light brown sugar

○ Sterilize glass jars and lids.

○ To make the muffins: Preheat the oven to 380°F. Line 8 small muffin cups with baking paper. Beat together all ingredients and divide equally among the cups. Bake for 30 minutes. Serve with a salad of spring or seasonal greens and tomato chutney.

○ To make the chutney: In a large, heavy-bottom pot, combine all ingredients and cook slowly over low heat for 1 hour, stirring frequently, to reach a jam-like consistency. Pour chutney into sterilized jars and lid tightly. Can be stored for up to two months in a cool place. Refrigerate after opening.

"WELL DAD I TOOK TIME OUT TO EAT ABOUT TWO POUNDS OF FRESH COOKED SPINACH— SHURE [SIC] LIKE IT."

Jackson Pollock[1]

Detail of Jackson's paint can.

[1] Letter from Jackson to his father, 1932.

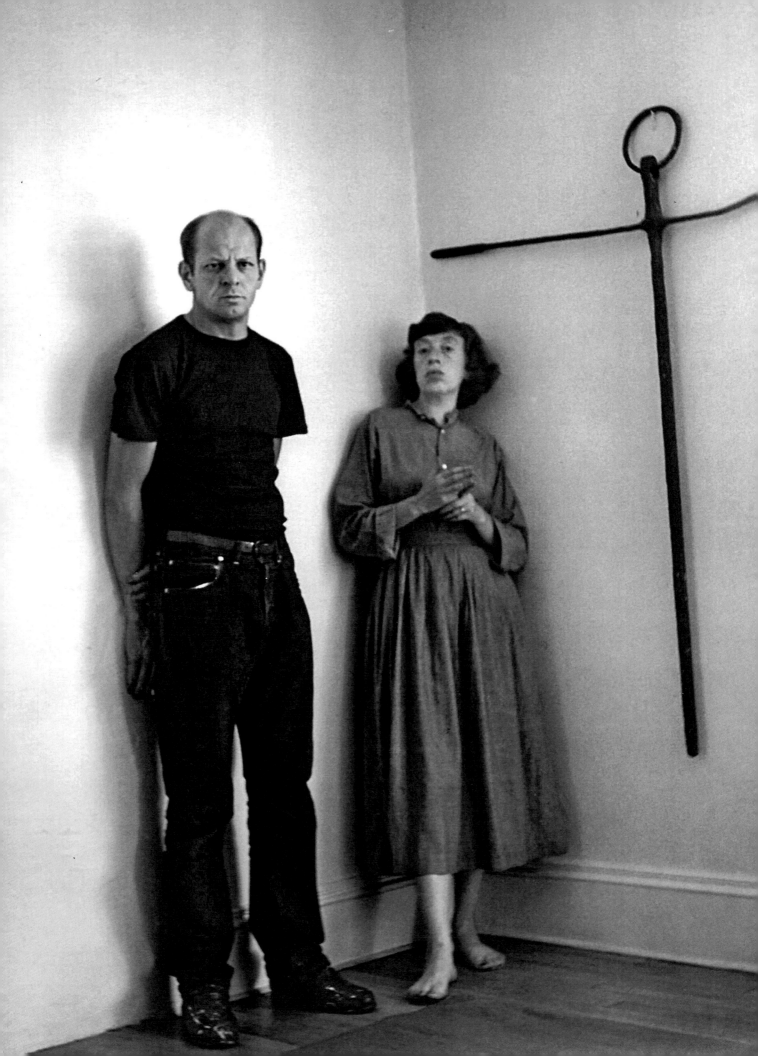

STELLA'S POTATO PANCAKES

During the early years of Jackson and Lee's relationship, World War II food rationing had a significant impact on meal planning and preparation, but with creative use of ingredients cooks could still come up with enticing meals. M. F. K. Fisher's recipe book *How to Cook a Wolf* was released in 1942, the year Jackson and Lee began living together, and provided easy recipes to create with rations. In her typical witty style, Ms. Fisher wrote, "Potatoes are one of the last things to disappear in times of war…they should not be forgotten in times of peace."[1]

Lee and Jackson did not abandon the humble potato as a staple ingredient when the war was over. In fact, potatoes were then, and continue to be, the number one crop on the South Fork of Long Island, where Springs is located. Jackson and Lee obviously liked potato pancakes, as they kept two recipes, this one in Lee's handwriting, given to them by Stella, and another recipe cut from a newspaper.

Makes 1 large 8" pancake or 4 small 3" pancakes

4 potatoes (yukon gold
 or russet are best)
1½ tsp salt
2 eggs, beaten
generous amount freshly
 ground black pepper
3 Tbsp bacon fat, goose fat,
 or olive oil
sour cream, dill pickles,
 pink peppercorns, and dill,
 for serving

- In a bowl, coarsely grate potatoes and sprinkle with salt. Let sit 5 minutes, then squeeze out excess liquid, using hands and a paper towel. Add eggs, ground pepper, and a little more salt to taste.

- In an 8-inch round skillet, heat fat or oil over medium heat, and add the potato mixture, spreading it evenly. When the bottom of the pancake is golden and the top looks translucent, flip it in one quick motion. Bake until the bottom is golden and crispy. Alternatively, make four small pancakes, flipping each one with a spatula.

- Serve with sour cream, pickles, peppercorns, and dill for topping.

Stella's Potato Pancakes. *Opposite:* Jackson and Lee in their living-dining room, 1950.
On the wall is a broken anchor that they found and used as a decoration.

[1] *How To Cook a Wolf,* by M. F. K. Fisher, 1942, p.121.

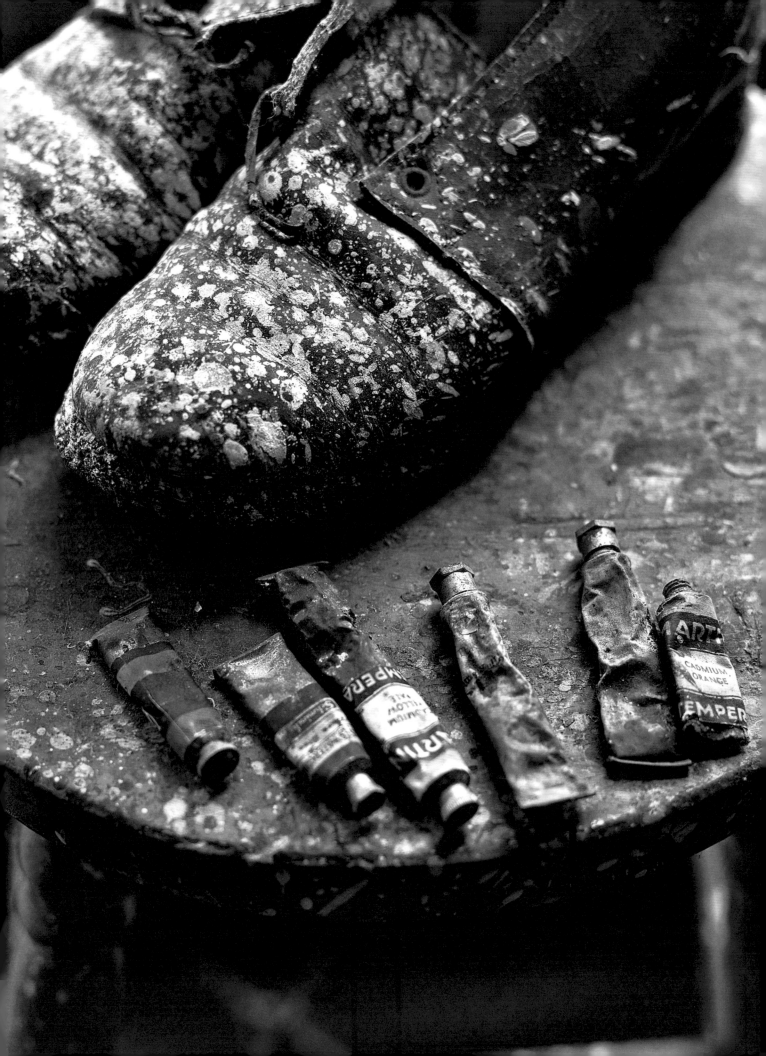

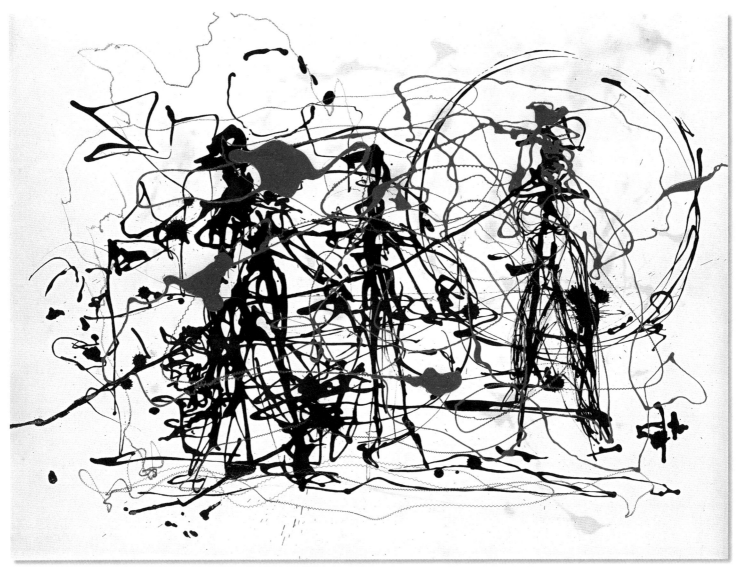

Jackson Pollock, *Untitled*, c. 1948–49. Ink and enamel on paper, 22³/₈ x 30¹/₈ in. (56.8 x 76.5 cm). *Opposite:* Shoes and paint in the studio.

> **"THE SECRET OF SUCCESS IS CONCENTRATING INTEREST IN LIFE...INTEREST IN THE SMALL THINGS OF NATURE, INSECTS, BIRDS, FLOWERS, LEAVES, ETC. IN OTHER WORDS TO BE FULLY AWAKE TO EVERYTHING ABOUT YOU AND THE MORE YOU LEARN THE MORE YOU CAN APPRECIATE, AND GET A FULL MEASURE OF JOY AND HAPPINESS OUT OF LIFE."**

LeRoy Pollock[1]

[1] Letter from LeRoy Pollock to Jackson, September 19, 1928, from *American Letters, 1927–1947: Jackson Pollock & Family.*

SWEDISH MEATBALLS

In America, Swedish meatballs were a popular dish in the Midwest during the early to mid twentieth century, having been introduced by the Scandinavians who migrated to the area. They were often served as hors d'oeuvres or as part of a buffet-style dinner, reflecting their traditional placement in Sweden as part of a smorgasbord with lingonberry jelly and boiled potatoes and pickles. They can also be served with other fruit jellies such as red currant, a favorite of Lee's, or green grape jelly, such as was made by friend Josephine Little using grapes fresh from the vines at Duck Creek Farm. This recipe is from Stella's recipe book and is a dish that would be equally appealing for children or adults.

Serves 6

FOR THE MEATBALLS

½ cup onion, very finely chopped

2 Tbsp butter plus another
 2 Tbsp butter

1 egg

½ cup milk

½ cup fresh bread crumbs

1¼ tsp salt

2 tsp sugar

½ tsp allspice

¼ tsp nutmeg

½ tsp caraway seeds,
 toasted and ground

1 lb ground beef chuck steak

¼ lb ground pork shoulder

Italian parsley, for garnish

pickles, for serving

FOR THE GRAVY

3 Tbsp flour

1 tsp sugar

1 tsp salt

pepper to taste

1 cup beef broth or bouillon

¾ cup sour cream

○ In a large skillet, sauté onion in 2 Tbsp butter until golden. Meanwhile, in a large mixing bowl, beat egg, add milk and bread crumbs. Let mixture stand 5 minutes then add salt, sugar, allspice, nutmeg, caraway seeds, ground beef, ground pork, and browned onions. Blend well with fork. Form meat mixture into small balls, about ½ inch to ¾ inch in diameter.

○ In a skillet, melt 2 Tbsp butter; in small batches, brown the meatballs well on all sides, removing them to a warm casserole dish between batches. Repeat until all meatballs are browned, reserving rendered fat in skillet to make gravy.

○ To make the gravy: Add flour, sugar, salt, and pepper to reserved fat in the skillet, and reduce heat to minimum. Add broth and sour cream slowly, stirring over low heat until thickened.

○ If desired, return meatballs to gravy and heat thoroughly, or serve meatballs in covered casserole and pass the gravy around the table. Garnish meatballs with Italian parsley. If using for hors d'oeuvres, pierce each meatball with a toothpick and serve on a platter with the gravy in a small serving dish in the middle, and pickles on the side.

○ The entire dish may be prepared a day earlier, refrigerated, and reheated before serving.

Swedish Meatballs.

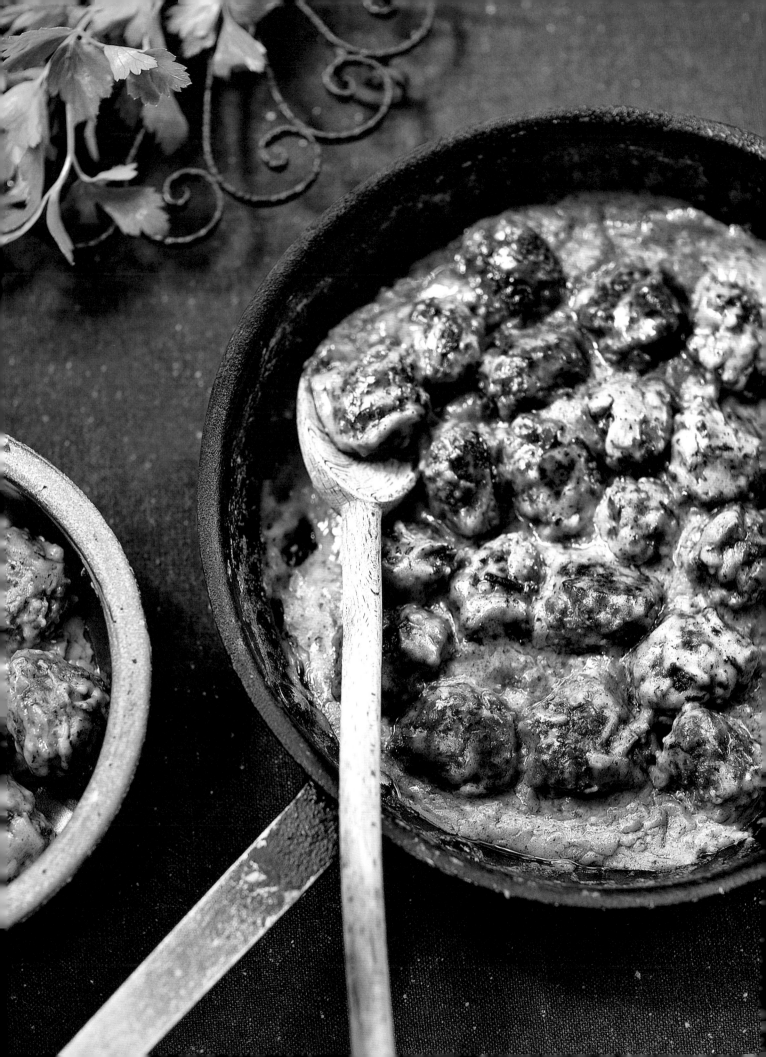

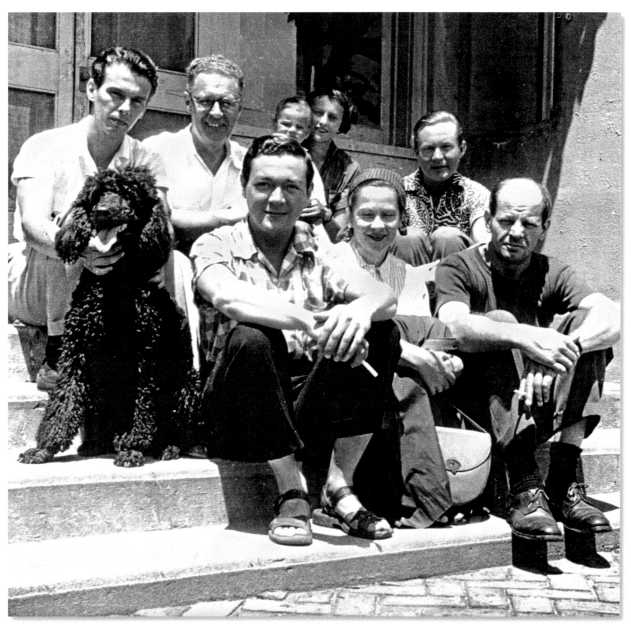

At Alfonso Ossorio's estate, The Creeks,
Wainscott, c. 1953. *Front row, from left:*
Alfonso Ossorio, Halina Wierzynski,
Jackson Pollock. *Back row, from left:* Edward
F. Dragon with poodle Horla, Polish
poet Casimir Wierzynski, Josephine
Little, holding daughter Abigail,
artist Joseph Glasco.

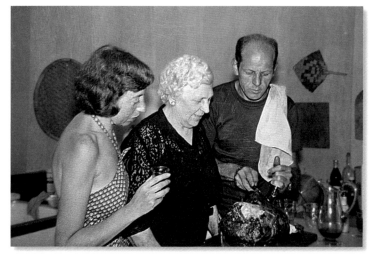

Lee Krasner, Stella Pollock, and Jackson Pollock in the kitchen, Springs, 1950.

Opposite: Jackson and Lee at their home in Springs, c. 1949.

MAIN COURSES

CHERRYSTONE CLAMS WITH GARLIC & DRY VERMOUTH

This clam recipe and the one for Mussels with White Wine & Parsley (page 70) were written by Lee on a prescription note by Jackson's doctor, Ruth Fox. A psychiatrist specializing in alcoholism, Dr. Fox treated Jackson in her Lexington Avenue, New York, office for a little over a year, from March 1951 to June 1952. Above the recipe is her recommendation that Jackson take "Sodium chloride—1 gram 3 x a day," possibly to help with dehydration. Whether Jackson followed Dr. Fox's instructions is unknown, though it is clear that he loved to gather clams and share the subsequent dishes with friends. Clams were plentiful in Springs and included small littlenecks, which can be served raw, and slightly larger cherrystones, which were often steamed. The still larger quahogs, otherwise known as chowder clams, were typically used in dishes such as clam pie and chowder.

Serves 4

3 lb cherrystone clams
2 Tbsp olive oil
½ bunch parsley, chopped,
 plus extra for garnish
1 clove garlic, chopped
1¼ cups dry vermouth
2 Tbsp butter, softened
salt and pepper, to taste
crusty bread, for serving

- Scrub clams and soak in cold fresh water about 1 hour.

- In a large saucepan, heat olive oil, parsley, and garlic; sauté 5 minutes. Add the clams and dry vermouth, cover, and cook over medium heat about 10 minutes until the clams open.

- To finish, stir in the softened butter and garnish with fresh parsley. Serve with crusty bread.

Louse Point, one of Lee and Jackson's favorite beach locations.
Previous pages: Detail of Jackson's paint can.

CHILI CON CARNE

Lee liked to ask her Texas-born friend Francile "Cile" Downs to whip up her favorite chili recipe and bring it over when they had a house party. "Being from Texas, I knew how to make a great chili,"[1] Cile recalled. On one occasion, Lee asked Cile to prepare enough chili for a dinner of more than thirty people. By the time Cile arrived, proudly bearing vast quantities of chili, she was looking forward to joining in the fun. But on attempting to present the dish to her hostess, Lee then also asked her to serve it to the guests. "When Lee said serve, I served!"[2] she laughed.

Serves 6

2 Tbsp olive oil

1½ lb beef chuck,
 cut into ½-inch cubes

1 onion, finely chopped

1 clove garlic, crushed

1 tsp cumin seeds

2 Tbsp tomato paste

½ lb tomatoes,
 peeled and chopped

3-6 whole chili peppers,
 fresh or dried
 (chilies vary in heat,
 so add those you prefer)

1 can red beans or cooked
 frijoles, rinsed

sour cream, cooked rice, or
 corn tortillas, for serving

○ In a large, heavy-bottom pot, over medium-high heat, sauté beef cubes in olive oil for 5 minutes until well browned. Add chopped onion, garlic, cumin seeds, tomato paste, and tomatoes, and chili peppers to taste.

○ Cook slowly, covered, for at least 3 hours, until meat is tender. A little water can be added during cooking, as needed.

○ Before serving, stir in beans and adjust salt and pepper to taste. Serve hot with rice or corn tortillas, and garnish with sour cream.

○ Making the dish a day before serving will improve the flavor.

Red beans for Chili con Carne.

[1] Interview with Francile Downs conducted by Robyn Lea, January 27, 2014.
[2] Interview with Francile Downs conducted by Robyn Lea, October 15, 2013.

CLASSIC MEAT LOAF WITH MUSTARD SAUCE

This Pollock family recipe is for a classic American meat loaf that has been improved with the addition of pistachios. Stella recommended serving the dish with her mustard sauce; either Dijon or grainy mustard can be used, depending on your preference, for texture.

Serves 6

FOR THE MEAT LOAF

1 lb ground veal

1 lb ground pork

1 lb ground ham

2 eggs

1½ cups milk

2 handfuls pistachios, shelled

2 cups crushed crackers
 or bread crumbs

salt and pepper, to taste

FOR THE MUSTARD SAUCE

1 egg

½ cup mustard

½ cup vinegar

¼ cup butter

½ cup sugar

1 Tbsp flour

◦ Preheat oven to 325°F. Line one large loaf tin, or two smaller tins, with baking paper and grease well.

◦ In a large mixing bowl, combine all meat loaf ingredients and mix well. If using two small tins, bake 30-40 minutes; for one large tin, bake 60-80 minutes, depending on desired doneness.

◦ Meanwhile, in a saucepan combine all mustard sauce ingredients and bring to a gentle boil, about 5 minutes. Stir and remove from heat.

◦ Slice meat loaf and serve with mustard sauce and a green salad.

Classic Meat Loaf with Mustard Sauce. *Opposite:* Aerial view of the dramatic landscape of Arizona, where the Pollock family moved when Jackson was a baby. Growing up on the family farm, Jackson developed a strong feeling for the rugged surroundings and natural beauty, which later informed his work.

CREAMY LOBSTER STEW

Lobster was served at the first Thanksgiving in 1621 in Plymouth, Massachusetts, along with clams and venison. Lobster was a favorite of Jackson's; he had experienced its creamy pleasures at the table of Rita Benton during summers on Martha's Vineyard in the 1930s. Rita would religiously meet the local fishermen of Menemsha Bay as their boats pulled onto shore around noon, and would buy a supply at 25 cents each. This recipe was inspired by a dish prepared for Jackson in Springs by friends John and Cynthia Cole in September 1953. The Coles lived in a charming New England–style house across the road from Ashawagh Hall, an easy walk from Lee and Jackson's place.

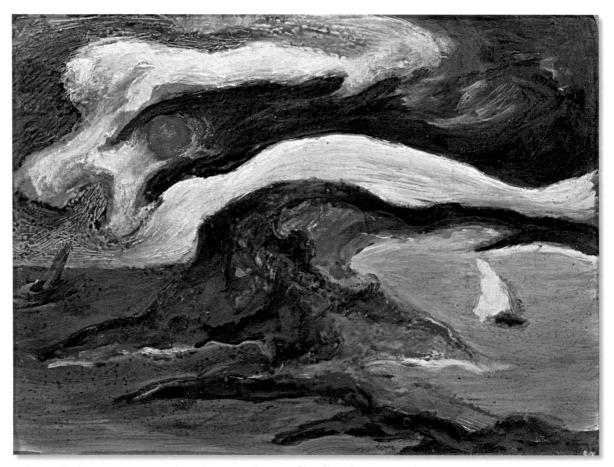

Jackson Pollock, *T. P.'s Boat in Menemsha Pond*, c. 1934. Oil on tin, $4^5/_8$ x $6^3/_8$ in. (11.6 x 16.2 cm).
Opposite: Creamy Lobster Stew.

Serves 4

20 oz lobster meat, from
 two medium-size cooked
 lobsters
1 large carrot, peeled and
 roughly chopped
1 leek, washed and roughly
 chopped
2 stalks celery, washed and
 roughly chopped
1 small fennel bulb, washed
 and roughly chopped
½ bunch of parsley, washed
5 Tbsp butter
1½ cups heavy cream
2 cups whole milk
⅓ cup dry white wine
salt and pepper
fresh tarragon leaves, dill,
 or chives, for garnish
crusty toasted bread
 or garlic croutons,
 for serving

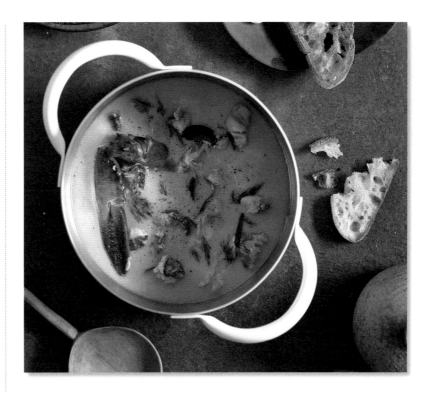

- Crack open 2 cooked lobsters, remove all the meat from the shells, chop meat into small pieces, and set aside. Place all the cleaned shells in a large stockpot along with the chopped carrot, leek, celery, fennel, and parsley and cover with cold water. Bring to a simmer and cook 2 hours. Strain through a fine sieve and set aside, discarding the shells and vegetables. Yields about 2 cups of lobster broth.

- In a large, heavy-bottom pot, melt 4 Tbsp butter over high heat, add lobster meat, and stir about 2 minutes. Slowly add the cream, milk, and reserved lobster broth. Cook on medium heat for 2 minutes, add white wine, salt, and pepper. Heat until tiny bubbles form, then cool overnight.

- The following day, a short time before serving, heat the stew slowly in a double boiler for 15 minutes, stirring gently and being careful not to boil. Add the remaining 1 Tbsp butter and adjust salt and pepper as needed.

- Garnish with fresh herbs such as tarragon, dill, or finely chopped chives, and serve with crusty toasted bread or garlic croutons.

EARTH-GODDESS STUFFED PEPPERS

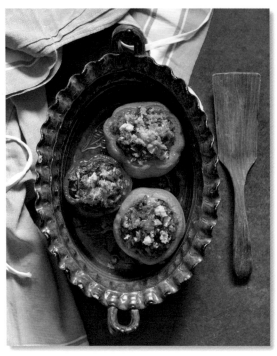

Earth-Goddess Stuffed Peppers.

" **WITH JACKSON THERE WAS QUIET SOLITUDE. JUST TO SIT AND LOOK AT THE LANDSCAPE. AN INNER QUIETNESS. AFTER DINNER, TO SIT ON THE BACK PORCH AND LOOK AT THE LIGHT. NO NEED FOR TALKING. FOR ANY KIND OF COMMUNICATION.** "

Lee Krasner[1]

Rita Benton, along with Lee and Stella, was an important female figure in Jackson's life, particularly during his years living in New York City in the 1930s. He was drawn to her warm Italian personality and her desire to care for others, which extended to her preparation of large, delicious meals, including this dish. This recipe is based on Rita Benton's version, as detailed in her handwritten recipe preserved in the home she shared with her husband, Thomas Hart Benton, in Kansas City, Missouri. Thomas and Rita were like family to Jackson and supported, taught, and guided him in many ways. Stella Pollock also had a recipe for stuffed peppers, which she titled Mexican Peppers. In her version, a can of tomatoes is poured into a large pot and the stuffed peppers are nestled on top and cooked for an hour and a half; for the last half hour, a can of cooked lima beans is added.

[1] *Originals: American Women Artists*, by Eleanor C. Munro, 1979.

Serves 4

4 medium peppers (red and yellow, as desired)

¼ cup olive oil, plus more for baking and serving

1 onion, finely chopped

2 stalks celery, finely chopped

½ lb lean ground beef or lamb

2 Tbsp tomato paste

1 cup mixed fresh herbs such as parsley, basil, and oregano

sea salt and black pepper

water or broth, as needed

2 cups rice, cooked

1 cup parmesan cheese, grated

1 cup bread crumbs

½ cup white wine mixed with ½ cup water or vegetable broth

○ Preheat oven to 380°F. Cut tops off peppers, remove seeds, and set aside.

○ In a large saucepan, gently heat olive oil, add finely chopped onion and celery, and cook, covered, until soft, stirring often. Add ground meat and sauté until browned; add tomato paste and fresh herbs, and season well with sea salt and black pepper. Cover and cook for half an hour, adding a little water or broth as needed to keep mixture just moist and simmering. Remove from heat and stir in the cooked rice.

○ Rub the outside of the peppers with a little olive oil; stuff each pepper. Top the stuffed peppers with parmesan and bread crumbs and a drizzle of olive oil. Place peppers in a baking dish lined with lightly greased baking paper. Pour white wine and stock mixture in the bottom of the dish; cover and bake 40 minutes. Remove cover and bake 20 minutes more or until peppers are soft and golden brown.

○ Serve immediately.

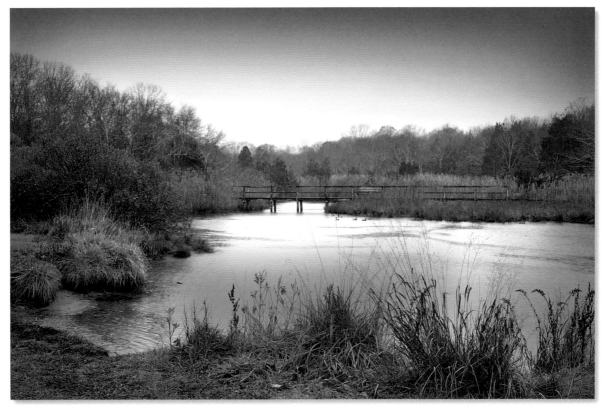

Across the road from the Springs General Store, Accabonac Creek rises in Pussy's Pond and flows out to Gardiner's Bay.

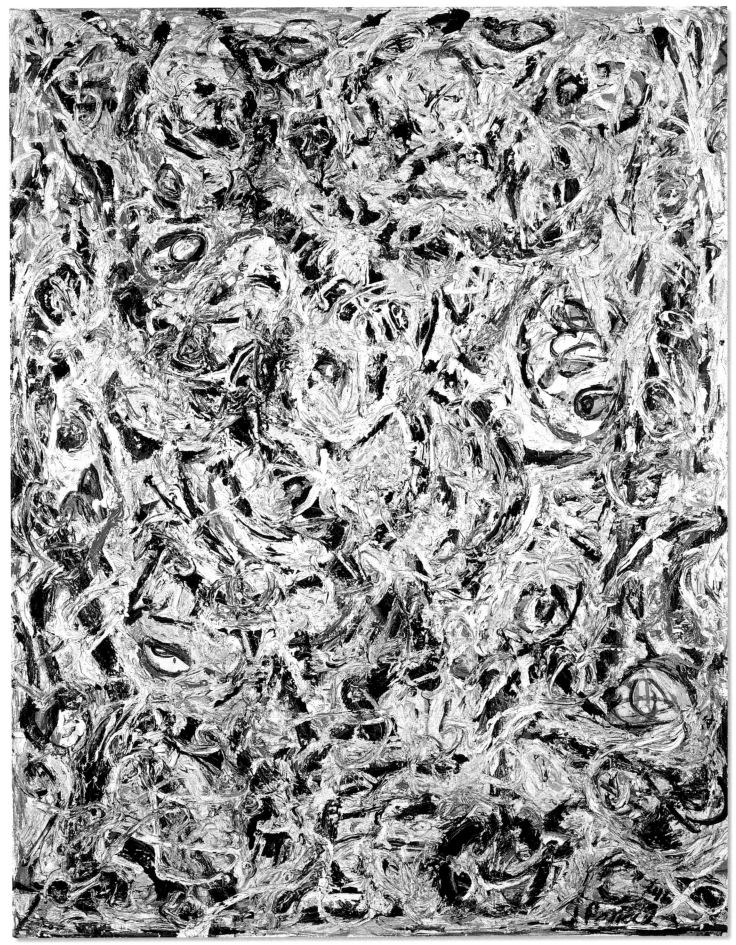

Jackson Pollock, *Eyes in the Heat*, 1946. Oil and enamel on canvas, 54 x 43 in. (137.2 x 109.2 cm).
Opposite: Jackson with one of his paintings in his studio in Springs, August 23, 1953.

FRENCH-STYLE ROAST CHICKEN WITH HERB STUFFING

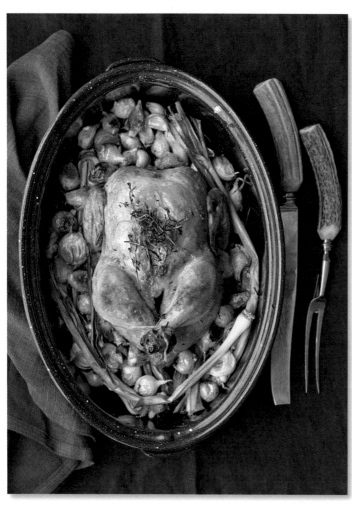

Springs locals, known as Bonackers, were somewhat immune to the scarcities and steep price increases for chicken during and after World War II. Many locals raised their own chickens, including Lee and Jackson's friends the artists John and Josephine Little. For those who didn't keep their own chickens, Salvadore Iacano, known by locals as "Sal," at Iacono Farm in East Hampton, also sold chickens and fresh eggs as well as ducks in the fall. Other locals placed newspaper ads when live chickens were available for purchase, such as one in 1946 that offered Barred Rocks, White Wyandottes, and White Rocks varieties for $1 each. Jackson and Lee's friend Cile Downs recalls how Lee would season the bird heavily then roast it uncovered in a Le Creuset pot—cookware to which artist Alfonso Ossorio introduced her. This recipe can be prepared with Jackson's sister-in-law Arloie's stuffing recipe, which was found in Lee and Jackson's recipe collection. If a Le Creuset pot is not available, use a large oval roasting pan and nestle the vegetables around the bird.

Serves 4

FOR THE CHICKEN

3 lb organic free-range chicken

½ cup olive oil

2½ tsp sea salt

¼ tsp black pepper

2 Tbsp fresh thyme leaves

12 cloves garlic, skins on and
 rinsed well

12 shallots or small onions,
 peeled and kept whole

1 lemon, zest and juice

FOR ARLOIE'S STUFFING

2 Tbsp butter

2 medium onions,
 finely chopped

2 stalks celery, finely chopped

2 cups rough-cut bread crumbs
 or crumbled dry bread

1 Tbsp each fresh sage,
 rosemary, and thyme

parsley, chopped

1 pinch powdered ginger

salt and pepper

○ Preheat oven to 350°F. Remove giblets from chicken, rinse the bird inside and out, pat dry. Rub all over with ¼ cup olive oil, sea salt, pepper, and thyme leaves. Set chicken aside to come to room temperature while making stuffing.

○ To make the stuffing: In a heavy-bottom pot, melt butter, add chopped onions and celery, and cook until soft. In a large bowl, combine all stuffing ingredients and moisten with a little water.

○ Fill chicken cavity loosely with stuffing and tie legs together with kitchen string.

○ In a large cast-iron casserole, Le Creuset pot, or roasting pan, on the stovetop, warm the remaining olive oil, add garlic and shallots or small onions, and cook about 10 minutes.

○ Remove from heat and place chicken in pot, breast side up. Baste chicken all over with pan juices until well covered; roast 1 hour. Baste with pan juices and lemon juice and sprinkle with lemon zest.

○ Increase oven temperature to 430°F and roast 15 minutes more, or until skin is crisp and golden. Let chicken rest 15 minutes, then carve to serve.

"ART IS WHAT YOU LIVE THROUGH EVERY DAY ALTHOUGH YOU MAY NOT PUT YOUR EVERYDAY OBJECTS INTO IT."

Lee Krasner[1]

[1] Oral history interview with Lee Krasner, November 2, 1964–April 11, 1968, Archives of American Art, Smithsonian Institution.

HEAVENLY LOVING CLAM CHOWDER

This chowder recipe is based on the original by Jackson's friend the artist John Little, who was passionate about food and shared the recipe with his neighbors in a local Springs newsletter. John and Jackson's friendship flourished in Springs through their shared loved of fishing, cooking, clamming, gardening, swimming, and home renovating. Passionate entertainers, the Littles shared their garden's magnificent bounty with Lee and Jackson and other artist friends, regularly having an open-house policy at Christmas and Thanksgiving. They often served their meals with their own signature wine made from the grapevines they planted on their Springs property.

Serves 6-8

3 lb littleneck clams

3 lb steamer clams

½ cup kosher salt dissolved in 1 gallon water

½ lb pancetta or non-smoked bacon, diced in ¼-inch cubes

1 large yellow onion, finely diced

2 stalks celery, finely chopped

2 lb potatoes (russet or yukon gold), peeled, diced, and boiled until al dente

1 Tbsp parsley, finely chopped

½ cup butter

½ cup scallions, finely chopped

½ cup all-purpose flour

3 cups whole milk

2 cups heavy cream

½ tsp paprika or cayenne pepper

¼ tsp finely ground black pepper

salt

fresh thyme and/or parsley, chopped, for garnish

corn bread or pilot crackers, for serving

- Scrub and wash the clams, and place them in the salted water so they expel any sand. Repeat if necessary and discard any clams that float to the top.

- In a large pot, steam clams in 4 cups of water for about 3 minutes, removing them as they open. Reserve the cooking liquid and strain it through a fine sieve to remove any sand. Set aside. Remove clam meat from shells and chop into small pieces.

- In another large pot, gently brown the pancetta or bacon, add the onion and celery, and gently sauté until soft. Remove from heat, add potatoes, chopped clams, and parsley, and stir lightly to combine.

- In a separate pot, melt butter over medium heat and sauté scallions until soft, add the flour, mix with a wooden spoon, and stir for a minute to cook but not brown. Stirring constantly, add 2 cups of the reserved clam liquid, plus the milk and cream. Simmer 5-10 minutes until thickened, stirring occasionally. Add chopped clam mixture and stir well to combine. Add paprika or cayenne pepper, and season with salt and pepper to taste.

- Serve in large, warmed bowls with hot buttered corn bread or pilot crackers, and garnish with chopped thyme or parsley.

A snow-covered pond in Springs.

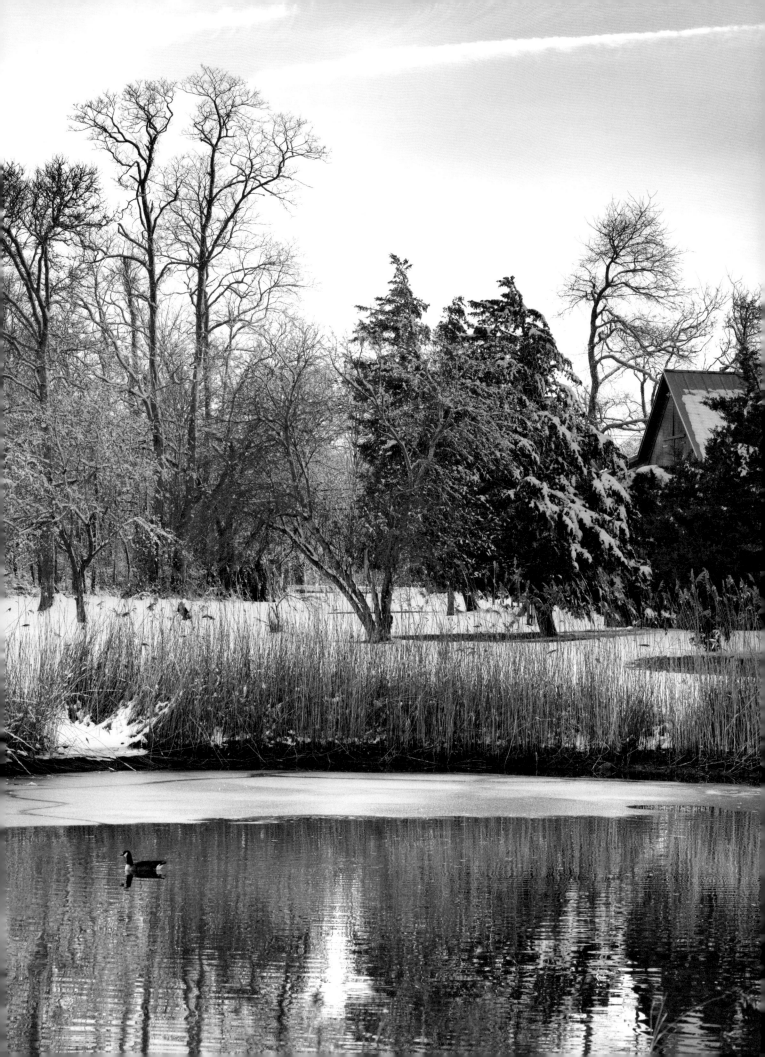

Living room of the Pollock family home in Cody,
Wyoming, before they moved to Phoenix, Arizona.

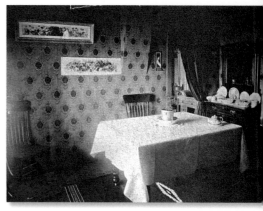

Dining room in the Pollock family home in Cody.

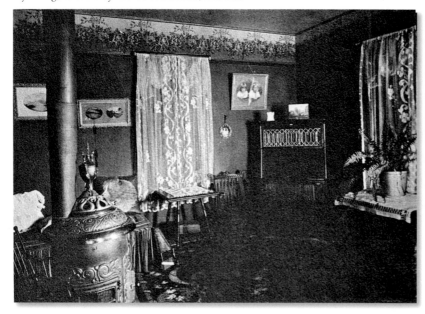

View from the kitchen to the dining room
of the Pollock-Krasner House, c. 1958.
On the wall behind the dining table is
Lee Krasner's 1957 painting *Sun Woman II.*
Night Life, a 1947 canvas from her
Little Image series, hangs over the
English court cupboard.

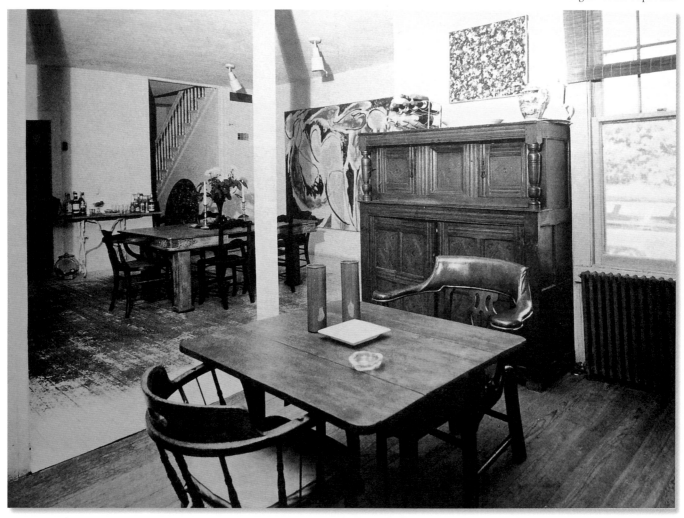

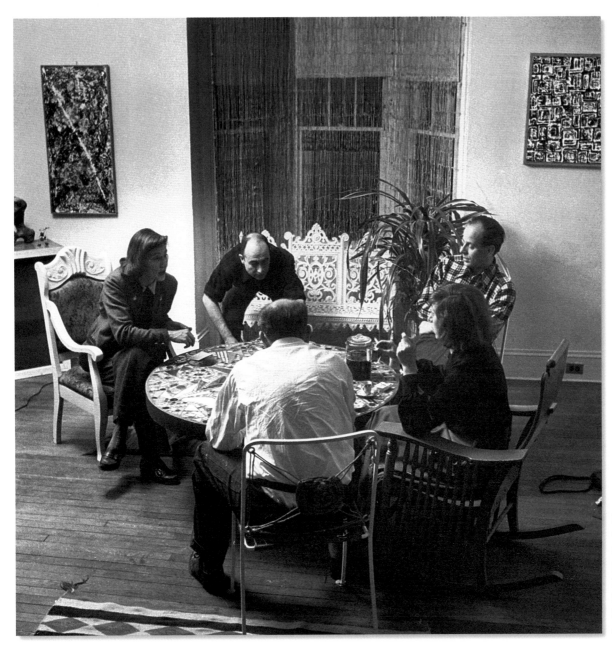

In the foreground, with their backs to the camera, are Jackson and Lee. In the background, from left: Vita Peterson, John Little, and Gustaf Peterson.

JACKSON LOVED NOTHING MORE THAN TO MAKE A BATCH OF FLUFFY PANCAKES FOR HIS FRIENDS, OPEN FRESH CLAMS AT HIGH SPEED TO SHARE WITH GUESTS WHO CAME UP FROM THE CITY, OR BAKE AN APPLE PIE FOR THE ANNUAL LOCAL FAIR COMPETITION.

JACKSON'S FAMOUS SPAGHETTI SAUCE

Jackson was eighteen before he tried spaghetti for the first time, at a Sunday-night dinner hosted by Tom and Rita Benton in their New York apartment. Accompanied by his brothers Frank and Charles, it was also the first time he met Rita. When the pasta was served, Jackson wasn't sure how to eat it. Amused and charmed by Jackson's provincial inexperience, Rita gave him a lesson in tackling the dish, establishing an immediate mother-son–like relationship. Jackson learned this recipe from Rita and became famous for it among his friends. The recipe was provided directly from the private archives of Rita and Thomas Hart Benton.

Serves 4

2 Tbsp olive oil

1 onion, finely chopped

1 lb pork tenderloin or pork
 chops, finely cut by hand

½ lb mushrooms, sliced

6 oz can tomato paste

1 can water

1 bay leaf

salt and pepper, to taste

1 lb spaghetti

1 cup parmesan cheese,
 grated, for serving

- In a heavy-bottom skillet, heat the oil and brown the onion. Add meat, mushrooms, tomato paste, water, and seasonings; cover and simmer 30 minutes or until pork is tender.

- Meanwhile, cook spaghetti in salted boiling water 8-10 minutes; drain.

- Toss spaghetti with sauce, and serve with cheese.

Jackson's Famous Spaghetti Sauce. *Opposite:* Spaghetti ready for the pot.

67

LONG ISLAND CLAM PIE

When he was interviewed by Berton Roueché for a 1950 *New Yorker* story, Jackson said that when he and Lee moved to Springs, they lived for a year off the money earned by the sale of one painting as well as a few clams he dug out of the bay with his toes.[1] Clams could be found in Abbabonac Creek at the base of their property, as well as around the shorelines of Louse Point, along Gerard Drive and Three Mile Harbor, and were abundant and a key ingredient in many traditional local recipes. To get to the creek for his clamming expeditions, Jackson would only have to walk the short distance across the property, the expanse of the sky opening up before him with marshland underfoot. Once at the water's edge Jackson would take off his shoes and clam with a rake, or directly with his feet, feeling around for their shells on the sandy riverbed.

The ritual of connecting with nature was as important as finding food for a meal, and Jackson loved to share the activity with their house and dinner guests who helped him in the search. Jackson preferred not to chat much during such expeditions, instead the sounds of birds, frogs, and moving water played their gentle soundtrack in the background. Jackson named his first group of paintings done in Springs the Accabonac Creek series in recognition of the environment's influence on his art.

This classic recipe was inspired by the many variations found in Springs where most families have handed down their favorite versions through the generations.

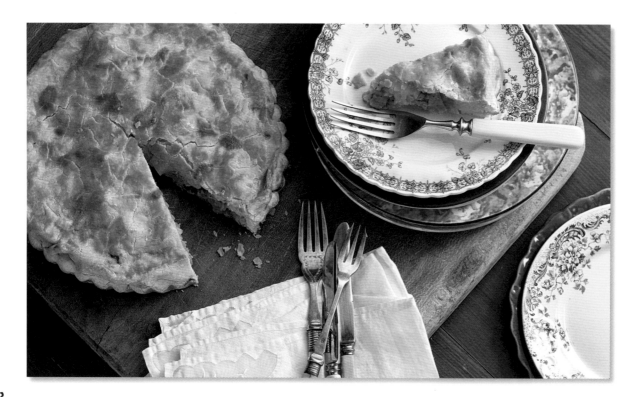

Serves 6

2 large potatoes, peeled and
 cut into small cubes
36 littleneck clams
½ cup salt dissolved in
 1 gallon of water
2 Tbsp butter
½ large onion,
 coarsely chopped
1 Tbsp all-purpose flour
¼ cup whole milk
1 Tbsp lemon juice
zest of 1 lemon
1 tsp salt
½ tsp black pepper
1 Tbsp parsley,
 finely chopped
9-inch short-crust pastry
 shell with top crust
1 egg, lightly beaten,
 for egg wash

○ Preheat oven to 400°F. In a saucepan, add the chopped potatoes, cover with cold water, bring to a boil, and cook until al dente, about 15 minutes; drain and set aside.

○ Scrub and wash the clams, and place them in the salted water so they expel any sand. Repeat if necessary and discard any clams that float to the top. In a large pot with 2 cups boiling water, steam clams just until they open. Drain the liquid, reserving ¼ cup. Remove clam meat from shells and chop coarsely.

○ In the same pot, melt butter and gently sauté onion until soft, add chopped clam meat, stir, and cook gently, being careful not to brown. Remove from heat, add cooked potatoes, flour, milk, lemon juice and zest, reserved clam liquid, salt, pepper, and parsley. Mix lightly to combine; pour mixture into pastry shell.

○ Brush pastry rim with egg wash, cover with top crust, and crimp to seal pastry all around the rim. Cut a small hole in the middle of the top crust for steam to release, and brush top crust with egg wash. Bake 10 minutes, reduce heat to 370°F, and bake about 30 minutes more, or until the top is golden.

○ Serve with seasonal green vegetables such as peas, asparagus, or green beans.

"SOMEBODY HAD BOUGHT ONE OF MY PICTURES. WE LIVED A YEAR ON THAT PICTURE, AND A FEW CLAMS I DUG OUT OF THE BAY WITH MY TOES."

Jackson Pollock

Long Island Clam Pie.

[1] "Unframed Space," by Berton Roueché, *The New Yorker*, August 5, 1950, p. 16.

MUSSELS WITH WHITE WINE & FRESH PARSLEY

Varieties of mussels were available in the area around Lee and Jackson's home in Springs, though not all of them were edible. Horse mussels, avoided by locals, were easily spotted around the shallows of Accabonac Creek at the back of Lee and Jackson's property, and are identified by their ribbed shell and their preference to hug the grasses around the shallows of the creeks and bay. Instead, Lee and Jackson used blue mussels, sometimes also known locally as black mussels, which they steamed with simple ingredients such as butter, garlic, white wine, and parsley.

Serves 4

2-3 lb mussels
3 Tbsp butter
1 small onion,
 finely chopped
1 clove garlic,
 finely chopped
1 glass white wine
1 handful fresh parsley,
 chopped
salt and pepper

o Scrub and de-beard mussels.

o In a large saucepan, melt butter and sauté onion until soft but not brown. Add mussels, garlic, wine, parsley, salt, and pepper.

o Cover and cook over medium heat for 10 minutes until mussels open.

Detail of tree trunk on the Pollock-Krasner property.

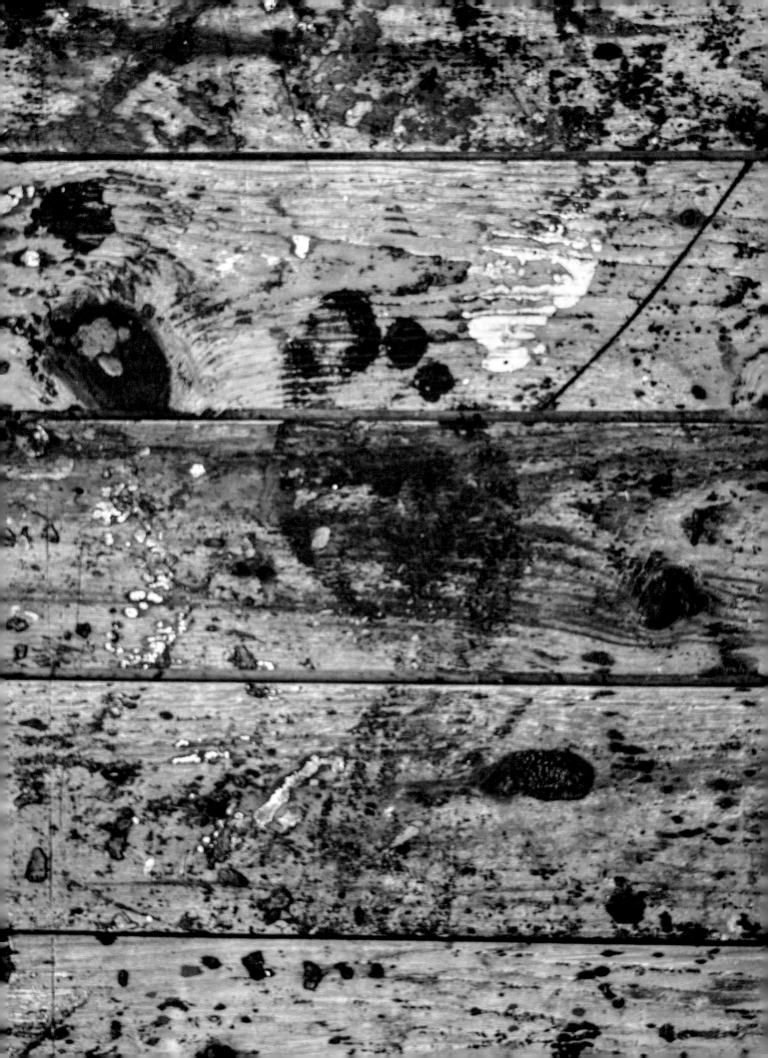

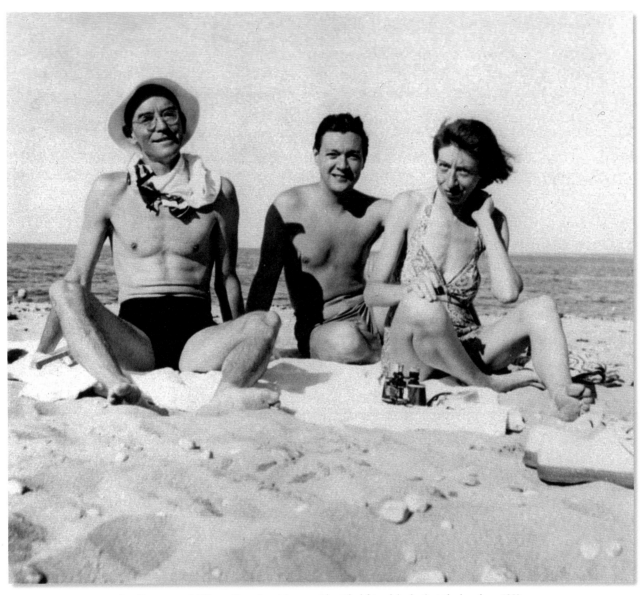

Lee Krasner and Alfonso Ossorio with an unidentified friend (in hat) at the beach, c. 1952.
Opposite: Jackson's footprint on the studio floor.

"JACKSON USED TO GIVE HIS PAINTINGS CONVENTIONAL TITLES...BUT NOW HE SIMPLY NUMBERS THEM. NUMBERS ARE NEUTRAL. THEY MAKE PEOPLE LOOK AT A PICTURE FOR WHAT IT IS—PURE PAINTING."

Lee Krasner[1]

[1] "Unframed Space," by Berton Roueché, *The New Yorker,* August 5, 1950.

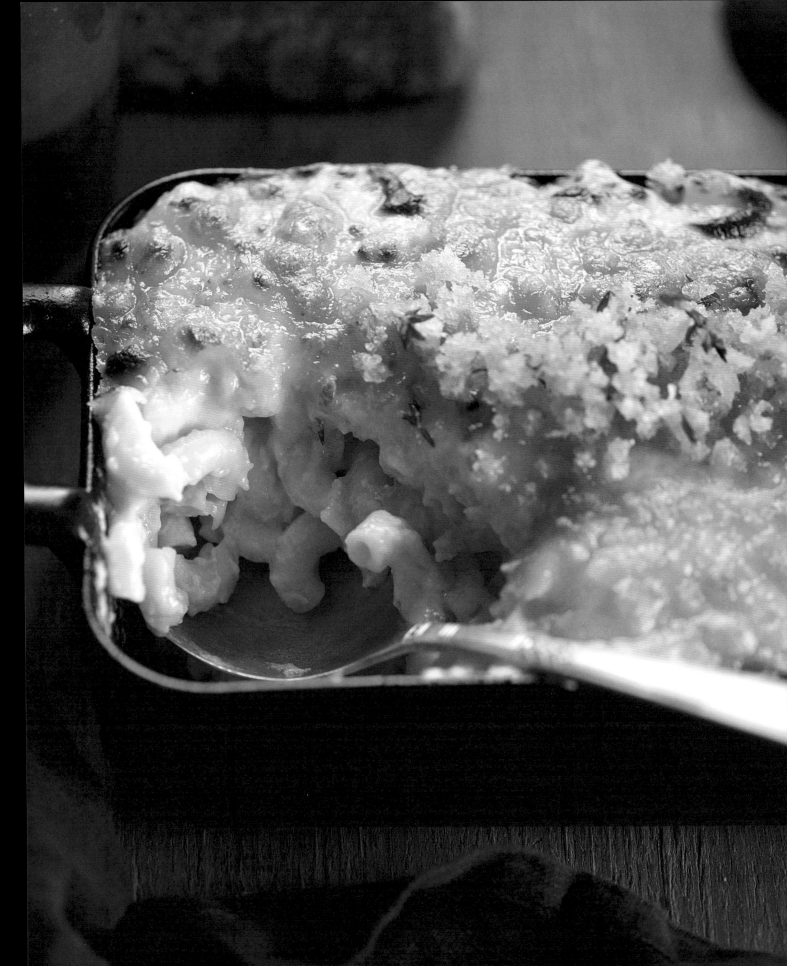

OLD-FASHIONED MACARONI & CHEESE

Macaroni and cheese is a wonderful classic that was part of Lee and Jackson's repertoire. It was introduced to North America by President Thomas Jefferson, who discovered the dish while touring abroad. With a view to serving it for prominent guests, he organized to have pasta, parmesan, and olive oil imported from Italy, and in 1802 he put it on the menu at an important state dinner at Monticello, his private mountaintop home and plantation in Virginia. It remained a recipe for the upper classes until pasta was broadly available in the late 1800s. By the 1940s the dish had dropped in status at the White House and became a hearty, inexpensive meal for the working classes. Here, grated cheddar replaces the traditional parmesan, and paprika is sprinkled on top for color and flavor.

Serves 4

½ lb elbow macaroni

7 Tbsp butter

4 Tbsp all-purpose flour

2 cups milk

salt, pepper, and
 nutmeg to taste

2 cups mixed grated cheese
 (such as gruyere and
 sharp cheddar)

1 cup bread crumbs

paprika

- Preheat oven to 350°F. Cook elbow macaroni in lightly salted boiling water until al dente; drain well.

- Meanwhile, in a saucepan over medium-low heat, melt 4 Tbsp butter, being careful not to let it brown; add flour, and stir until butter is absorbed. Slowly add milk, stirring constantly; add salt, pepper, and nutmeg. When sauce is thickened, add 1 cup grated cheese. Remove from heat and stir until cheese is melted.

- When the macaroni is cooked and drained, return it to the pot, pour the cheese sauce over the pasta, stir to combine, then pour into a lightly greased baking dish. Sprinkle with remaining cheese.

- In a small saucepan, gently melt remaining butter, add bread crumbs, and toss well. Top the macaroni and cheese with the buttered bread crumbs and sprinkle with paprika. Bake 25-30 minutes.

- Serve with green salad or cooked broccoli.

Old-Fashioned Macaroni & Cheese.

PERLE FINE'S BOUILLABAISSE

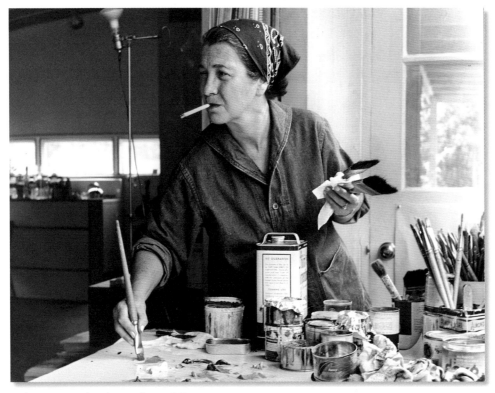

Perle Fine at work in her studio, c. 1958.

Bouillabaisse was a favorite in Lee and Jackson's circle, with versions by Rita Benton, Alfonso Ossorio, and Lee herself. The dish has its origins in Marseille, France, where fishermen would serve the broth separately from the seafood, which was arranged on a platter. This version of the recipe is by artist Perle Fine and includes tomato and Tabasco, giving the dish an American twist. Perle and Lee met during their days as students of artist Hans Hoffman in New York City. The two women had much in common, being children of impoverished immigrants who established small food businesses in America. Lee's parents had a fruit, vegetable, and fish stall in Brooklyn, and Perle's parents had a dairy farm in Massachusetts.

In 1954, looking for a change from the New York art scene, Perle decided to join Lee and Jackson in Springs. She built a studio on Red Dirt Road and moved there, while her husband, artist and art director Maurice Berezov, remained in New York, where he worked, and he commuted to Springs to visit.

Serves 6–8

1½ lb fish fillets (non-oily
 type, such as bass),
 cut into 1-inch cubes
2 lobsters, about 1 lb each,
 cooked, shelled, meat
 chopped into pieces
24 mussels
20 littleneck clams
½ cup salt dissolved in
 1 gallon of water
¼ cup olive oil
1 cup onion, chopped
2 cups leeks, finely chopped
½ cup celery, finely chopped
2 bay leaves
salt and pepper, to taste
1 large pinch saffron mixed
 with 2 Tbsp boiling water
3 ripe tomatoes, peeled and
 roughly chopped
1 lb can tomato puree
1 clove garlic, unpeeled
Tabasco, to taste
a few sprigs of thyme,
 to taste
1 quart unsalted fish stock
½ bottle dry white wine
chopped fresh herbs,
 for garnish

○ Prepare fish fillets and lobsters. Scrub, wash, and de-beard mussels. Scrub and wash the clams, and place them in the salted water to expel any sand. Repeat if necessary and discard any clams that float to the top.

○ In a large, heavy-bottom fry pan, heat oil; add chopped onion, leeks, celery, bay leaves, salt, and pepper; cook until softened but not colored.

○ Add saffron mixture, tomatoes, tomato puree, garlic, Tabasco, thyme, fish stock, and white wine. Bring to a boil, then turn heat to low and simmer 1 hour.

○ Remove from heat, add fish cubes in a single layer, let stand 1 hour, covered.

○ Add mussels and clams, and simmer, covered, 10 minutes, until mussels and clams open. Add chopped cooked lobster meat.

○ Serve in bowls with fresh herbs to garnish.

Some of Jackson's paint cans.

Following pages, from left: Chalk from Jackson's studio; studio floor detail.

QUICHE WITH FOREST MUSHROOMS

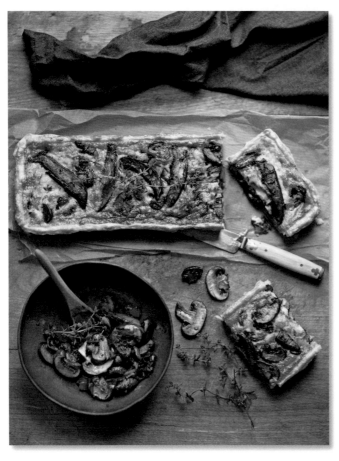

Quiche became a popular dish in America during the 1950s, and Jackson and Lee followed the trend. They had various quiche recipes, two of them handwritten, including a mushroom quiche by artist Alfonso Ossorio, adapted here, and another version for a classic Quiche Lorraine. Jackson enjoyed eggs cooked a number of ways, having grown up with recipes made by his mother from the fresh eggs he collected from their chickens on their farm in Phoenix. With his mother standing in an apron and wide-brimmed hat nearby, young Jackson would hunt for eggs, finding them warm and smooth among the straw. More than just a food source, the experience was perhaps also a source of artistic nourishment for Jackson, and his choice of title for his 1947 painting *The Nest* may have been influenced by his early memories of this daily farmyard ritual.

In Springs, fresh eggs were also on the menu at nearby Jungle Pete's, where Jackson would sometimes go for brunch. The owner, Nina Federico, would feed him even if he couldn't afford to pay: "I wouldn't turn a dog away if it was hungry."[1] This recipe calls for a mixture of mushrooms, as foraging for them was a common activity for Springs residents.

Quiche with Forest Mushrooms.
Following pages, from left: A stack of Jackson and Lee's original recipe books found in their pantry; a clipping from Stella's faux-leather recipe book advising how to keep knives sharp.

[1] Interview with Nina Federico conducted by Jeffrey Potter, 1981, from the Jeffrey Potter audiotapes in the Oral History Collection, Pollock-Krasner House and Study Center, East Hampton, New York.

Serves 6

1 sheet store-bought or
 homemade short-crust
 pastry
1 egg, beaten, for egg wash
dry beans or rice,
 for blind baking,
 to discard afterward
2 Tbsp butter
1 large red onion, sliced
3 Tbsp olive oil
1¼ lb fresh mushrooms
 (mixture of available
 varieties), sliced
1 Tbsp each fresh flat-leaf
 parsley and thyme,
 finely chopped, plus more
 for garnish
4 eggs
1¼ cups cream
1 cup plus ½ cup parmesan
 or romano cheese, grated
½ tsp nutmeg, grated
salt and pepper
green salad, for serving

○ Preheat oven to 450°F. Place the pastry sheet in a greased quiche pan, letting it drape ½ inch over the sides. Pierce pastry in several places with a fork, brush all over with egg wash, then trim pastry around the edges. Line the pastry shell with baking paper and fill with dry beans; blind bake pastry in the oven until set and lightly browned, about 10 minutes. Remove from oven, discard baking paper and beans, and allow pastry shell to cool. Reduce oven temperature to 350*F.

○ In a large fry pan, melt butter and sauté onion until tender. Increase heat, add olive oil, mushrooms, parsley, and thyme; sauté about 10 minutes until browned and cooked. Set aside to cool slightly.

○ In a bowl, whisk eggs and cream, add cheese, nutmeg, salt, and freshly ground pepper.

○ Spread the mushroom mixture evenly over the bottom of the pastry shell, reserving some mushrooms to garnish the top of the quiche before serving. Pour egg mixture over the mushrooms and sprinkle with ½ cup grated cheese. Bake about 40 minutes until filling is set and the top is just golden.

○ Garnish with more fresh parsley and/or thyme and the reserved mushrooms, and serve with a fresh salad of mustard greens dressed with lemon and olive oil.

THE FOREST OFFERED STILL MORE WILD INGREDIENTS, INCLUDING MUSHROOMS, LEEKS, AND FIDDLEHEAD FERNS.

THE ART OF FISH COOKERY

HE2 | 2 | COOK-BOOK | 60¢

LIZABETH WOODY

THE POCKET CO

THE MYSTERY CHEF'S OWN COOK BOOK

MR. & MRS. ROTO-BRO

CONSTRUCTIVE MEAL PLANNING

VEGETABLE JUICES N. W

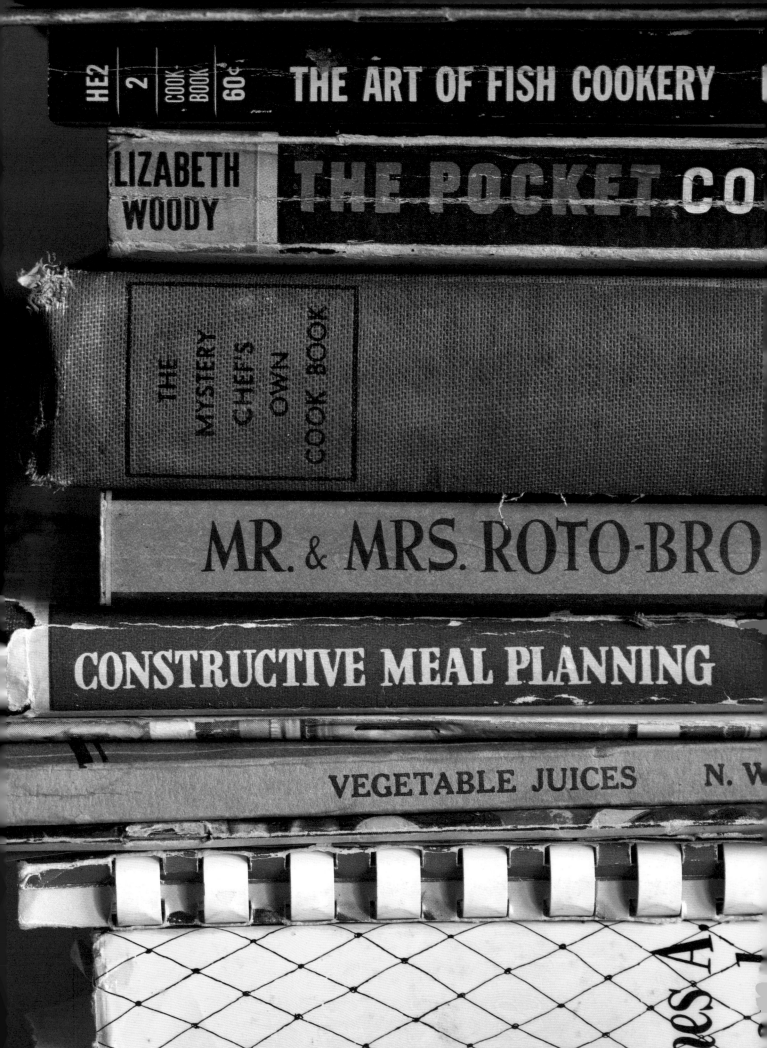

For Sharpened Knives

To keep kitchen knives sharp, housewives could take a tip from the butcher or the barber, two persons in the community who depend on sharp blades for their livelihoods. The sharpening should take place at least once a month. A new, easy-to-use version of the sharpening stone has been designed by Ekco Products Company. It is the Flint knife sharpener, available at B. Altman's for $1.95. It has a silicone carbide sharpening stone set in a long Pakkawood handle, with a thumb safety guard.

ROAST BEEF WITH YORKSHIRE PUDDING & ARLOIE'S GRAVY

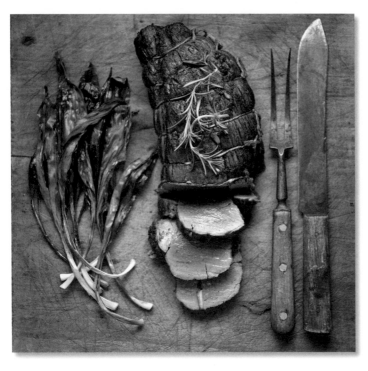

November 25, 1950, the Saturday after Thanksgiving, was a clear and cold day. Jackson had been outside working on a film with Hans Namuth, and the last day of shooting was over. Lee had invited a group of close friends to a special dinner in celebration of the completion of the shoot, which had commenced four months prior. The guest list included Hans Namuth and his wife, Carmen Herrera, Jeffery and Penny Potter, Wilfrid and Elizabeth Zogbaum, John Little, Peter Blake, Ted Dragon, and Alfonso Ossorio. Lee's carefully planned menu included roast beef, Yorkshire pudding, brussels sprouts, creamed onions, gravy, and salad. Hans was supplying his own home-baked bread.

Jackson's patience for the filming process waned with multiple takes repeating actions and gestures, and by the last day of shooting his enthusiasm had turned to simmering resentment. Friend Cile Downs recounted that the process had made Jackson feel "like a trained terrier. It drove him crazy and he went off his rocker." Soon after Lee served the main course, and with several bourbons already consumed, Jackson became argumentative. As the tension and pitch increased, Jackson stood and overturned the heavy oak table, sending the entire main course and all the tableware onto the floor, narrowly missing several guests. As adept in her skills of denial as she was in her skills as a hostess, Lee was said to have appeared from the kitchen declaring that coffee would be served in the front room. Some time after Jackson died, Lee gave the dining table to Cile, and Ted Dragon helped Lee shop for a large round antique table to replace it.

Serves 6

FOR THE ROAST BEEF

3 lb beef roast (sirloin or
 porterhouse)

6 cloves garlic

2 Tbsp olive oil

sea salt and pepper

1 lb potatoes, peeled and
 quartered lengthwise

12 small whole onions,
 peeled

1 small handful mixed fresh
 herbs, such as rosemary,
 thyme, sage

*FOR THE YORKSHIRE
 PUDDING*

8 oz all-purpose flour, sifted

salt and pepper

3 eggs, beaten

1¼ cups milk

½ cup lard or goose fat

FOR THE GRAVY

1 heaping Tbsp all-purpose
 flour

1 cup beef or chicken broth

¼ cup milk

1 Tbsp Worcestershire sauce

salt and pepper

- Remove meat from refrigerator at least an hour before cooking; allow it to come to room temperature. Preheat oven to 375°F. Make small incisions in meat with a sharp knife and push garlic cloves into the holes. In a heavy-bottom fry pan over high heat, add 1 Tbsp olive oil and sear meat quickly all over until dark brown. Season with salt and pepper, and transfer to a roasting pan.

- In a bowl, toss potatoes, onions, herbs, remaining olive oil, and a pinch of salt. Arrange vegetables around the meat in the pan, and roast according to the following times: rare, 30 minutes; medium rare, 45 minutes; well done, 60 minutes. Remove meat from oven, cover with foil, and let rest.

- While the meat is roasting, prepare the Yorkshire pudding batter: In a mixing bowl, sift flour with salt and pepper to taste. In a separate bowl, mix the eggs and milk, then whisk into flour mixture, stirring well until there are no lumps. Allow batter to rest, up to 1 hour.

- Arrange 12 ramekins on a baking tray, or use a 12-cup muffin tin. Place a small amount of lard or goose fat in each container, then heat the muffin tin or tray of ramekins in the oven until the fat is hot and bubbling. Remove tray from oven, distribute batter evenly among 12 containers, and bake 15-20 minutes until brown and risen.

- While the puddings are baking, make the gravy: Remove the meat, vegetables, and most of the fat from the roasting pan, leaving 2-3 Tbsp fat. With pan over medium heat, stirring constantly, sprinkle in flour to make a roux, then add broth a little at a time to reach desired consistency. Bring to a boil then reduce to a simmer for a few minutes. Add milk and Worcestershire sauce. Simmer a few more minutes then season to taste, and serve while hot.

- To serve, slice meat and transfer to platter or individual plates. Place slices of meat and a Yorkshire pudding on each plate and cover with gravy. Serve with brussels sprouts, creamed onions, roasted potatoes, and homemade bread.

SLOW-COOKED POT ROAST

Jackson learned to cook one of his favorite lamb dishes while staying with fellow artist Richard Davis in his log cabin in the Pocono Mountains in 1933. The two would spend the days drawing or sculpting, and late in the day would collect milk and fresh vegetables from Richard's housekeeper's garden, then cook together in the cabin on the slopes of Seven Pines Mountain. Richard, a sculptor, taught Jackson to prepare lamb stew and he served it with his own homemade beer. Years later in Springs, Lee and Jackson added other lamb recipes to their collection, including one for mustard-and-bread-crumb-coated lamb roll that was saved from the luxury dining cars of the Union Pacific. This particular pot roast recipe was adapted from the one given to them by Jackson's sister-in-law, Arloie, and can be prepared with either lamb or beef.

Jackson was a fan of Arloie's cooking, and he benefited from her culinary skills when she married his brother Sande and moved in with the brothers in New York City in 1936. Arloie was a good-natured and patient woman who prepared a variety of tasty meals. This recipe combines Arloie's original pot roast with the option of adding scallions and chickpeas at the end, as was Lee's habit.

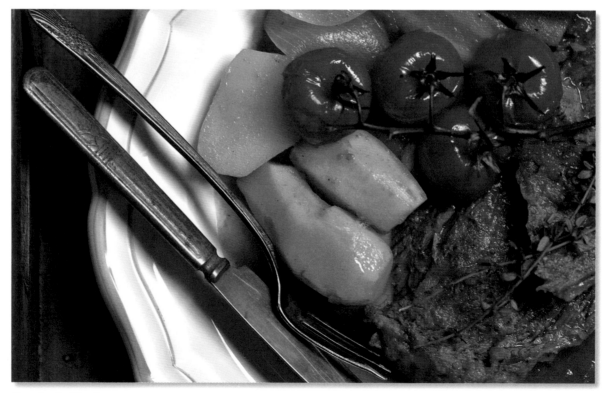

Slow-Cooked Pot Roast.

Serves 6

3-4 lb pot roast, boned
 shoulder or leg,
 beef or lamb
1 Tbsp flour
1 Tbsp butter
1 Tbsp olive oil
5 cloves garlic, bruised
1 medium-size onion,
 finely chopped
14 oz can crushed tomatoes
1 Tbsp rosemary,
 finely chopped
½ cup water, plus more
 as needed
salt and pepper
favorite seasonal vegetables
 such as potatoes, carrots,
 and onions, washed,
 peeled, and sliced
14 oz can chickpeas, drained
 and rinsed, if desired
1 bunch scallions, washed
 and sliced, if desired

- Remove meat from refrigerator about an hour before cooking; allow it to come to room temperature. Preheat oven to 375°F. Season meat with salt and pepper and rub all over with flour. In a large Le Creuset pot on the stovetop over high heat, melt the butter with the olive oil and sear the meat on all sides until well browned. Remove meat and set aside.

- To the pot, add bruised garlic, onion, tomatoes, rosemary, and water. Stir and bring to a simmer; return the meat to the pot, and baste with the sauce. Cover pot and roast in the oven 1 hour. Season roast again with salt and pepper, adding a little more water if needed. Reduce oven to 300°F and roast 4 hours more, covered, turning each hour and basting regularly. During the last hour, add favorite vegetables as desired, such as potatoes, carrots, and onions. For the last 15 minutes of roasting time, add chickpeas and scallions, if desired.

- This slow-cooked roast should barely need carving; it should fall apart easily. Serve with Lee and Jackson's favorite roasted vegetables such as Long Island or sweet potatoes and carrots, drizzled with juices from the pot.

AMONG LEE AND JACKSON'S HANDWRITTEN RECIPES WERE FAMILY FAVORITES BY JACKSON'S MOTHER, STELLA POLLOCK, AND HIS SISTER-IN-LAW, ARLOIE McCOY.

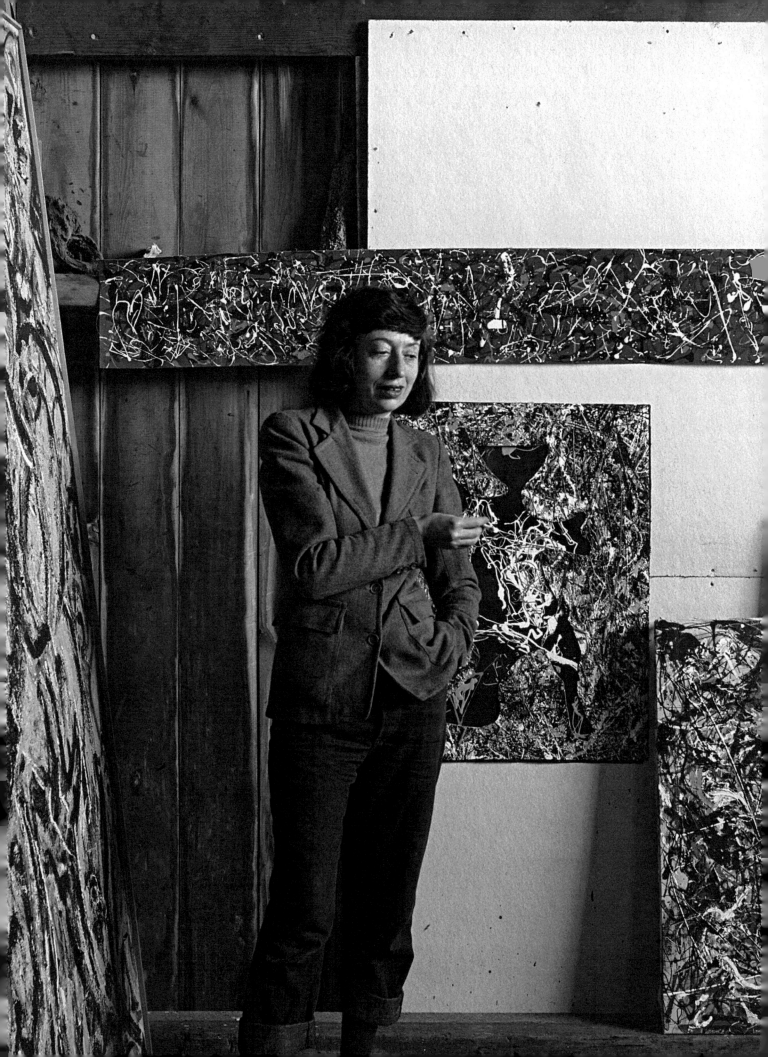

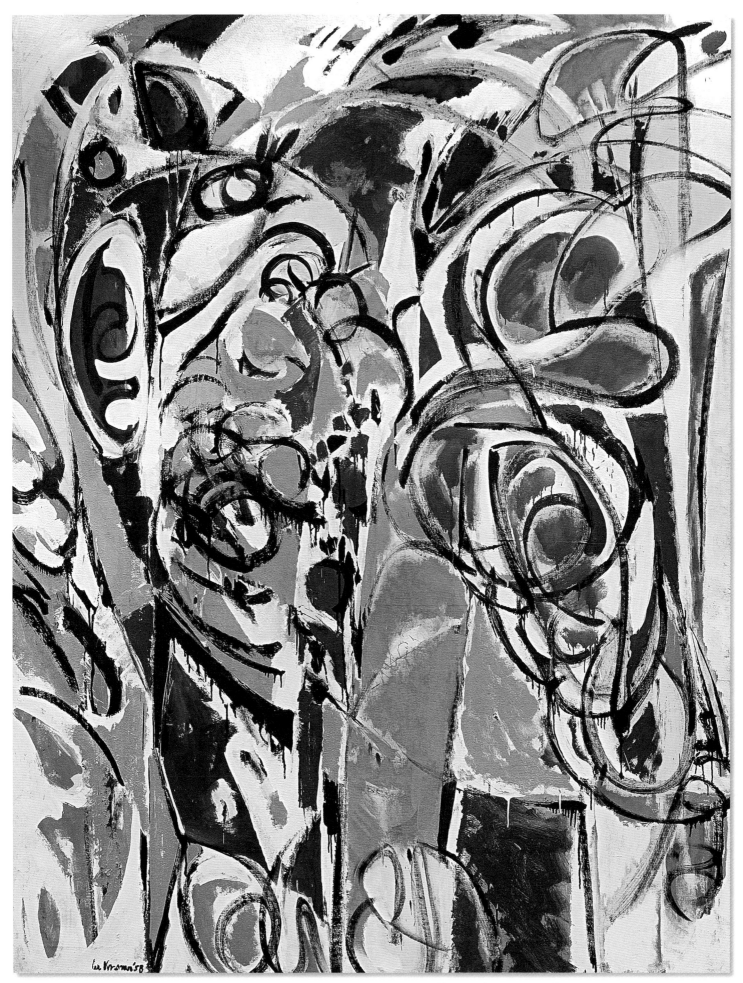

Lee Krasner, *Cornucopia*, 1958. Oil on canvas, 90½ x 70 in. (229.9 x 177.8 cm). *Opposite:* Lee in Jackson's studio, 1949.

LUCIA WILCOX'S BEACH PICNIC

Jackson and Lee clamming in Accabonac Harbor, 1947.

Lucia Wilcox and her husband, Roger Wilcox, were another couple who had a pivotal role in the art scene of the Hamptons area in the 1940s and '50s and were close friends with Jackson and Lee. Lucia was a gifted hostess and an artist who exhibited alongside Jackson and Lee at Guild Hall shows in East Hampton. She was a natural magnet for artists and intellectuals fleeing war-torn Europe. Lucia encouraged, fed, and housed many of these refugee surrealists. She was also known as one of the most talented cooks in Lee and Jackson's circle and she loved preparing large feasts for their houseguests and friends.

Based in Amagansett, Lucia would sometimes pack a Syrian-style beach picnic for Roger and Jackson and the two men would spend hours at the beach together and return before sundown. Roger became Jackson's confidant, and they often walked together and explored the beaches of Montauk or Napeague Harbor, a few miles from Springs. Lucia had first visited the Hamptons with her former partner, Fernand Léger, as guests of Sara and Gerald Murphy in their sweeping beachside mansion in East Hampton.

Lucia taught her grandson Alexander Kabbaz to cook, and he provided Lucia's typical picnic menu, which included stuffed grape leaves, hummus, and kibbee. This exotic picnic can be served with marinated olives, flatbread, baby radishes, fresh dates, and pomegranate seeds for garnish.

Opposite: Waves crashing onto East Hampton beach.

BABA GHANOUSH

Serves 8

2 large eggplants

juice of 2 lemons

2 Tbsp tahini
 or sesame paste

salt

1 large clove garlic, crushed

¼ cup chopped parsley
 and/or pomegranate
 seeds, for garnish

2 Tbsp extra virgin olive oil,
 to finish

flatbread, for serving

○ Prick eggplant skins with a fork in multiple places. Blister the skin of the whole eggplants over a gas flame, turning until they are charred all around and the interior flesh has softened and collapsed. Depending on the size of the eggplants, this should take about 15 minutes each. Let cool about 1 hour, then peel eggplants, discarding the stems.

○ In a medium-size bowl, place the eggplant flesh, add lemon juice, tahini, and salt to taste; mix well. Add crushed garlic and stir through the mixture. Garnish with parsley and/or pomegranate seeds and drizzle with olive oil. Serve with flatbread.

HUMMUS

Serves 6–8

2 cups cooked or canned
 chickpeas, drained

⅔ cup tahini

½ cup lemon juice

2 cloves garlic, crushed

1 tsp salt

Italian parsley, chopped,
 for garnish

flatbread, for serving

○ Hummus can be made either smooth or chunky. For a smooth version, place chickpeas, tahini, lemon juice, garlic, and salt in a blender and blend to make a smooth paste. For a textured, chunkier version, place chickpeas in a bowl and mash with a fork, then mix in remaining ingredients.

○ Garnish with parsley, and serve with flatbread.

The twisted path to one of Jackson's favorite Montauk beaches.

LUCIA WILCOX'S BEACH PICNIC

KIBBEE

Makes 8-12 small kibbee

FOR THE CRUST

2 cups No. 3 bulghur
 or cracked wheat

2 quarts boiling water

2 lb round steak, minced

1 onion, finely chopped

salt and freshly ground
 black pepper

cold water, if required

FOR THE STUFFING

3 Tbsp butter

6 small white onions, peeled
 and finely chopped

½ cup pine nuts

¼ tsp ground allspice,
 or to taste

2 lb round steak, minced

salt and freshly ground
 black pepper

½ cup canola or sunflower
 oil, for pan frying

○ In a heat-proof medium-size mixing bowl, combine the wheat with boiling water and stir. Cover and let stand 3 hours, then drain in a colander lined with cheesecloth and squeeze dry. In a large bowl, mix meat, onion, salt, and pepper. Add the wheat and blend ingredients by hand, adding tiny amounts of cold water, if required, to create a pliable dough.

○ In a heavy-bottom fry pan, heat butter and sweat onions until soft. Add pine nuts and cook, stirring constantly, until nuts are lightly golden. Sprinkle with allspice, add minced meat, season with salt and pepper. Break up the meat with a fork. Cook over medium heat but do not allow the meat to brown. When meat has lost its red color and all the moisture has absorbed, remove from heat.

○ Form dough into golf-size balls. Push a deep hole into the ball with finger, then gently hollow the hole, using index finger inside and thumb outside, pressing around the edges as you turn the ball. When edges and base of the casing are thin, even, and sturdy, fill the cavity with the meat stuffing. Cover opening and pinch the ends of the kibbee into points.

○ Heat a medium fry pan with oil and fry kibbee until browned all over. Drain on paper towels.

○ Serve with cold yogurt or tahini for dipping.

LUCIA WOULD PACK A SYRIAN-STYLE PICNIC FOR ROGER AND JACKSON AND THE TWO MEN WOULD SPEND HOURS AT THE BEACH.

Lucia Wilcox's beach picnic.

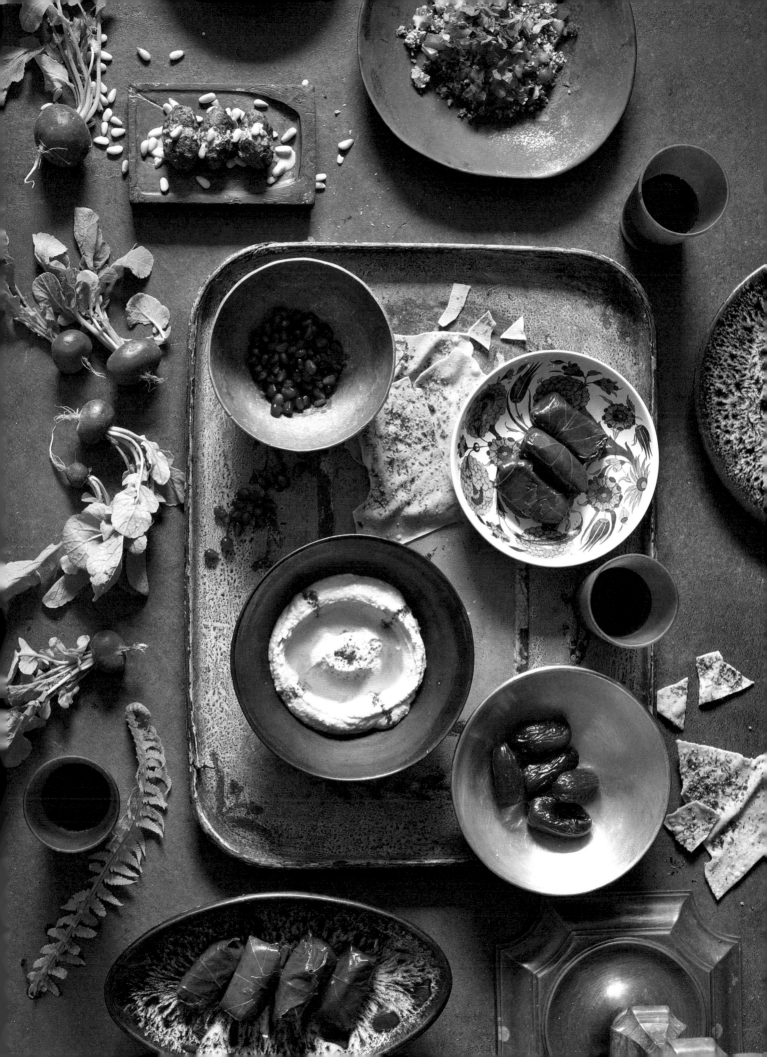

STUFFED GRAPE LEAVES

Makes about 50

3 cups ground lamb,
 ground beef,
 or combination

¾ cup rice, uncooked

juice of 2 lemons

2 tsp allspice

1 Tbsp salt

1 tsp pepper

2 Tbsp butter

55-60 large fresh grape leaves

lamb bones (optional)

- If grinding meat at home, leave a little fat on the meat. In a bowl, wash and drain uncooked rice; cover with water, rinse again, and drain well. Add lemon juice, allspice, salt, and pepper to rice; mix thoroughly. With hands, mix butter into ground meat, combine thoroughly with rice mixture, and set aside.

- To clean grape leaves: Remove stems with scissors. Spread half the leaves in a rectangular baking pan, cover with boiling water, and gently swish and turn them for a few minutes. Rinse and drain well, pressing out water. Repeat with remaining leaves. If using leaves canned in brine, soak leaves for 30 minutes in hot water, rinse, and press out water.

- On a table or board, spread leaves face down, with stem end toward you. Place about 1 Tbsp of rice-meat mixture across the width of each leaf, just above the stem line. If leaf is small, use less mixture. To form a lightly compact roll, fold stem end over rice-meat mixture, fold in the sides, and firmly roll away from you.

- If using bones for extra flavor, remove fat, season with salt and pepper, and place the bones in a medium-size pot. Layer the grape leaf rolls close together, on top of bones. If not using bones, place a few extra leaves on the bottom of the pot, and layer the rolls on top.

- Place an easily removable metal or ovenproof plate on top of rolls to weight them down. Cover with cold water up to the plate, ensuring all rolls are submerged. Cover pot and bring to a boil, then lower heat to simmer, tilting the cover if necessary to prevent boiling over. Check rice for tenderness after about 45 minutes. If rolls are not quite cooked and liquid has evaporated, make sure heat is low and add 1-2 cups of water, but this is seldom necessary if the leaves are tender.

- When rice is done, carefully remove plate, and tilt pot to mix juices. Serve hot. Leban, bread, and salad go beautifully with this great invention. Leftovers can be warmed up in the juice.

Lee Krasner at the beach, Provincetown, c. 1939.

LUCIA WILCOX'S BEACH PICNIC
TABBOULEH

Serves 6

1 cup No. 1 (fine) bulghur or
 cracked wheat

¾ cup onion, finely chopped

½ cup spring onion, both
 green and white parts,
 finely chopped

1 tsp salt

¼ tsp freshly ground
 black pepper

1 cup Italian parsley,
 finely chopped

½ cup fresh mint leaves,
 finely chopped

½ cup lemon juice

¾ cup extra virgin olive oil

2 fresh tomatoes,
 peeled and diced

○ In a heat-proof bowl, place the bulghur wheat, add boiling water to cover, and let stand 1 hour. Drain in a colander lined with cheesecloth and squeeze dry.

○ In a large bowl, place the bulghur wheat, onions, salt, pepper, parsley, mint, lemon juice, and olive oil; mix well by hand. Garnish with chopped tomatoes, and serve.

Paints and brushes in Jackson's studio.
Opposite: The beach where Jackson and his friend Roger Wilcox would walk and sit together, often for hours at a time. The seascape is reminiscent of Jackson's 1953 work *Ocean Greyness,* with swirling gray and blue hues.

BREADS, LOAVES & PANCAKES

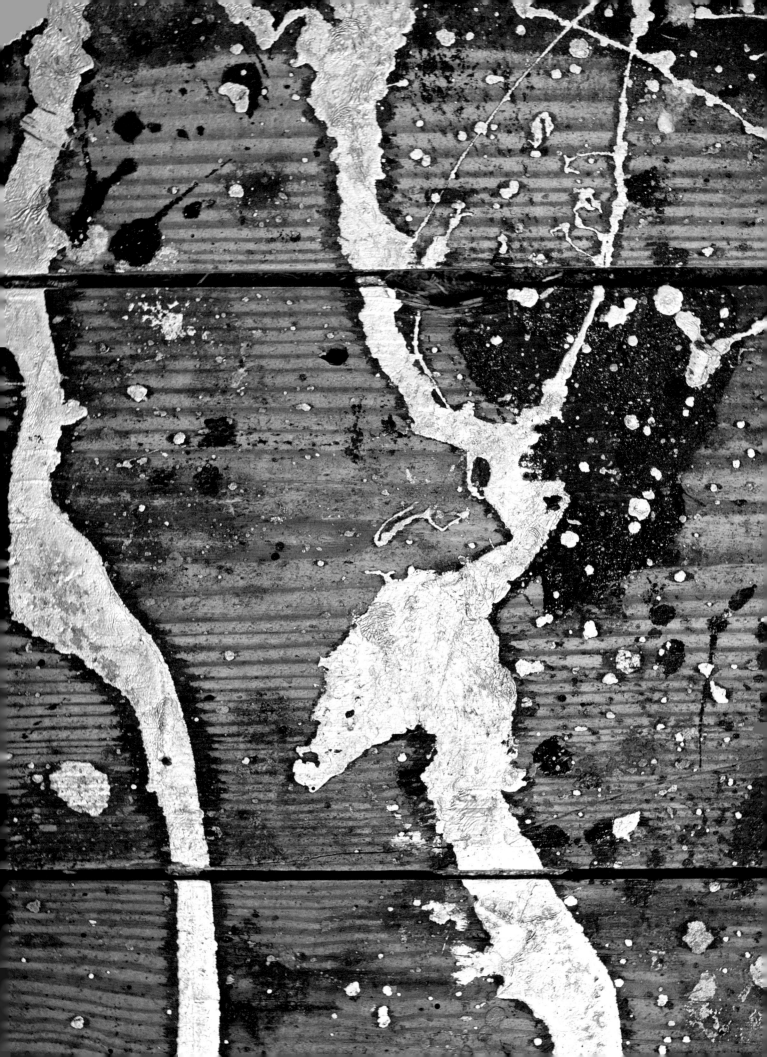

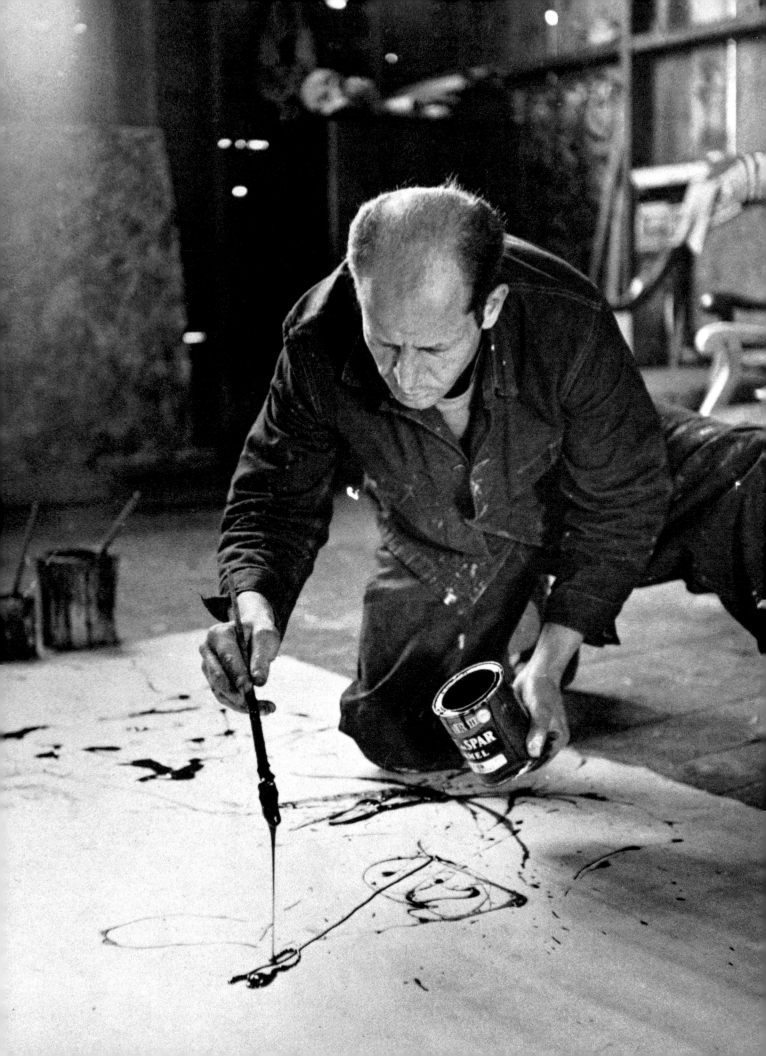

ACCABONAC CORNMEAL PANCAKES

In early spring 1948, Jackson and Lee found a seventeenth-century house with twenty-seven acres on Three Mile Harbor Road for artist John Little. John bought the house and Jackson helped him with the extensive renovations. When John invited his future wife, Josephine, to Springs to inspect his new home, called Duck Creek Farm, he also wanted to show her other special aspects of his life there. "For him, it was only natural that having met his house, I should then meet his friends the Pollocks."[1] The first meeting was a success, and the two couples shared a delicious meal of cornmeal pancakes with bacon and maple syrup: "a brunch for us; breakfast for Lee and Jackson… snowy March Saturday morning, 1950."[2] This recipe was given to Lee and Jackson by Stella and was scrawled with black pen on a scrap of paper.

Makes 8 small 3" pancakes

1 cup cornmeal

1 cup all-purpose flour

4 tsp baking powder

1 tsp salt

3 Tbsp butter

3 Tbsp honey

2 eggs

1 cup milk, more or less,
 as desired for consistency

butter or corn oil, for frying

crispy bacon and maple
 syrup, for serving

○ In a bowl, mix cornmeal, flour, baking powder, and salt; work butter into dry ingredients with fingertips, handling as little as possible. Beat in honey, eggs, and enough milk to make batter to desired consistency.

○ On a griddle, heat a little butter or corn oil; drop batter onto hot griddle and cook pancakes, turning only once.

○ Serve with bacon and maple syrup.

Jackson working in his studio adjacent to his home, April 1949.
Prevoius pages: Jackson's studio floor, detail.

[1] Interview with Abigail Tooker conducted by Robyn Lea, April 15, 2014, and subsequent letters and documents provided to Robyn Lea by Abigail Tooker.
[2] Ibid.

CROSS-COUNTRY JOHNNY CAKES

In June 1934 Jackson and his eldest brother, Charles, set out on a road trip from New York across the vast American terrain in a Model T Ford. The destination was the home of their mother, Stella, in California, and they also wanted to finally pay their respects at the grave of their father, who had died more than a year before. Encouraged by their teacher Thomas Hart Benton's belief in the importance of American road trips for artists, they packed their sketchbooks, two harmonicas (Benton had encouraged Charles and Jackson to learn), and other supplies and set off on a cross-country adventure. Their drawings depicted the sometimes desperate scenes of daily life during the Depression. All around them they saw its effects and yet "everywhere they have been friendly. The kids, even in the most poverty stricken sections, are especially likeable"[1] (West Virginia, June 16, 1934). At the end of each day they searched out camping areas close to water to wash clothes and bathe away the summer's heat. They slept under shelters at local schools, on the properties of local farmers, occasionally drawing a portrait in exchange for food and a dry place to sleep, and they lived on the simplest of meals.

Johnny Cake became their meal of choice. Charles wrote to his first wife, Elizabeth, "in Tennessee I bought a large bag of corn meal and we prepare Johnny Cake for our meals. So far we haven't tired of it"[2] (July 9, 1934). They alternated the Johnny Cake with whatever food was readily available and inexpensive, such as tortillas in Texas, watermelon in Arizona, and, of course, their mother's magnificent meals once they arrived in California.

Makes 15 small 2" johnny cakes

1 cup finely ground cornmeal

1 tsp sugar

½ tsp salt

1 cup boiling water

¼ cup milk, more or less, as desired for consistency

butter or corn oil, for frying

butter and/or maple syrup, for serving

○ In a medium bowl, combine cornmeal, sugar, and salt. Slowly add boiling water, stirring, to make a paste. Stir in milk until mixture resembles mashed potatoes, adding more if a thinner consistency is preferred.

○ In a fry pan, heat butter or corn oil, then drop spoonfuls of batter to make 2-inch cakes. Cook 3-5 minutes each side or until a brown, crunchy crust forms, while the inside remains soft.

○ Serve hot with butter and/or maple syrup.

[1] Letter between Charles Pollock and his first wife, Elizabeth Pollock, as quoted in *American Letters, 1927–1947: Jackson Pollock & Family*.

[2] Ibid.

Cross-Country Johnny Cakes.

HANS NAMUTH'S BREAD

Reeds under snow along Louse Point beach.

Photographer and filmmaker Hans Namuth first saw Jackson's work at the Betty Parsons Gallery in 1949, the same year that Hans and his wife, Carmen Herrera, rented a house in East Hampton. Knowing of Jackson's reputation as an artist, Hans asked his permission to photograph him in his studio, and the images and subsequent film showing Jackson at work became important historical documents of his artistic style and approach. Like Jackson, Hans found pleasure in bread making and would do so religiously each weekend at his home in Water Mill, a charming hamlet about half an hour from Springs. Hans became known locally as the "dean of home bakers," and this recipe is based on his own much-loved formula.

"CERTAINLY JACKSON'S RELATIONSHIP TO NATURE WAS INTENSE. JUST WALKING ON THE BEACH IN THE WINTERTIME, WITH SNOW ON THE SAND WAS EXCITING. HE IDENTIFIED VERY STRONGLY WITH NATURE."

Lee Krasner[1]

[1] "Jackson Pollock at Work: An Interview with Lee Krasner," by Barbara Rose, *Partisan Review,* vol. 47, no. 1, 1980.

Makes 2 loaves

2 Tbsp dry yeast

1 tsp sugar

2 cups warm water

4-6 cups unbleached white
 flour, sifted, as necessary,
 plus more for dusting

2 Tbsp honey

2 tsp sea salt

2 Tbsp melted butter
 or 4 oz plain yogurt

2 Tbsp wheat germ

¼ cup olive oil

¼ cup cornmeal

Optional:

1 egg yolk, beaten

1 handful sesame seeds

○ In a large, warmed mixing bowl, sprinkle yeast and sugar over 2 cups warm but not hot water (105-115°F). Stir gently and let stand 30 minutes or until the surface is bubbly. Add honey, salt, melted butter or yogurt, wheat germ, and 1 cup flour and beat with a wooden spoon until smooth. Slowly stir 2 cups or more of flour into the mixture; when you have a cohesive mass, begin kneading by hand in the bowl. Then turn the dough onto a lightly floured counter or board, and with more flour at hand continue kneading about 10 minutes, adding additional flour as necessary. The exact amount of flour to be added will vary with the weather and may be up to 6 cups total.

○ Form dough into a ball, coat with olive oil, place in the bowl, cover with a damp towel, and leave to rise in a warm place about 1 hour or until doubled in size. Meanwhile, line two baking trays with baking paper and sprinkle with an even layer of cornmeal.

○ Once the dough has risen, knead it down and divide it in two. Form into round or long loaves as desired and place on the trays, brush with olive oil, cover each with a clean, damp towel and allow to rise a second time until doubled in size.

○ Preheat oven to 350°F. Dust each loaf with a little flour and make three slashes in each loaf, about ½ inch deep, with a sharp knife. Bake about 60-70 minutes, rotating the pans at least twice. If very crusty bread is desired, raise oven temperature to 450°F for the last 10 minutes. The bread is done when it sounds hollow when tapped on the bottom. Let cool on a wire rack.

○ Variation: After second rising, instead of dusting with flour, brush with beaten egg yolk and sprinkle with sesame seeds.

Following pages, from left: Ingredients and utensils arranged in Jackson and Lee's kitchen, ready for use; the East Hampton flour mill under snow.

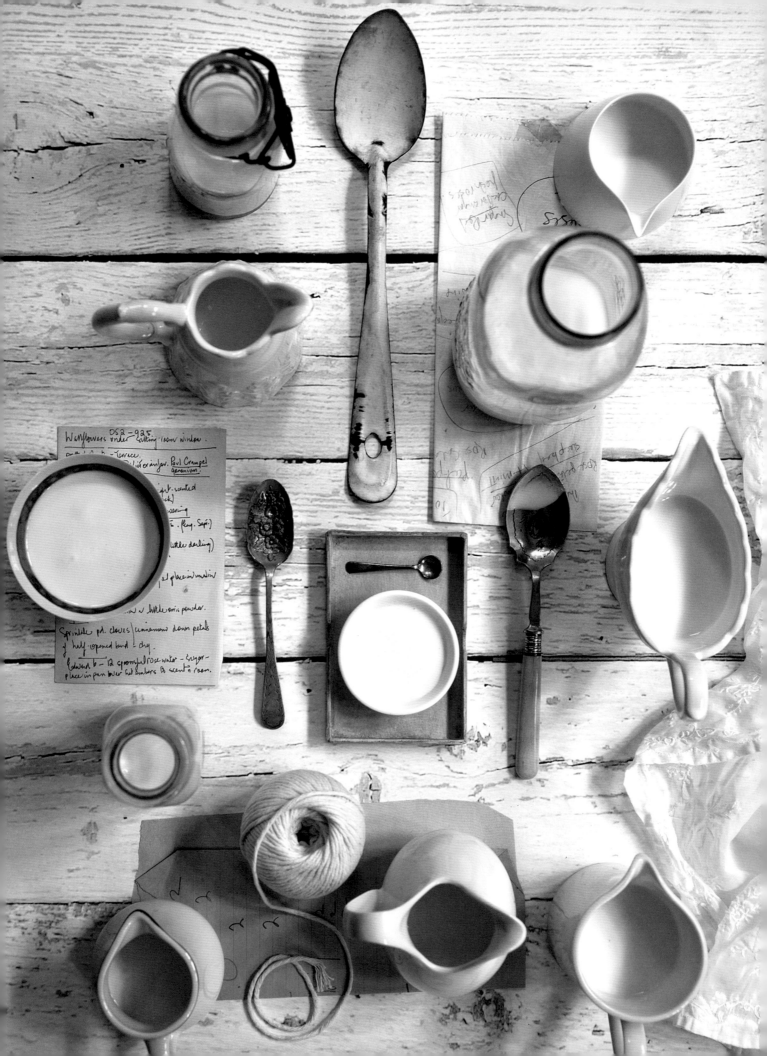

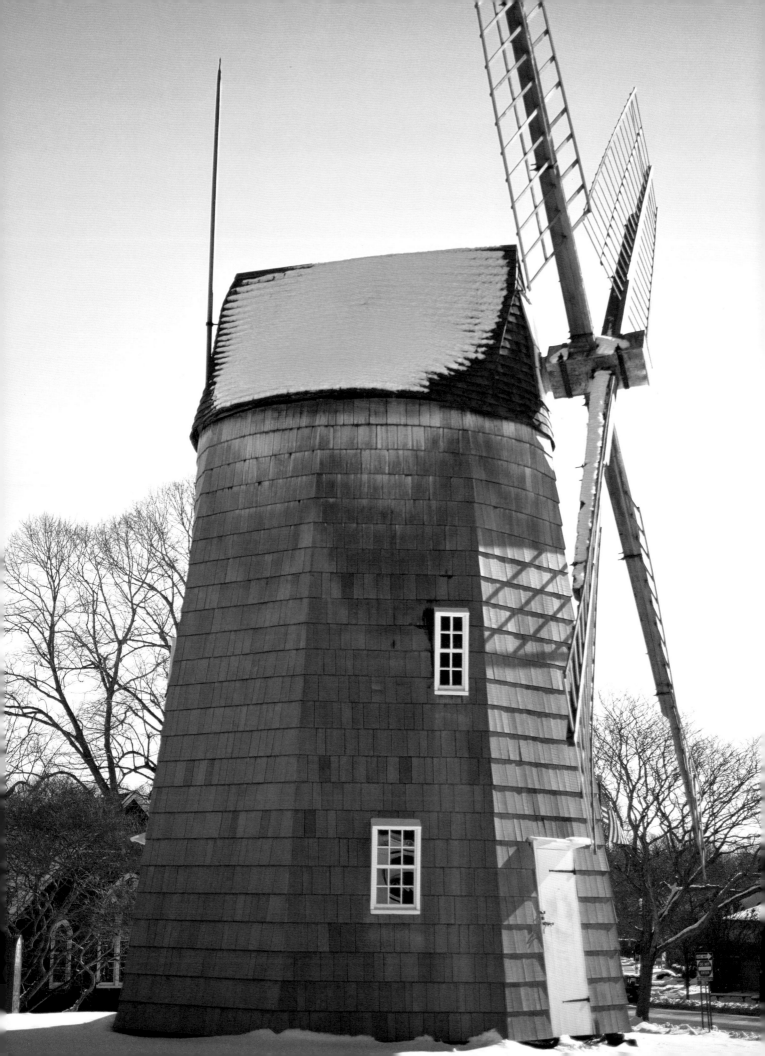

JACKSON'S CLASSIC RYE BREAD

Many of Lee and Jackson's friends talked with nostalgia about Jackson's homemade bread. This recipe, handwritten by Jackson, is for rye bread, which, while being readily available in New York City (usually used in a delicatessen sandwich with mustard and corned beef or pastrami), was not as prevalent around Springs. Rye flour, however, was available locally, freshly ground at the Old Kappeli Konquest Hook Mill in East Hampton.

Like his mother, Jackson was very proud of his homemade bread, and considered baking a fine art to be taken very seriously. Stella's own bread recipes included Boston Brown Bread, Apricot Yeast Bread, Date Banana Bread, Potato Rolls, and Festival Sweet Rolls. Stella's recipe book notes that caraway seeds can be added to various dishes including soups, stews, breads, and candies, and this has been added to the ingredients here, as an option to include as desired.

Lee recalled that if a loaf of Jackson's didn't work, his temper would flare. Bread making among many of their neighbors in Springs was a weekly ritual usually performed on Saturdays, following the Puritan tradition that discouraged cooking on Sundays.

This fresh bread is delicious served warm with butter. Or try making your own preserves or conserves such as those commonly served in the Pollock household. Among the favorite family recipes were: Apple Relish, Strawberry and Rhubarb Preserves, Plum Conserve, Blackberry and Apple Jelly, Ripe Grape and Pineapple Jam, Rhubarb and Orange Conserve, Persimmon Jam, and Yellow Tomato Preserve with Honey.

Ingredients for Jackson's Classic Rye Bread.

Makes 3 loaves

4½ tsp (2 packets) dry yeast

½ cup lukewarm water

1½ Tbsp sugar

4 cups rye flour

3 cups buttermilk

2 tsp salt

2 Tbsp caraway seeds,
 if desired

2 cups all-purpose flour,
 plus more as needed

½ cup melted butter,
 for brushing top of loaves

○ In a small bowl, dissolve yeast in lukewarm water; add sugar and let stand about 20 minutes, until the surface is bubbly. In a large mixing bowl, combine rye flour, buttermilk, and salt. Add yeast mixture and stir well. Set bowl in a warm place to rise until dough is full of bubbles. When risen, add caraway seeds if desired, and gradually add enough white flour to make a dough that is a little stiff.

○ Preheat oven to 425°F. Turn dough onto a lightly floured counter or board and knead until smooth and elastic. Divide dough into three loaves, place in well-oiled 9 x 5-inch bread tins, and brush tops with melted butter. Cover with a towel and let rise until doubled in size. Using a sharp knife, make a couple of shallow incisions on the top of each loaf. Bake about 1 hour. Allow to cool on a wire baking rack.

"JACKSON LOVED TO BAKE. I DID THE COOKING BUT HE DID THE BAKING...HE WAS VERY FASTIDIOUS ABOUT HIS BAKING— MARVELOUS BREAD, CAKE, AND APPLE PIES. HE ALSO MADE A GREAT SPAGHETTI SAUCE."

Lee Krasner[1]

[1] "Who Was Jackson Pollock?" by Francine du Plessix and Cleve Gray, *Art in America* May–June 1967, p. 51.

JACKSON'S WHITE BREAD

It is interesting to note that many of the recipes Jackson chose as his "signature" dishes were baking recipes requiring precision and patience, two things Jackson is not commonly known for. Generally Jackson is perceived to have the opposite approach—wild, unruly, and undisciplined. His baking is evidence that he was in fact a person who enjoyed the formal discipline required for bread making. He enjoyed working the dough with his hands, perhaps in a similar way to his enjoyment of ceramics and working with stone and clay. In his painting Jackson also denied that his technique was an accident, that in fact in launching the paint into the air he knew exactly how it would land on the canvas below.

Jackson's white bread is the perfect honest loaf, ideal for a dinner party—unfussy and delicious.

**Makes 2 loaves
or 8–10 dinner rolls**

1 cake compressed yeast

1½ cups lukewarm water

1 Tbsp sugar

1½ tsp salt

¼ cup butter, melted

5–5½ cups all-purpose flour,
 as needed

1 egg, beaten, for brushing
 top of loaves

○ Soften yeast in water. Add sugar, salt, and melted butter and set in a warm place for about 10 minutes until yeast is bubbly. Add flour gradually, beating thoroughly after each addition until dough is stiff enough to knead. Turn dough onto lightly floured counter or board and knead until smooth and elastic. Cover with a warm, damp cloth and set in a warm place to rise until double in volume. Work down dough, cover with a warm, damp cloth, and allow to again double in size. Work down lightly.

○ If making loaves, preheat oven to 450°F. Divide dough in two and place in well-oiled 9 x 5-inch bread tins. Again, cover and let rise until doubled. Brush loaves with egg wash and bake about 15 minutes. Reduce oven to 410°F and bake another ½ hour, or until done. Remove tins from oven and allow loaves to sit in pans for 10 minutes before removing bread to cool on a wire rack. Loaves should sound hollow when tapped on the bottom.

○ If making rolls, preheat oven to 410°F. Form dough into eight round dinner rolls, place on a greased, parchment-lined baking sheet, and bake 15-20 minutes until golden brown. Remove to wire racks to cool.

Jackson's White Bread with local handmade preserves and butter.
Opposite: Detail of one of Jackson's handwritten bread recipes.

2 Teaspoons Salt

Soften yeast in water. add
thoroughly after each addi
Turn onto lightly floured b
cover with a warm, da
double in bulk. Work a
allow dough to again
form into loaves. Plac
a warm, damp cloth
until double in bulk.
Re-grease the bread she

SOUR CREAM GRIDDLE CAKES

A favorite of Jackson and Lee's, this handwritten griddle cake recipe is one of the many incarnations of the American pancake, which include Indian corn cakes, buckwheat pancakes (introduced by Dutch settlers), hoecakes (baked on a hoe over hot coals), slapjacks, flapjacks, battercakes, hotcakes, and flannel cakes. These ingredients include sour cream, which is swapped for sour milk or buttermilk in other versions of the recipe. It can also be made with or without eggs. This makes a delicious breakfast served with fresh berries and maple syrup. The recipe was handwritten in fine spidery script on a small recipe card, and Jackson was known to serve this with crispy bacon and maple syrup.

Serves 4

2 eggs, separated
1 cup sour cream
½ cup milk
2 cups all-purpose flour
1 tsp baking powder
½ tsp baking soda
½ tsp salt
2 Tbsp melted butter
crisp bacon and maple
 syrup, for serving
sliced banana and honey,
 for serving, if desired

- In a large bowl, whisk egg yolks, sour cream, and milk until smooth. In a separate bowl, sift together flour, baking powder, baking soda, and salt. Stir flour mixture into liquid mixture until blended.

- In a separate bowl, beat egg whites until stiff peaks form. Gently fold egg whites into the batter.

- Lightly brush griddle or fry pan with butter and heat pan on medium until hot but not smoking.

- Drop ¼ cup batter onto hot griddle, three to a batch. Cook until puffy and edges are dry. Flip with a spatula and continue cooking about 1-2 minutes.

- Serve with crispy bacon and maple syrup for a delicious brunch; for a sweeter version, serve with sliced banana and honey.

Sour Cream Griddle Cakes.

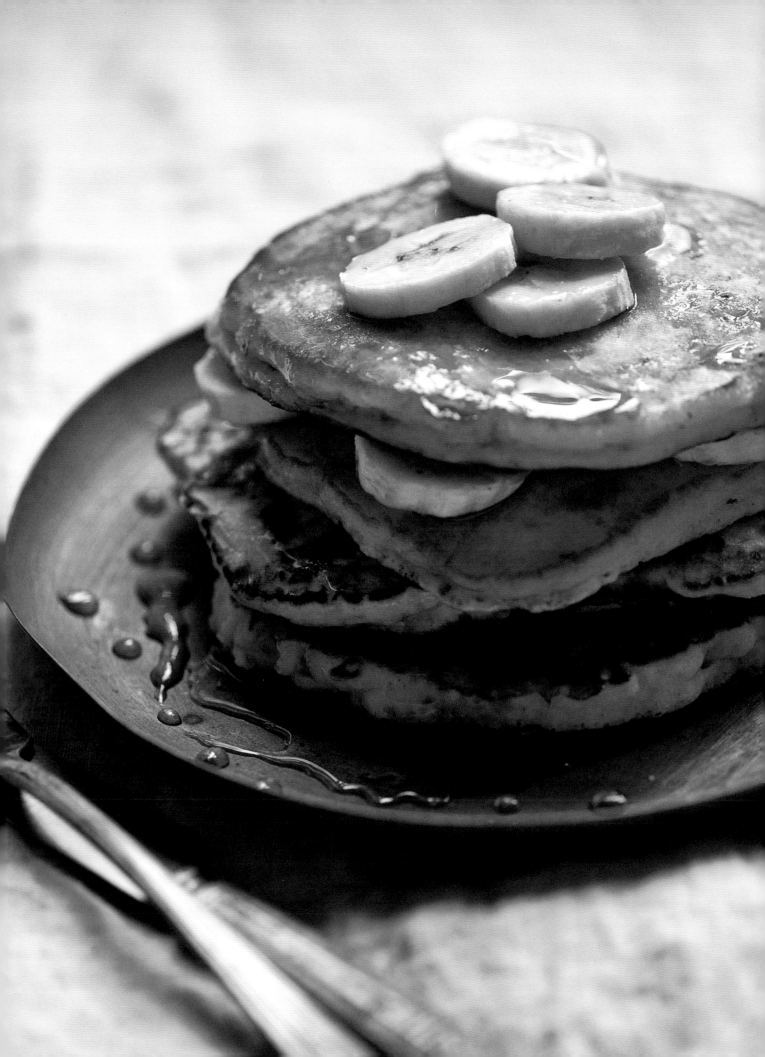

SOUTHERN-STYLE CORN BREAD

This handwritten recipe was given to Lee and Jackson by artists James ("Jim") and Charlotte Brooks, who loved to turn up for dinner parties equipped with cornbread ingredients in order to make, bake, and serve at their hosts' home. Lee and Jackson were regular visitors at Jim and Charlotte's in Montauk, which was set on the bluff at Rocky Point, with a separate studio they shared.

Various cornbread recipes have been handed down through the generations from the original Springs settlers, along with echoes of the British accents their forebears brought with them from Kent and Dorset. Lee and Jackson had several cornbread recipes in their collection, and Stella also had a newspaper cutting for a cornbread recipe by a Mrs. Rogers. The dish is versatile and can be served alongside traditional Southern soul-food recipes, then reheated in the morning as a sweet dish drizzled in warm milk and a sprinkling of sugar.

Serves 6

2 cups cornmeal

1 tsp baking soda

2 tsp baking powder

1 Tbsp sugar

1 tsp salt

2 eggs

4 Tbsp butter, melted

2 cups buttermilk

2 Tbsp butter, softened,
 for brushing top of bread

◐ Before starting, bring all ingredients to room temperature. Preheat a well-greased 12-inch round cast-iron fry pan in a 450°F oven until very hot.

◐ In a medium bowl, mix dry ingredients; add eggs, melted butter, and buttermilk, and mix. Pour batter into sizzling-hot fry pan. Turn oven down to 400°F and bake 20-30 minutes.

◐ Remove pan from oven, brush top of bread with softened butter, and serve while still hot, alongside the other dishes in your main meal.

VEGETABLES, SALADS & SIDES

BEET PICKLES

Creating pickles from an abundance of ripe garden-grown vegetables was a great way to maximize the use of available produce without waste. A rainbow assortment of beet colors was widely available in the market gardens around the South Fork of Long Island, as well as many home vegetable gardens. This recipe is based on one from the collection of Stella Pollock, who was inventive in her use of whatever seasonal produce was in abundance. It makes an excellent accompaniment to meat dishes and has a deep burgundy color that would have appealed to the artists in the family.

Yields 2-3 quart jars

1 lb beets

1 tsp coarse sea salt

1½ cups tarragon wine vinegar, or cider vinegar

1 large red onion, peeled and cut in thin rounds

1 lb cabbage, trimmed and roughly chopped

½ cup fresh horseradish, peeled and thinly sliced (optional)

2 cups sugar

1 Tbsp sea salt

1 tsp peppercorns

1 tsp mustard seeds

2 Tbsp pickling spice

1 bay leaf

○ Sterilize the glass jars and lids.

○ Wash and scrub beets thoroughly. In a large saucepan, place beets whole, cover with cold water, and add salt. Cook until tender, then drain through a fine sieve, reserving beet liquid. Place beets in a bowl of ice water to cool. When cool, trim off roots and stems, remove skins, and slice thinly.

○ In a medium saucepan, combine 1½ cups reserved beet liquid with all remaining ingredients, except the sliced beets. If preferred, peppercorns, mustard seeds, pickling spice, and bay leaf may be placed in a spice bag and added to the pot. Bring to a boil, reduce heat, and simmer gently for 15 minutes. Remove spice bag, if used.

○ In sterilized glass jars, layer sliced beets with onion-cabbage brine, lid tightly, and refrigerate for at least 1 week. After opening, store beet pickles in the refrigerator and consume within 1 month.

○ Serve pickles alongside red meat or venison, or in a sandwich of crusty buttered bread with aged cheddar.

Beet Pickles.
Previous pages: Wild leeks.

ELAINE DE KOONING'S BREAKFAST FRUIT & GRAIN SALAD

In 1948 Jackson and Lee invited fellow artists Elaine and Willem de Kooning to join them for a weekend at their home in Springs. Like Pollock and Krasner, the de Koonings had a deep respect for nature, sharing the view that it provided artists with an inner anchor and guide.

Both Lee and Elaine were stabilizing influences in their husbands' lives, though one major difference in their approach was that Elaine refused to play housewife, more interested in her own artwork. Possibly as a result, she preferred using fresh raw ingredients to provide quick and healthy meals.

Lee, on the other hand, labored to produce elaborate meals and used the dinner party setting to further Jackson's career. Elaine recalled in an interview with Jeffery Potter, "Her ambition seemed to be for Jackson, all of her manipulation socially, 'cause that's what Lee did, with the dealers and so on, invite people to dinners, she was very conscious of that kind of thing."[1] Over time relations between the two couples cooled and Lee began to describe them privately to friends as "The Academy," with its negative connotations of outdated ideas. Mutual friend Cile Downs remembers the rift between the two couples as coming from the two women, who were "like tigers, and their husbands were very tame and docile."[2]

This recipe was first reproduced in *Palette to Palate: The Hamptons Artists Cookbook,* by Jean Kemper Hoffmann, published by Guild Hall in East Hampton, and it makes a beautiful breakfast on a Long Island summer's morning.

Foraged wild strawberries. *Opposite:* Elaine de Kooning's Fruit & Grain Salad.

[1] Interview with Elaine de Kooning conducted by Jeffrey Potter, 1980, from the Jeffrey Potter audiotapes in the Oral History Collection, Pollock-Krasner House and Study Center, East Hampton, New York.
[2] Interview with Francile Downs conducted by Robyn Lea, April 3, 2014.

Serves 6

¼ cup fresh ginger, peeled and
thinly sliced

¼ cup dried coconut shavings

1 handful mint, washed and
finely chopped

½ cup orange juice

¼ cup lime or grapefruit juice

3 cups mixed seasonal fruit,
washed and cut into
small pieces, such as
apples, strawberries,
peaches, pears, figs, plums,
prunes, apricots, grapes,
blueberries, raspberries,
or pomegranate seeds

2 Tbsp whole wheat flakes

2 Tbsp whole oat flakes

2 Tbsp millet flakes

2 Tbsp bran flakes

2 Tbsp wheat germ,
toasted or raw

1 cup cottage or ricotta cheese

½ cup thick natural yogurt

2 Tbsp each walnuts and
almonds, chopped,
for garnish

Edible flowers, for garnish,
if desired

○ Marinate ginger, coconut, and mint in citrus juices for at least 1 hour. Meanwhile, prepare fruit of choice and place in a bowl. Remove ginger from citrus marinade and pour over fruit; marinate about 1 hour. In a separate bowl, combine grains with cheese and yogurt.

○ To serve, gently stir the juice and fruit, taking care not to bruise the softer fruit. Top fruit with grain mixture and sprinkle with chopped nuts. Garnish with edible flowers, if desired.

JACKSON AND LEE'S SPRINGS PROPERTY HAD AMPLE SPACE FOR JACKSON TO FOLLOW IN THE FOOTSTEPS OF HIS FATHER AND BOTH HIS PATERNAL AND MATERNAL GRANDFATHERS, AND PLANT A GARDEN OF VEGETABLES AND FRUIT.

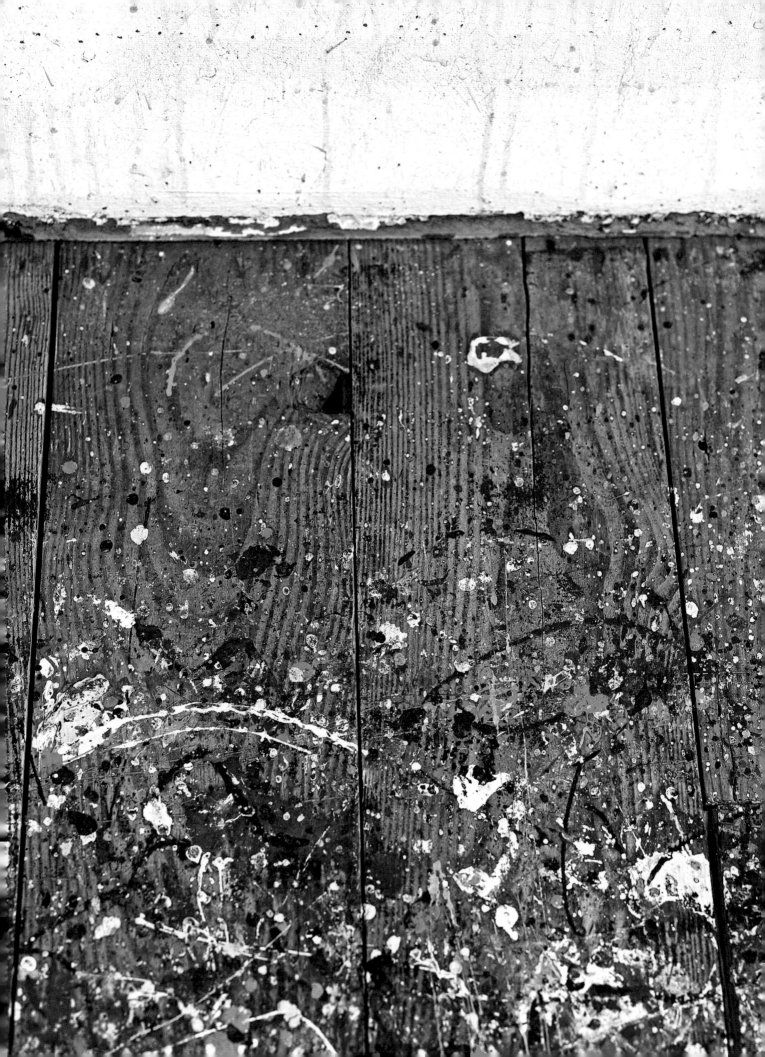

PEA SALAD WITH RUSSIAN DRESSING

This fresh, crunchy salad came from a Pollock family recipe in Stella's collection, which she kept in a red faux-leather book. Alongside her many handwritten recipes she pinned clippings and cuttings from newspapers and magazines.

Fresh peas are the ideal basis for the dish, though Stella may have used canned peas when they were not in season. Frozen baby peas, quickly blanched, can be used if fresh ones are not available. The tartness of the pickles and cabbage balance the cheese and rich mayonnaise-based dressing.

Serves 2–4

FOR THE SALAD

2 cups fresh baby spring peas,
 shelled

½ cup American cheese,
 cut into small chunks

3 tsp onion, finely chopped

3 tsp sweet pickles, such as bread-
 and-butter, finely chopped

8 pecans

2 cups shredded cabbage,
 if desired

FOR THE DRESSING

1 cup mayonnaise

4 Tbsp chili sauce

1 tsp fresh parsley,
 finely chopped

1 Tbsp red onion,
 very finely chopped

1 tsp Worcestershire sauce

2 dill pickles, chopped

salt and pepper

○ This salad may be combined all together in a large bowl before serving, or the elements layered individually onto the plates before adding small dollops of dressing. To make the dressing, combine all ingredients in a small bowl and season with salt and pepper to taste.

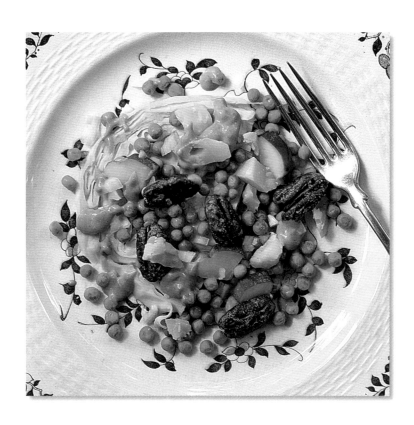

Pea Salad with Russian Dressing. *Opposite:* Studio floor detail.

Following pages, from left: Pigments, paints, and brushes in Jackson's studio; a cigar box of Jackson's paints.

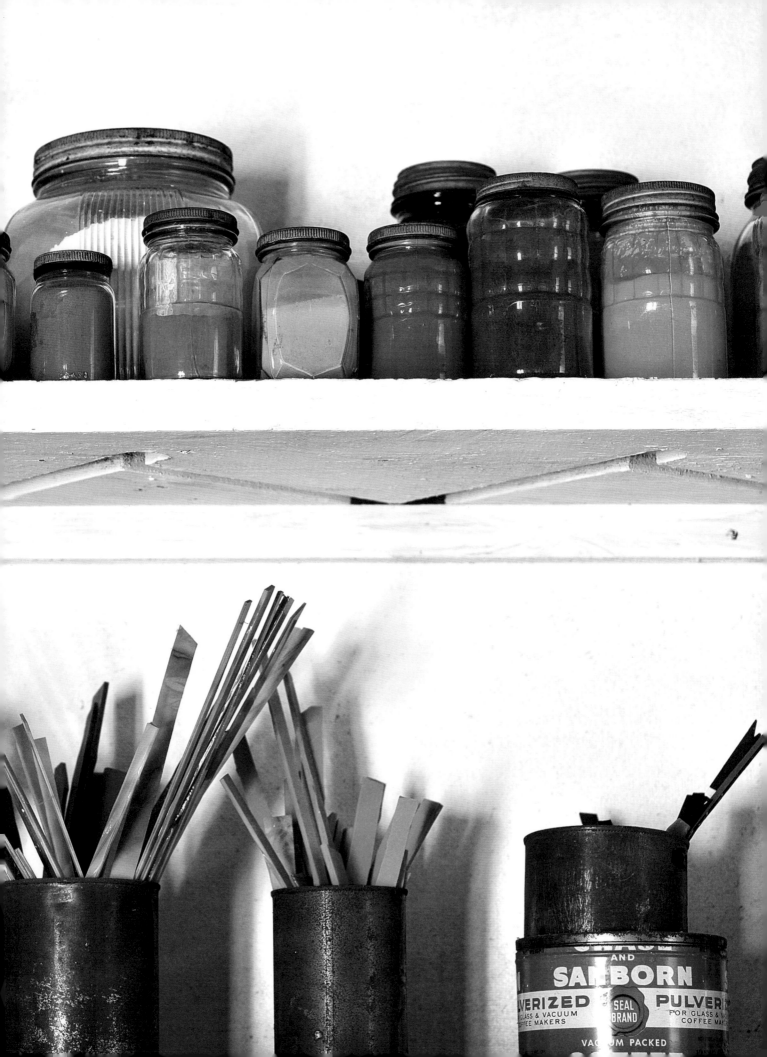

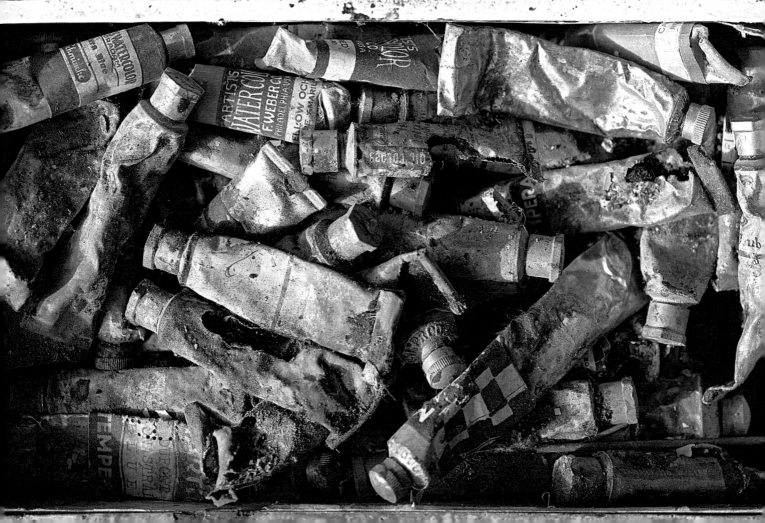

ROASTED ROOT VEGETABLES WITH WALNUT & MAPLE DRESSING

Jackson began treatment with Mark Grant in the 1950s in one of many attempts to cure his alcoholism. Grant's philosophy hinged on the idea that alcoholism was a result of chemical imbalances and could be cured with the proper diet. He introduced Jackson to a mainly vegetarian menu, thrice-daily doses of a soy emulsion he called "Proteen," to "be taken at room temperature or warmed in a double boiler," along with salt baths and mineral injections. Grant's detailed lists were kept among Lee and Jackson's recipe books and informed his patient that the emulsion "is a complete food… and therefore a substitute for poultry, fish, meat, egg white, milk, cheese, sugar, and starches."[1]

Suggestions for breakfast, lunch, and dinner included guidelines such as "Fruit should be used for breakfast—one kind only, vary each day," and lunch should be "confined to Raw Vegetable Salad—as liberal amount as can be consumed." Cooked vegetables were allowed for dinner, such as turnips, pumpkin, onion, beets, and squash. And certain varieties of nuts, such as walnuts, were allowed at any meal, "but must be masticated thoroughly."[2]

This recipe was developed from the diet's list of options available to Jackson for cooked vegetables. According to Grant's list, black molasses was allowed, but here it has been substituted for a "banned" ingredient: maple syrup.

Root vegetables ready for roasting.

[1] Nutritional diet plan titled "Proteen Diet," given to Jackson by his self-styled nutritionist, Mark Grant, in 1951. The date of the pamphlet is not specified. From the Research Collection at Pollock-Krasner House and Study Center, East Hampton, New York.
[2] Ibid.

Serves 6

FOR THE VEGETABLES

1 lb each baby beets, baby
 carrots, and baby parsnips,
 washed and peeled
4 Tbsp olive oil
salt and freshly ground
 black pepper
½ cup walnuts, toasted and
 roughly chopped,
 for garnish
½ bunch parsley, roughly
 chopped, for garnish

FOR THE DRESSING

½ cup sherry vinegar
2 Tbsp pure maple syrup
½ cup extra virgin olive oil
4 tsp shallot, minced
1 large pinch cayenne pepper
¼ tsp kosher salt

○ Preheat oven to 400°F. Wash and peel the vegetables. In a large bowl, coat vegetables with olive oil, salt, and pepper. Spread vegetables on a large baking paper–lined tray and place in the oven. After 20 minutes, turn the tray and roast another 20 minutes or until golden.

○ Meanwhile, in a lidded jar, combine all dressing ingredients and shake until blended and thick.

○ In a pan over low heat, toast the walnuts for five minutes, being careful not to burn them; when cool, roughly chop.

○ To serve, arrange vegetables on a platter, drizzle with half the dressing, and sprinkle with parsley and walnuts. Serve with remaining dressing.

Art tools, stored in the studio in old cigar boxes.

WILD FOREST GREENS WITH ANCHOVY FRENCH DRESSING

The Littles' new home, Duck Creek Farm, was repaired with Jackson's help and, when finished, John planted a magical kitchen garden complete with a fruit orchard. "He was a monster gardener,"[1] his daughter Abigail remembered. She was born in 1951 and was treated to lovingly prepared dishes with various ingredients only widely adopted in America decades later. "I grew up with arugula and mustard greens and gorgeous lettuces, basil pestos, and herbs of every sort. He planted fruit trees—pear, peach, and apple—and put in four long rows of French wine grapes, which he tended assiduously."

This wonderful anchovy French dressing recipe was ticked by Lee or Jackson inside their Waring blender cooking brochure, which came with their purchase of the blender in the late 1940s. The ingredients create a perfect balance of tangy and smooth. To create the sort of salad Lee and Jackson would have enjoyed at the many meals they attended at the Littles' home, mustard greens would have been mixed with wild greens and fresh herbs, and tossed with this dressing.

Makes 1 cup

FOR THE DRESSING
¾ cup extra virgin olive oil
¼ cup red wine vinegar
1 Tbsp lemon juice
6 anchovy fillets
½ cup chives, finely chopped
½ cup fresh flat-leaf parsley
1 tsp fresh thyme leaves
salt and freshly ground black
　　pepper

FOR THE SALAD
Mixture of fresh baby lettuces,
　　mustard greens, wild
　　greens, micro-greens, and
　　fresh herbs.

○ For the salad, select a blend of fresh baby lettuces such as mustard greens, wild greens, and a combination of micro-greens and fresh herbs. Wash and dry lettuces, greens, and herbs, tearing larger leaves into bite-size pieces if necessary.

○ In a blender, combine all dressing ingredients and process until contents are smooth and emulsified, about 30 seconds. The dressing should be a lovely bright green color and may be kept in the refrigerator for up to five days.

[1] Interview with Abigail Tooker conducted by Robyn Lea, April 15, 2014, and subsequent letters and documents provided to Robyn Lea by Abigail Tooker.

Fresh herbs and wild forest greens.
Following pages: Jackson's studio at dusk on a winter evening.

DESSERTS & SWEETS

BANANA CREAM CAKE

Stella came to visit Jackson and Lee's new home in Springs in January 1946. In preparation for her arrival, Jackson spun into a frenzy of food preparation. According to his friend and confidant, Roger Wilcox, Jackson spent a whole day baking bread and cakes, apparently in a bid to impress his mother. This handwritten recipe from Lee and Jackson's collection might have reminded Jackson of his early childhood. Sometimes when Jackson was assigned to the care of his brother Sande, the brothers would visit nearby Phelan Ranch, where the Chinese cook would offer them a slice of banana cream cake if their young faces appeared at the kitchen door.

Serves 8–10

FOR THE CAKE

½ cup butter, softened

1 cup sugar

1 tsp vanilla extract

2 eggs

1 cup ripe bananas, mashed

⅓ cup sour cream

1 tsp lemon juice

2 cups all-purpose flour

1 Tbsp baking powder

¼ tsp baking soda

½ tsp salt

¾ cup pecans or walnuts, chopped

FOR THE FROSTING

½ cup butter, softened

8 oz cream cheese, softened

1 tsp vanilla

3½ cups powdered confectioners sugar, sifted

¼ cup pecans or walnuts, roughly chopped, for garnish

- Preheat oven to 360°F. Grease a rectangular 9 x 5-inch bread tin and line the base with greased baking paper. In a large bowl, cream together the butter, sugar, and vanilla until light and fluffy, then add eggs one at a time. Beat until thoroughly combined. In a separate bowl, mix together the banana, sour cream, and lemon juice. In another bowl, sift together the flour, baking powder, baking soda, and salt. Add half the banana mixture to the egg mixture, followed by half the flour mixture. Fold until well combined, then repeat with the remaining ingredients. Lastly, fold in the chopped nuts. Pour batter into prepared pan and smooth with a spatula. Bake about 1 hour. Allow to cool in tin for a few minutes before turning onto a wire rack. When cake has cooled completely, spread with frosting.

- To make the frosting: Cream together the butter, cream cheese, and vanilla until smooth. Add powdered sugar half a cup at a time and beat with an electric mixer on low speed until combined. When all powdered sugar is added, beat on high speed until frosting is smooth. Spread on cooled cake.

- Sprinkle chopped pecans or walnuts on top of frosted cake, if desired.

Banana Cream Cake. *Opposite:* Layers of sand and snow at Louse Point in winter.

BLUEBERRY BLINTZES

This recipe was scrawled in red pencil by Lee on both sides of a used envelope addressed to "Mr. Lee Krassner," dated November 27, 1944, just a year before she moved to Springs with Jackson. Blintzes are a type of unleavened pancake, similar in style to a crepe, and were introduced to North America by immigrant Jews from Russia and Eastern Europe. Blintzes were typically stuffed with cheese and shallow-fried in oil for traditional Jewish holidays such as Shavuot (Day of the First Fruits) and Hanukkah (Festival of Lights), occasions in which Lee would have participated when growing up in her Orthodox Jewish family in Brooklyn.

Serves 6

FOR THE CREPES

1½ cups all-purpose flour

1 Tbsp sugar

½ tsp baking powder

½ tsp salt

2 cups milk

2 eggs

½ tsp vanilla

butter, as needed,
 for cooking crepes and for
 pan-frying blintzes

FOR THE FILLING

1 cup cottage cheese

8 oz cream cheese

¼ cup sugar

1 egg

2 tsp lemon juice

2 tsp all-purpose flour, sifted

1 tsp vanilla

1 pinch salt

FOR THE SAUCE

2 cups blueberries

1/3 cup water

2/3 cup sugar

1 Tbsp lemon juice

○ To make the crepes: In a medium bowl, combine flour, sugar, baking powder, and salt. Stir in milk, eggs, and vanilla; beat until smooth. In a fry pan, over medium heat, melt 2 Tbsp butter until bubbly. Pour ¼ cup batter into pan, tilting pan until batter covers the bottom. Cook until edges curl up slightly, then turn and brown lightly. Remove crepe to serving dish. Repeat with remaining batter, adding more butter to the pan as needed.

○ To make the cheese filling: In a small bowl, whisk together all ingredients until smooth and creamy.

○ To make the blueberry sauce: In a medium saucepan, place blueberries, water, and sugar and bring to a simmer for 5 minutes until syrup thickens slightly; add lemon juice. Allow to cool a little before serving.

○ To assemble the blintzes: Lay a crepe on counter or board; place about 3 Tbsp cheese filling across width of lower third of crepe. Fold lower third of crepe over filling, fold in the sides, and roll firmly. Repeat with remaining crepes and cheese mixture.

○ In a fry pan, over medium heat, melt 2 Tbsp butter until bubbly. Working in batches, place a few blintzes in the pan seam-side down to brown. Turn once. Remove cooked blintzes to a serving dish, and repeat with remaining blintzes, adding more butter to the pan as needed for each batch.

○ Serve with warm blueberry sauce.

Blueberry Blintzes.
Following pages: Original recipe for blintzes in Lee's handwriting on an envelope incorrectly addressed to her as "Mr. Lee Krassner" in 1944.

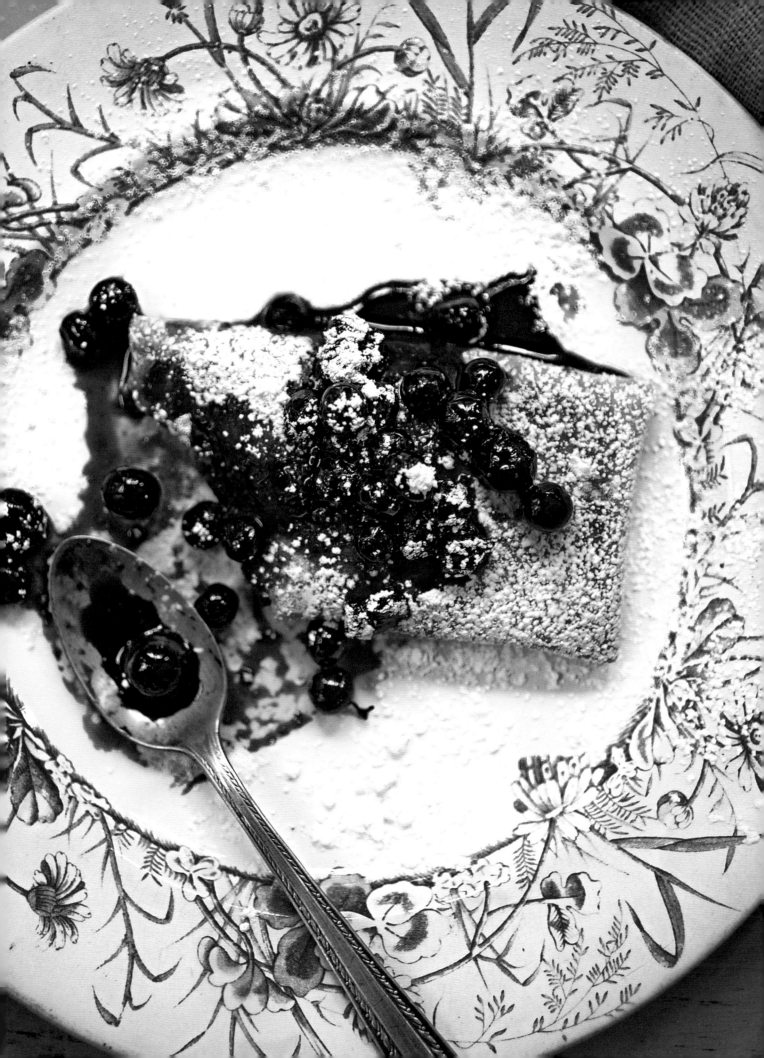

Mr. Lee Krassner
46 East 8th Street
New York, N. Y.

BRANDIED PEACHES WITH SOFT CUSTARD

Peaches soaking in brandy syrup.

Fruit and nuts were essential ingredients for Jackson's mother, Stella, who used them in many favorite family recipes. On their eighteen-acre ranch in Chico, California, where they moved when Jackson was five years old, they had almond, apricot, and peach trees. When there was an oversupply, Stella would create delicious preserves, jams, and jellies, or jars of poached fruit. Other times she would dry fruit in the local town, which had a community fruit-drying center.

On one of the recipes in Lee and Jackson's collection, Lee makes the suggestion of serving brandied peaches with cream. This recipe is equally delicious served with this soft custard recipe, or with French Cream.

"I WAS OVERPOWERED BY STELLA'S COOKING. I HAD NEVER SEEN SUCH A SPREAD AS SHE PUT ON. SHE HAD COOKED ALL THE DINNER, BAKED THE BREAD. THE ABUNDANCE OF IT WAS FABULOUS."

Lee Krasner[1]

[1] "Who Was Jackson Pollock?" by Francine du Plessix and Cleve Gray, *Art in America*, May–June 1967, pp. 33–34.

Yields 3 quart jars

FOR THE PEACHES

6 lb small to medium-size
 ripe peaches

3 cups water

4 cups sugar

4 cups brandy

FOR THE CUSTARD

1½ cups milk

2 eggs

3 Tbsp sugar

½ tsp salt

½ tsp vanilla extract

○ Sterilize glass jars and lids.

○ Bring a large pot of water to the boil. With a sharp knife, cut a shallow X into the bottom of each peach. Add the peaches to the boiling water one at a time and cook just until the skins loosen, 30 seconds to 1 minute. Plunge blanched peaches into ice water, peel off skins, and set aside on a large baking tray.

○ In a large saucepan, combine water and sugar and bring to a boil over high heat, stirring to dissolve. Boil the syrup until slightly reduced, about 5 minutes. Add peaches to the syrup and simmer until al dente. Remove peaches and place them in the sterilized jars. Add brandy to the syrup, bring to a boil, and reduce until thickened slightly.

○ Ladle hot brandy syrup over the jarred peaches, ensuring the fruit is covered by the liquid. Seal the jars and let cool to room temperature, then refrigerate. Unopened jars of Brandied Peaches can be stored in the refrigerator for up to 1 month.

○ When ready to serve, open a jar of Brandied Peaches, pour contents into a saucepan, and warm through over low to medium heat.

○ To make the custard: Scald milk in the top pan of a double boiler (or in a bowl over a saucepan of simmering water); let cool slightly. In a small bowl, whisk eggs lightly; add sugar and salt. Pour hot milk into the egg mixture slowly, stirring constantly; transfer mixture back to the double boiler. Cook, stirring constantly with a wooden spoon, until mixture thickens and coats the spoon. Remove from heat and set pan in cold water bath to cool quickly. When cool, stir in vanilla.

○ To serve, spoon a small pool of custard in the center of a shallow dessert bowl, place a whole brandied peach on top, and drizzle with brandy syrup.

CHOCOLATE COCONUT BLANCMANGE

This recipe came from a newspaper clipping that was saved with Lee and Jackson's recipe books and handwritten recipes. The ingredients reflect quite a departure from the traditional European version of blancmange, which had neither coconut nor cornstarch, but instead was made with a base of almond paste to which water, milk, and gelatin were added. In France they would also sometimes add other ingredients such as rum, Maraschino liqueur, pistachio, coffee, or even fresh strawberries. Perhaps inspired by the lavish and often French-inspired meals served at Alfonso and Ted's home nearby, Lee and Jackson had various dinner party–style recipes from magazines and newspapers, and this recipe would have provided a fancy dessert, served in Lee's cut-glass bowls and glasses with their polished silver spoons.

Serves 6

1¾ cups milk,
 plus ¼ cup cold milk
3 Tbsp cornstarch
¼ cup sugar
2 Tbsp cocoa powder
 (or 1 square good-quality
 chocolate, chopped in
 small pieces for melting)
¼ tsp salt
2 eggs, separated, yolks well
 beaten
½ cup shredded coconut
1 tsp vanilla extract
whipped cream and shaved
 chocolate, for serving

○ In a small saucepan, scald 1¾ cups milk and set aside. If using chocolate pieces, add them to the scalded milk to melt.

○ In another saucepan, combine cornstarch, sugar, cocoa powder (if using), salt, and ¼ cup cold milk. Add scalded milk (with melted chocolate, if using) to cornstarch mixture. Cook until mixture thickens, stirring constantly. Remove from heat and allow to cool slightly; mix in well-beaten egg yolks, coconut, and vanilla and transfer mixture to a medium-size mixing bowl. Place a piece of plastic wrap directly onto the surface of the custard to prevent a skin from forming. Allow to cool.

○ Just before ready to serve, beat egg whites to form stiff peaks. Fold half the egg whites into the custard and stir until well combined and there are no white streaks. Repeat with the remaining egg whites.

○ To serve, spoon blancmange into small glass dessert bowls or broad, shallow goblets and top with dollops of whipped cream and shaved chocolate.

Chocolate Coconut Blancmange.
Opposite: Detail from Lee and Jackson's original kitchen, Springs.

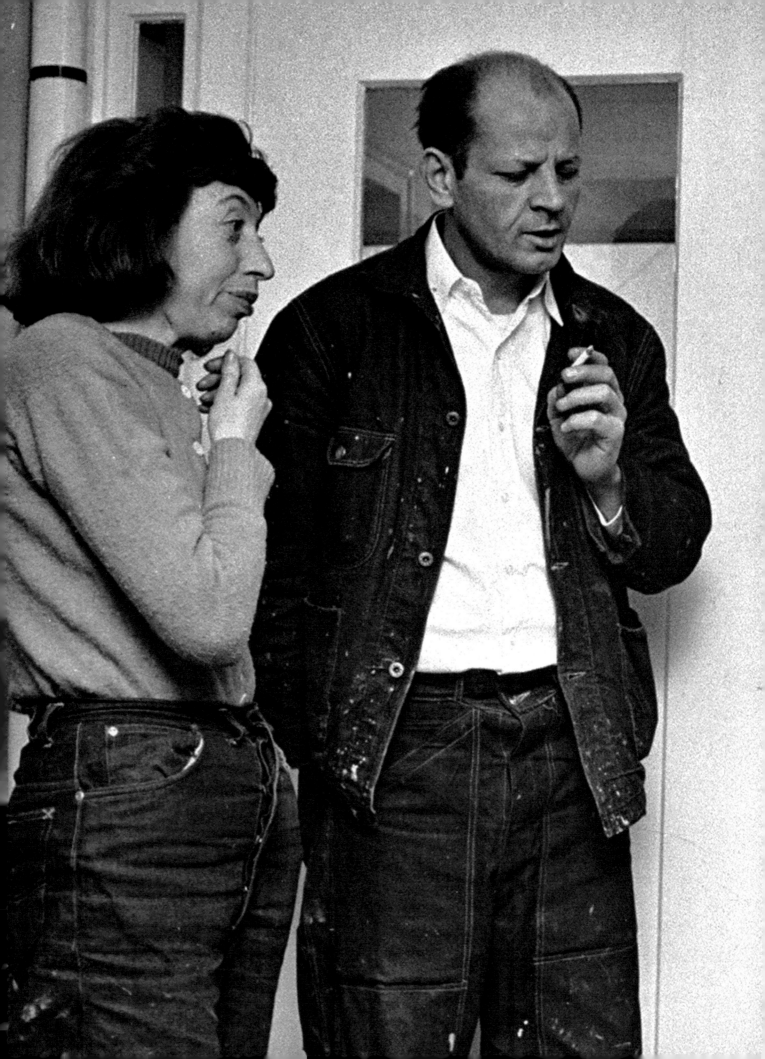

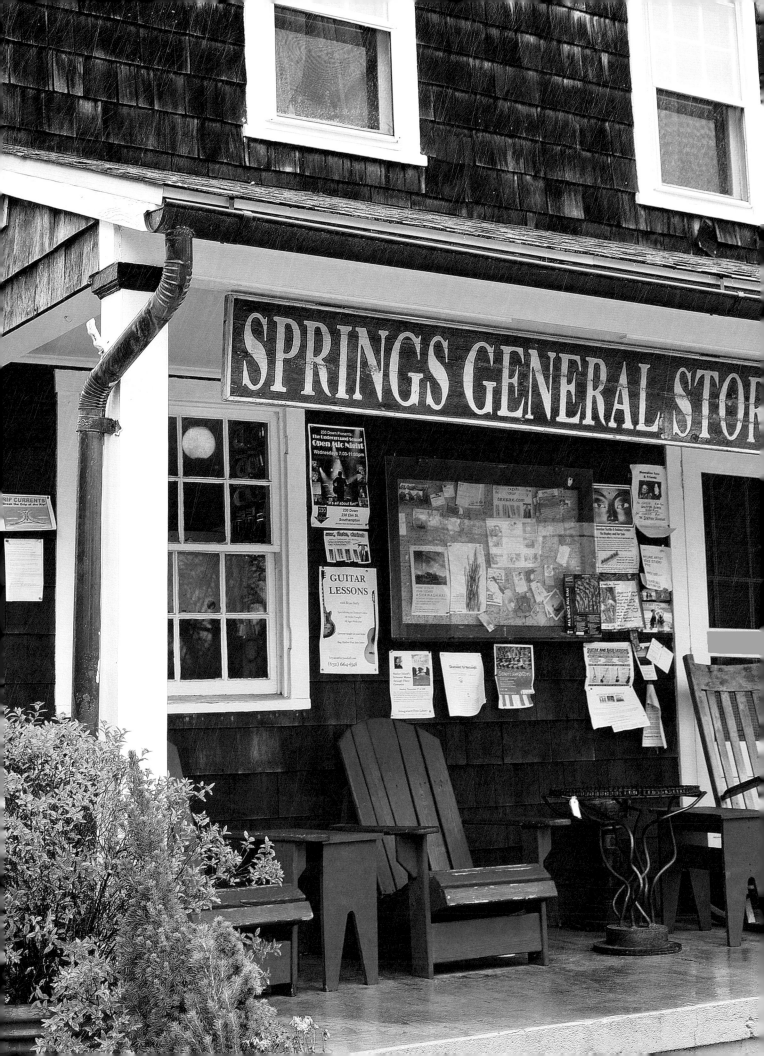

CODY COOKIES

These frosted cookies, which Stella titled "Cody Cookies," were presumably named after Jackson's birthplace of Cody, Wyoming. Jackson's parents, Stella and LeRoy, lived there from 1904 to 1913 and all five of their boys were born there. Cody is a small town framed by Rattlesnake Mountain, which heralds the entrance to nearby Yellowstone National Park. Cody was an important feature in Jackson's descriptions of his boyhood history, though he lived there only as an infant before his parents bought a ranch and moved the family to Phoenix, Arizona.

This recipe is essentially an old world–style molasses cookie, and the meringue on top gives it an interesting twist. The meringue can be lightly brûléed and the overall final effect is that of snow-capped peaks, miniature versions of the Rocky Mountains near Cody.

Makes 30–35 cookies

FOR THE COOKIES

½ cup butter

½ cup sugar

2 eggs

¾ cup molasses

½ cup boiling water

½ Tbsp baking soda

½ Tbsp cinnamon

4 cups all-purpose flour,
 more or less, enough to
 make a stiff cookie dough

*FOR THE MERINGUE
 FROSTING*

3 egg whites

1½ cups sugar

- Preheat oven to 325°F. Cream together the butter and sugar, then add eggs, molasses, and boiling water. When mixed, stir in all dry ingredients. Drop spoonfuls of dough onto a lined baking tray and bake 8-10 minutes or until risen and lightly browned. Allow to cool on a wire baking rack.

- To make the frosting: Beat egg whites to form soft peaks. Beat in sugar a little at a time and continue to mix until the grain of the sugar can no longer be felt and stiff peaks form.

- Top cookies with a dollop of meringue and place for a few minutes under a 300°F broiler, or use a small kitchen blow torch, to brown the white peaks slightly.

- Serve cookies with a big glass of cold milk, or with hot coffee or tea.

Cody Cookies. *Opposite:* Detail of a paint tube box in the studio.
Previous pages, from left: Jackson and Lee at the local general store in Springs, New York, April 1949;
Springs General Store, where Jackson once paid a grocery bill with a painting.

FRANCILE'S COOKIES

Francile Downs and her former husband, the late Sheridan Lord, moved to Springs in the early 1950s on the encouragement of their friends the writers Peter Matthiessen and Patsy Southgate. Sheridan was a painter and Cile a stencil artist, whose business partner, Adele Bishop, was married to painter Nicolas Carone, who also lived in the area.

Along with her sharp intellect, Cile's warm Southern nature and natural charm and wit made her the perfect hostess. She loved cooking Southern-style food, and also cookies and desserts, and for this cookie recipe she would use pecans that her Texas-based parents would send her in big bags. She hosted large dinner parties and was often called upon by Lee to help with hers. "Lee liked having a daughter-type around."[1] After Cile and Sheridan were introduced to Lee and Jackson they developed a close and trusting relationship that entailed numerous shared meals and recipes, plus help and support in difficult times. The couples shared a passion for nature, their vegetable gardens, food, and art.

Cile's cookies have a timeless appeal, like Cile herself, who has the elegance and charm of a bygone era.

Makes 32 cookies

¼ lb butter, softened

1 cup brown sugar, firmly packed

1 egg

2 cups all-purpose flour, sifted

1 pinch salt

1 tsp vanilla extract

1 cup pecans or walnuts, ground

◦ Cream together the butter and brown sugar until light and fluffy, then beat in the egg. Add flour and salt, then mix in vanilla and ground nuts.

◦ Shape dough into a log and roll up in wax paper; freeze roll until hard.

◦ Preheat oven to 380°F. Remove wax paper from roll. Using a very sharp knife, slice dough very thinly and arrange on a lightly greased baking sheet.

◦ Bake 10-15 minutes or until golden brown. Cool on a wire baking rack.

Jackson's studio floor, detail.

[1] Interview with Francile Downs conducted by Robyn Lea, November 21, 2013.

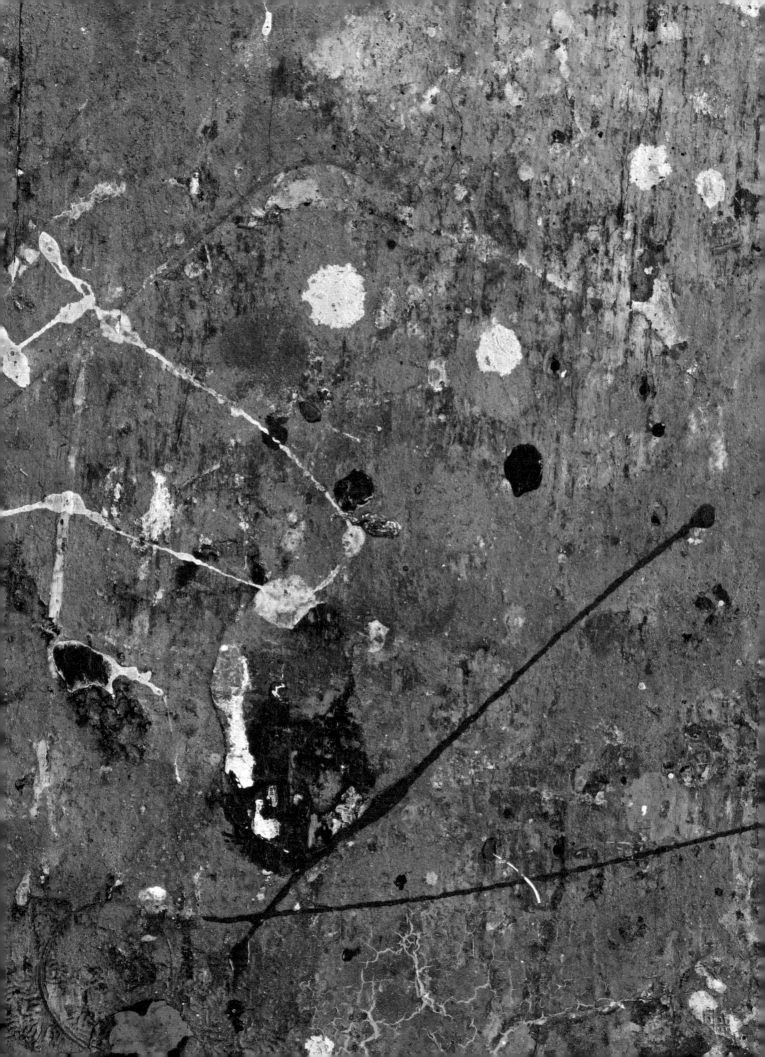

GOLD CAKE

Another cake from Stella's collection, the Gold Cake was found among the well-populated dessert recipes that she collected in her personal recipe book. Stella had almost 100 recipes for cakes, puddings, candy, frosting, sweet sauces, creams, pies, tortes, and cookies, and she was known for using large quantities of butter and eggs even during wartime rationing. This classic, simple cake is perfect for an afternoon tea or coffee break, served warm from the oven with cream or ice cream.

Serves 6–8

2¾ cups all-purpose flour
2½ tsp baking powder
½ cup butter, at room
 temperature
1 cup sugar
¼ tsp salt
1 tsp vanilla extract
¾ cup sugar
1 cup milk
8 egg yolks, beaten
powdered confectioners
 sugar, for dusting
cream or ice cream,
 for serving

- Preheat oven to 350°F. In a bowl, sift together flour and baking powder. In another bowl, cream together butter and sugar, add salt and vanilla, stir in sugar, milk, and sifted flour mixture. In a separate small bowl, beat egg yolks until light; add eggs to creamed mixture and stir to combine.

- Pour batter into greased 9-inch cake tin and bake about 40 minutes; check doneness with a wooden skewer in the center of the cake. If skewer comes out clean, the cake is done; if not, bake another 5-10 minutes. Allow cake to cool in the baking tin 5 minutes before turning onto a wire baking rack.

- While cake is still warm, dust with powdered sugar and serve with cream or vanilla ice cream or sprinkle with fresh berries and a drizzle of sweet creamy sauce.

" THOSE PIES! APPLE AND PUMPKIN AND MINCEMEAT, LEMON MERINGUE, BLUEBERRY AND PEACH COBBLER, ALL WITH CRUSTS AS LIGHT AS MILLE-FEUILLE THAT CRUMBLED THE INSTANT THE FORK TOUCHED THEM. "

Jeri Pollock-Leite, Stella's granddaughter [1]

Gold Cake. *Opposite:* Paintbrushes in the studio.

[1] E-mail interview with Jeri Pollock-Leite conducted by Robyn Lea, with responses received May 27, 2014.

JACKSON'S PRIZE-WINNING APPLE PIE

Jackson's apple pie was not only loved by his family and friends, it also became famous in the local community of Springs when it won first prize at the local Fisherman's Fair. Over the years, his pie's reputation grew and people would bid on it ahead of time, so that it was already sold well before delivery to Ashawagh Hall. The pie crust recipe is based on the original given by Stella to Jackson and Lee, written in the back of one of their recipe books. Inside the same historic book is the recipe for the pie filling, found on pages splattered with the evidence of busy preparation. For Jackson, apple pie was perhaps his signature dish and he proudly shared the method with interested friends. On one rainy Sunday afternoon Jackson went to friend Josephine Little's house nearby to teach her the recipe.

This dessert is delicious served with ice cream—vanilla or one of Lee's favorite flavors, rum raisin. Or perhaps homemade peach ice cream, a favorite of John and Josephine Little.

> **" OF COURSE, JACKSON WAS AWARE OF EUROPEAN ART, BUT WHAT HE IDENTIFIED WITH WAS ABOUT AS AMERICAN AS APPLE PIE. "**

Lee Krasner[1]

Jackson's Prize-Winning Apple Pie.

[1] "Jackson Pollock at Work: An Interview with Lee Krasner," by Barbara Rose, *Partisan Review*, vol. 47, no. 1, 1980.

FOR THE FILLING

4 lb granny smith apples,
 or any combination of
 tart apples
¼ cup water
1 cup sugar, or less if desired
1 tsp cinnamon
½ tsp nutmeg
1 tsp all-purpose flour, sifted

FOR THE PIE CRUST

2½ cups all-purpose flour
1 level tsp baking powder
1 level tsp salt
1½ cups cold butter
2 egg yolks,
 plus 1 whole egg for
 egg wash
½ cup cold milk,
 plus more as needed

○ To prepare the filling: Peel, core, and thinly slice apples. Stew apples in a pot with a little water to cover the fruit, plus the sugar and spices, until just cooked. Chill apples in a little of the juice. When cold, sift flour over the apples and stir gently to combine. Set aside.

○ Preheat oven to 450°F. To make the pie crust: Combine flour, baking powder, and salt. Add butter and cut in until mixture is crumbly. Add egg yolks and mix with enough milk to make a dough. Roll out dough lightly. Place the pastry in a greased 10-inch round pie dish, allowing pastry to overhang the edge of the pan by about 1 inch; trim away excess dough, roll it into a ball, and set aside to make the top crust. Be sure there are no cracks in the bottom crust; seal them by pressing edges together with fingers. Pour apple mixture into pie shell and distribute evenly.

○ For a simple top crust, roll out the remaining dough, slide the pastry sheet onto the rolling pin, and unroll it on top of the apple pie filling. Allow top crust to overhang the edge of the pan by about 1 inch; trim away excess dough, then pinch the top and bottom crusts together all around the rim to seal the pie. Prick the top crust with a fork in about a dozen places, or slice a few small openings with a knife, to allow steam to escape. Brush top pastry with egg wash and sprinkle lightly with a pinch or two of sugar.

○ For a more elaborate lattice-style top, roll out the remaining dough, cut into ½-inch strips, and weave strips across the top of the filling. Brush lattice strips with egg wash and lightly sprinkle with a pinch or two of sugar.

○ Place the pie in the center of oven and bake 10-15 minutes, then reduce oven to 325°F and bake 25-30 minutes more.

LEMON PUDDING

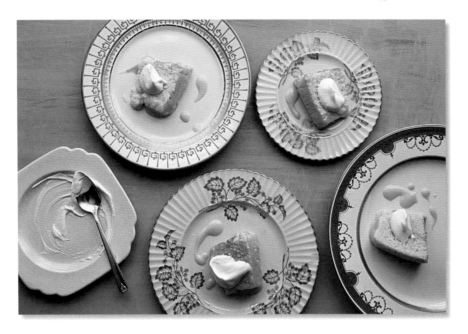

This classic lemon pudding recipe was most likely sourced by Lee around the same time that she collected many of Arloie Pollock's recipes, in the mid-1940s in New York City. It was scrawled inside a small spiral-bound notebook, with the page then carefully torn out and stored in the back of one of Lee and Jackson's recipe books. It can either be baked in a pudding dish or in individual ramekins and served with whipped cream or a generous scoop of vanilla ice cream. It has a self-saucing quality, and a sweet and tangy finish.

Serves 6

1 Tbsp butter

1 scant cup sugar

3 eggs, separated

1/3 cup all-purpose flour

juice of 1 lemon

1 cup milk

1 pinch salt

○ Preheat oven to 350°F. Grease a pudding dish or individual ramekins. In a bowl, cream together butter and sugar, add egg yolks and flour, then lemon juice, mixing well after each addition. Add milk slowly. In a separate bowl, beat egg whites and salt until stiff peaks form; fold into lemon mixture. Pour batter into pudding dish or spoon into ramekins and cover securely. Place dish or ramekins in a baking pan and add enough boiling water to come halfway up the side of the pudding vessel(s), being very careful not to get any water in the pudding. Bake 30-40 minutes or until the top of the pudding springs back when lightly pressed.

○ Serve warm with sauce from the pudding dish and whipped cream or ice cream.

Lemon Pudding.
Opposite: Original handwritten recipe for Lemon Pudding.

Lemon Pudding
3 egg yolks juice of
1 lemon, 1 scant cup
sugar creamed water
1 tables. butter juice
of salt ⅓ cup flour
cup milk
Beat eggs separ-
 ...y yolks juice
milk ...
...

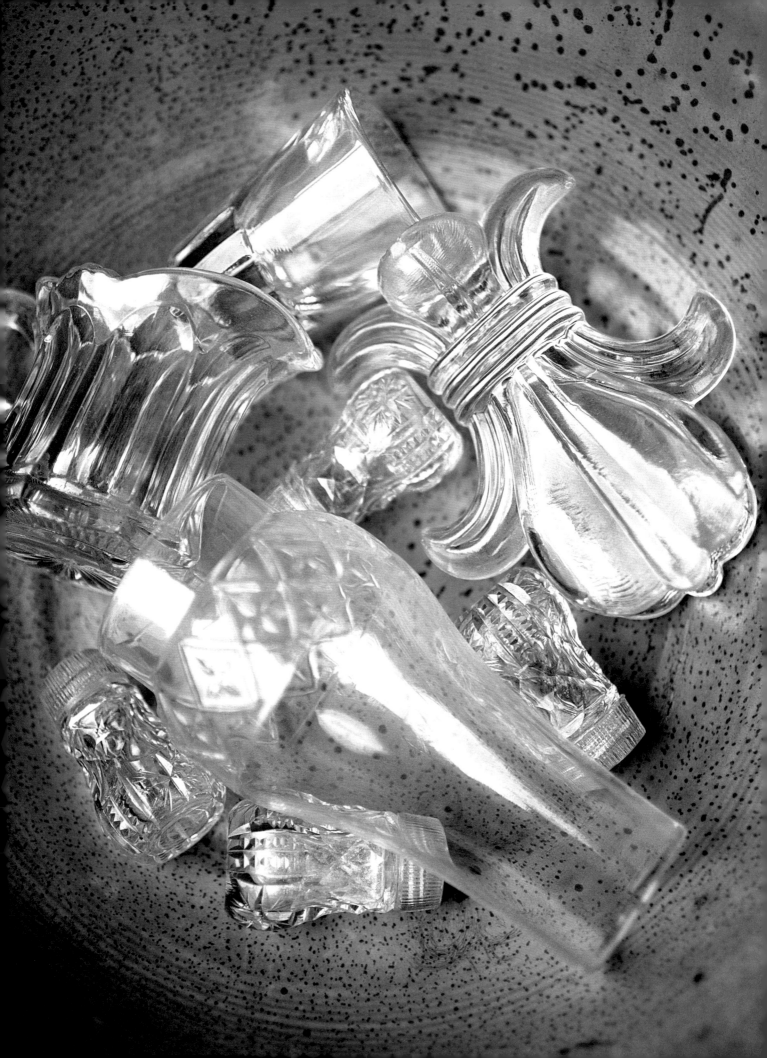

RASPBERRY-POACHED PEARS WITH BAVARIAN CREAM

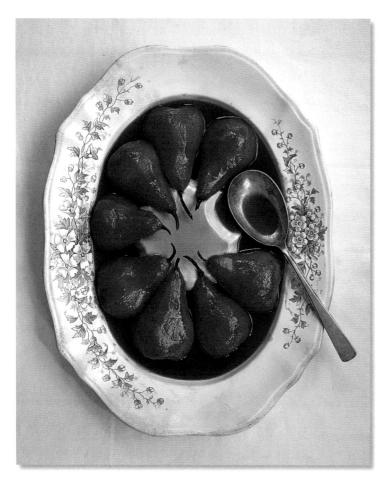

One of Lee's favorite dinner party dishes, this recipe is both beautiful and delicious. When inviting guests for dinner, Lee would often ask her friends to bring a dish, or invite them to come early to help with preparation. Instead of simply asking them to bring dessert or salad, Lee would sometimes provide this recipe, asking that it be followed using her preferred brands of ingredients. She would also give detailed presentation instructions before they brought it over.

It was in this fashion that Cile Downs learned Lee's recipe for Poached Pears in Raspberry Sauce. Cile was instructed to place a large mound of cream in the middle of a platter, around which raspberry-poached pear halves were to be leaned (they used canned pears, but fresh ones are better). The pears had been soaking in bright red raspberry sauce (also called Melba Sauce) and the contrast on the platter with the cream was precisely how the hostess liked it. The cream works well when it is set overnight, and can be either a traditional Bavarian Cream or French Cream.

Raspberry-Poached Pears with Bavarian Cream.
Previous pages, from left: Jackson and Lee's home in Springs; pieces from Lee's cut-glass collection.

Serves 8

FOR THE PEARS

10-12 oz raspberries

4 cups cold water

½ cup sugar

1 Tbsp fresh lemon juice

¼ cup apple juice

½ cup red currant jelly

6 Bosc pears,
 peeled and cored

FOR THE CREAM

1 vanilla bean
 or 1 tsp vanilla extract

1¼ cups heavy cream

2 Tbsp powdered gelatin

4 Tbsp milk

¼ cup sugar

5 egg yolks

1¼ cups whipping cream

○ To poach the pears: In a blender, puree raspberries, 2 cups water, sugar, and lemon juice; pass mixture through a fine sieve to remove seeds and pulp. Transfer mixture to a heavy-bottom saucepan, add remaining water, apple juice, and currant jelly. Place pears in the mixture and simmer, uncovered, about 40 minutes or until pears are soft. During cooking, turn pears periodically to ensure even coloring all around. Remove pan from heat, allow to cool, cover, and refrigerate overnight.

○ To make the Bavarian Cream: In a small saucepan over low heat, add split vanilla bean (or add vanilla extract, if preferred) to heavy cream, and bring to a boil. Remove from heat and let sit 1 hour. Extract the split bean and scrape out the seeds; add seeds to the hot cream and discard the pod.

○ In a small bowl, sprinkle powdered gelatin into 4 Tbsp milk, stir, and set aside. In a separate bowl, whisk together the sugar and egg yolks until pale and light.

○ Reheat cream mixture slightly until warm; whisk it slowly into the egg mixture. Place bowl containing cream and egg mixture over a separate saucepan of simmering water, like a bain marie or double boiler. Stir with a wooden spoon until mixture thickens. When mixture coats the back of the wooden spoon, remove bowl from atop the simmering water; add the gelatin mixture and stir. Set bowl in an ice-water bath and continue to stir while custard mixture cools to room temperature.

○ Whip cream to form soft peaks; fold into the cooled custard. Pour into lightly oiled mold of choice. Refrigerate until set, about 4-5 hours.

○ To serve, carefully unmold the Bavarian Cream onto the center of a platter. Slice poached pears in halves and arrange them around the cream; drizzle with remaining raspberry sauce.

RITA BENTON'S PECAN TORTE WITH MOCHA FROSTING

Pecans were a popular ingredient in many dinner party dishes among Lee and Jackson's circle. At one of Alfonso Ossorio and Ted Dragon's gatherings, pecan pie was preceded by turnip soup, American shad stuffed with shrimp, and served with asparagus in butter sauce and spinach.[1] Rita Benton's pecan torte was another magnificent dish, using pecans ground into flour, which imparts a wonderful texture to the cake. Covered with a rich mocha frosting, as per Rita's preference, and served with cream or ice cream, this recipe provides a decadent climax for a special party. This recipe comes from Rita and Thomas Hart Benton's private collection and was handwritten by Rita on a small piece of lined paper.[2]

Serves 6

FOR THE TORTE

6 eggs, separated,
 whites beaten to stiff peaks

1 cup confectioners sugar

1 cup pecans, chopped
 moderately fine, plus more
 for garnish

1½ cups pecans, finely ground
 into flour

½ lemon, juice and zest

2 Tbsp rum

FOR THE FROSTING

1½ cups butter, softened

6 Tbsp warm, strong coffee

2 tsp vanilla extract

1½ cups cocoa powder

6 cups confectioners sugar

2-4 Tbsp warm milk, as needed

- Preheat oven to 340°F. Beat egg yolks with powdered confectioners sugar until thick and creamy. Add chopped pecans, pecan flour, lemon juice, lemon zest, and rum, mixing well after each addition. Fold in the beaten egg whites. Divide batter between two 9-inch round baking pans and bake for 30 minutes. Rest cake pans on wire baking racks to cool completely before frosting.

- To make the frosting: In a large bowl, cream together the butter, coffee, and vanilla until smooth. In a separate large bowl, sift together the cocoa powder and powdered confectioners sugar, then slowly add to the creamed mixture. If required, slowly add a bit of warm milk to the frosting to achieve a workable consistency.

- When cakes are completely cooled, spread frosting between the layers then frost the top and sides of the cake. Garnish with additional crushed pecans, if desired.

Jackson and Lee's home under snow on a cold winter's morning.

[1] Alfonso Ossorio and Edward Dragon Young Papers (SC 15), file 982, Harvard Art Museums Archives, Harvard University, Cambridge, Massachusetts.
[2] Rita Benton's collection of recipes at the Thomas Hart Benton Home and Studio, Kansas City, Missouri, courtesy of Missouri State Parks.

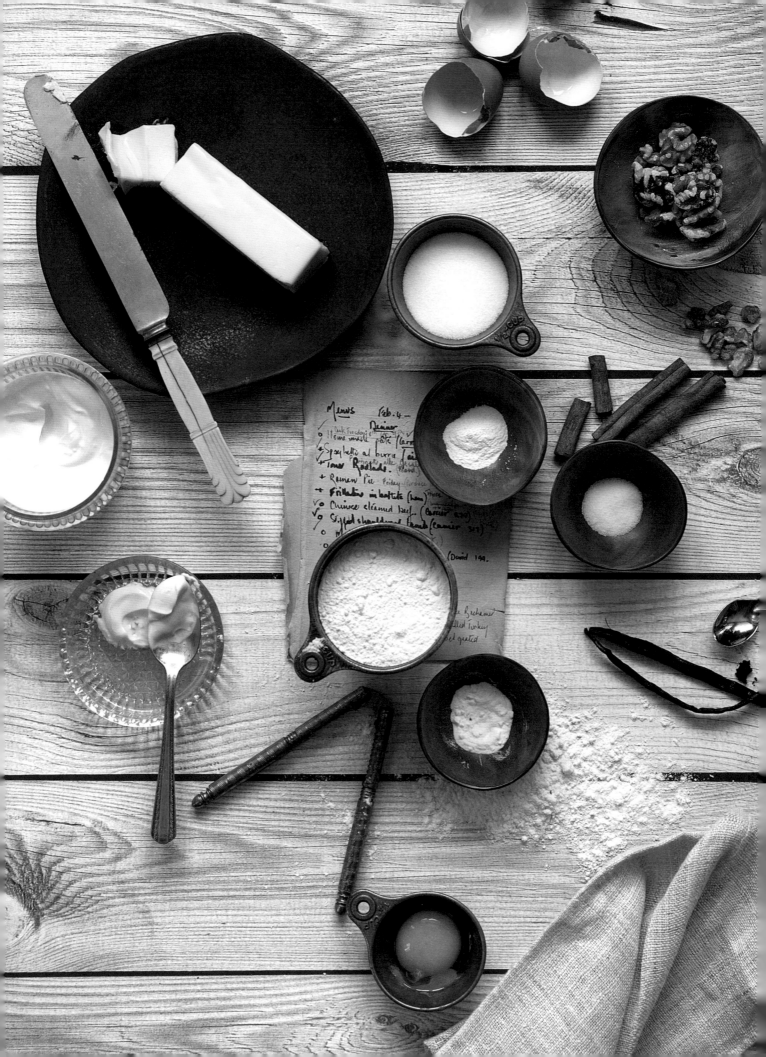

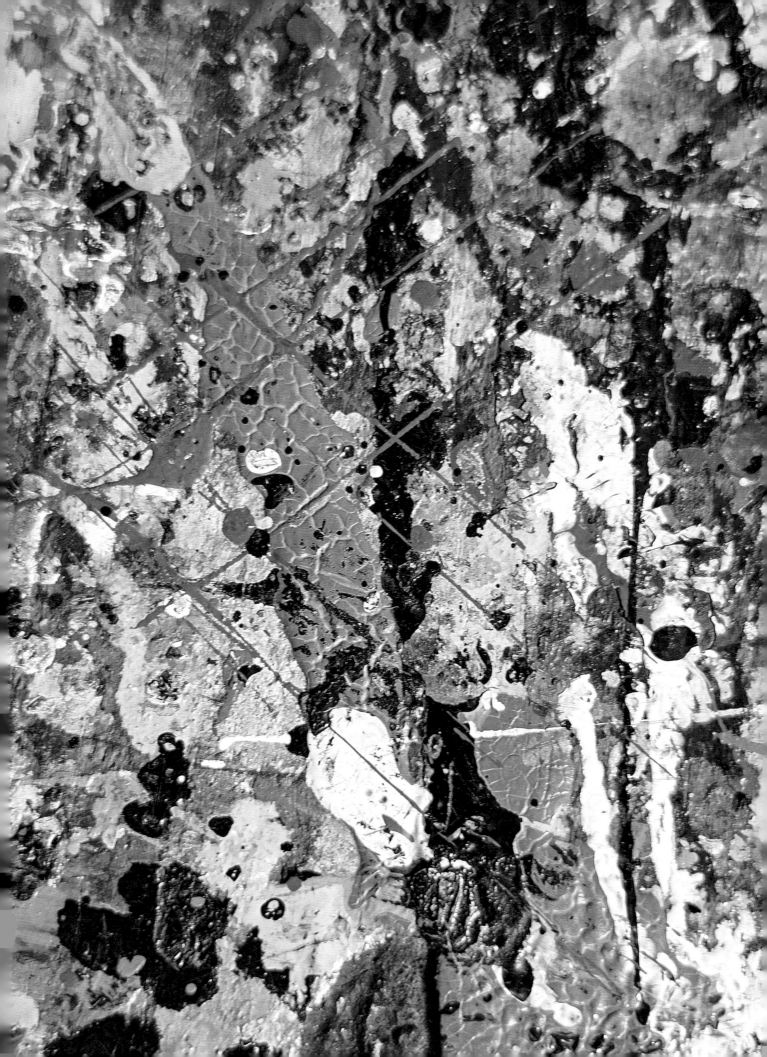

UPSIDE DOWN CHERRY CAKE

Cherry recipes were a favorite in the Pollock family, and Stella had multiple ways to use the wonderful fruit, including two versions of cherry pie, maraschino cherries, and this deep red Upside Down Cherry Cake. Remarkably easy to prepare, but with a stunning final effect, this cake provides an impressive grand finale to any dinner party.

Serves 6–8

FOR THE CHERRIES
2 cups unsweetened pitted
 cherries in syrup
 (canned or jarred,
 or use homemade)
½ cup sugar
1½ Tbsp cornstarch
¼ tsp salt

FOR THE BATTER
2 Tbsp butter
1 cup sugar
1 egg, beaten
1 tsp vanilla extract
2½ cups all-purpose flour
2 tsp baking powder
1 cup milk
¼ tsp salt

○ Preheat oven to 325°F. To make the cherry syrup: In a saucepan, drain juice from cherries and add enough water to make 1 cup of liquid; add sugar, cornstarch, and salt. Bring to a boil, stirring, to thicken the cornstarch and cook out its flavor.

○ Butter a 9-inch round cake pan and cover the bottom with a layer of cherries. Pour syrup over cherries.

○ To make the batter: In a large bowl, cream together the butter and sugar; add beaten egg and vanilla extract. Sift together the flour and baking powder into the creamed mixture, add milk and salt, and mix thoroughly. Pour batter over cherries and bake about 50 minutes.

○ Invert onto a platter and serve, either hot or cold, drizzled with cream.

Upside Down Cherry Cake. *Opposite:* Soaking cherries.
Previous pages, from left: Ingredients assembled for Rita Benton's Pecan Torte; detail of Jackson's studio floor.

"Yum Yum Cake"

1 cup sugar
1 " Buttermilk
1 cube Butter or 1/2 cup
2 scant cups flour
1 egg
1 cup rasins
3/4 " walnuts
1/2 teas B-P in flour
1 " " Soda in milk
1 " " clovs
1 " " nutmeg
1 1/2 " " cinnamon
pinch salt

YUM YUM CAKE

This cake was described by Stella in a note under the recipe as "Very Good,"[1] and knowing how her family enjoyed her desserts, the title seems fitting. Stella was described as having more cake recipes than days in the week, though her recipe book shows that her list of desserts would have ensured a new dessert every night for almost three entire months without repeating herself. Among the list are nineteen cake recipes, nine fruit pies, as well as cookies, cobblers, puddings, sundaes, and creams. Stella's granddaughter Jeri Pollock-Leite still remembers her sweets over fifty years after Stella's death: "…oh, god, those pies!! Apple and pumpkin and mincemeat, lemon meringue, blueberry and peach cobbler, all with crusts as light as mille-feuille that crumbled the instant the fork touched them."[2]

Serves 6–8

FOR THE CAKE
½ cup butter
1 cup sugar
1 egg
1 cup buttermilk
1 tsp baking soda, in buttermilk
2 scant cups all-purpose flour
½ tsp baking powder, in flour
1 cup raisins
¾ cup walnuts
1 tsp ground cloves
1 tsp ground nutmeg
1½ tsp cinnamon
1 pinch salt

FOR THE SAUCE
1 egg white
1 cup sugar
¼ tsp cream of tartar
½ cup boiling water
flavoring of choice,
 such as vanilla or rum

○ Preheat oven to 350°F. In a large bowl, cream together the butter and sugar; stir in the egg. Using a sturdy spoon or an electric mixer, mix in the buttermilk and baking soda mixture, alternating with the flour and baking powder mixture. Stir in the raisins, walnuts, cloves, nutmeg, cinnamon, and salt.

○ Pour batter into a greased 9 x 5-inch loaf pan or a rectangular baking tin. Lower oven temperature to 325°F, and bake 40 minutes, or until a wooden skewer inserted into the center of the cake comes out clean.

○ To make the sauce: Whisk together egg white, sugar, and cream of tartar. Add ½ cup boiling water and desired flavoring, such as ½ tsp vanilla extract or 1 Tbsp rum.

○ Serve cake with sauce or on its own with a light dusting of cinnamon. This is also lovely served warm with freshly whipped cream.

Stella's original handwritten recipe for Yum Yum Cake.

[1] Stella Pollock's original recipe book, courtesy of Jacqueline Pollock de Souza Costa, Sacramento, California, July 2014.
[2] E-mail interview with Jeri Pollock-Leite conducted by Robyn Lea, with responses received May 27, 2014.

BIBLIOGRAPHY

Alexander, Sarah. *Mr. & Mrs. Roto-Broil Cook Book*, rev. ed. Long Island City: Roto-Broil Corp. of America, 1955.

Allen, Ida Bailey. *The Budget Cook Book*. New York: The Best Foods, Inc., 1935.

Appelhof, Ruth. Personal interview conducted by Robyn Lea, October 15, 2014.

Ball Brothers Company. *The Ball Blue Book of Canning and Preserving Recipes.* Edition W. Muncie, Indiana: Ball Brothers Company, 1944.

Benton, Thomas Hart. *An Artist in America*, 4th rev. ed. Columbia: University of Missouri Press, 1983.

Charles Pollock papers, circa 1902–90. Archives of American Art, Smithsonian Institution.

Clement Greenberg papers, 1937–1983. Archives of American Art, Smithsonian Institution.

Downs, Francile. Personal interviews conducted by Robyn Lea at Francile's residence, East Hampton and by phone, 2013-2014.

Driftmier, Leanna Field, ed. *Field's Cook Book: Your KFNF Radio Cook Book "Best by Test."* Iowa: Henry Field Seed & Nursery Co., date not specified.

Ernst, Jimmy. *A Not-So-Still Life: A Child of Europe's Pre–World War II Art World and His Remarkable Homecoming to America.* New York: St. Martin's/Marek, 1984.

Farmer, Fannie Merritt. *The Boston Cooking-School Cook Book*, rev. ed. Boston: Little, Brown, and Company, 1923.

Fisher, M. F. K. *How to Cook a Wolf*, 1st ed. New York: Duell, Sloan and Pierce, 1942.

Friedman, B. H. *Jackson Pollock: Energy Made Visible.* New York: McGraw-Hill Book Company, 1972.

Grant, Mark. *Proteen Diet.* Unpublished typed diet prescribed to Jackson for the treatment of his alcoholism, and given to him by Grant in 1951. Sourced from the Research Collection at Pollock-Krasner House and Study Center, East Hampton.

Gruen, John. *The Party's Over Now: Reminiscences of the Fifties—New York's Artists, Writers, Musicians, and their Friends.* New York: The Viking Press, 1972.

Harrison, Helen, and Constance Ayers Denne. *Hamptons Bohemia: Two Centuries of Artists and Writers on the Beach.* San Francisco: Chronicle Books, 2002.

Harrison, Helen. Personal interviews conducted by Robyn Lea at the Pollock-Krasner House and Study Center, 2013–2014.

Hoffmann, Jean Kemper. *Palette to Palate: The Hamptons Artists Cookbook.* East Hampton: Guild Hall, 1978.

Jackson Pollock and Lee Krasner papers, circa 1914–84. Archives of American Art, Smithsonian Institution and online: http://www.aaa.si.edu/collections/jackson-pollock-and-lee-krasner-papers-8943.

Jason McCoy Gallery. Exhibition catalogue. *American Letters 1927-1947: Jackson Pollock & Family.* Edited by Stephen M. Cadwalader and Stephanie B. Simmons. New York: Mimesis Publishing, 2011.

Kiple, Kenneth F., and Kriemhild Coneè Ornelas, eds. *The Cambridge World History of Food.* Vol. 1., 2000. Reprint. Cambridge: Cambridge University Press, 2001.

Kiple, Kenneth F., and Kriemhild Coneè Ornelas, eds. *The Cambridge World History of Food.* Vol. 2., 2000. Reprint. Cambridge: Cambridge University Press, 2001.

Levin, Gail. *Lee Krasner: A Biography.* New York: William Morrow, 2011.

Lincoln, Mary J. *What to Have for Luncheon.* New York: Dodge Publishing Company, 1904.

MacPherson, John. *The Mystery Chef's Own Cook Book.* Philadelphia: The Blakiston Company, 1945.

McCormick Gallery. Exhibition catalogue. *Cascading Forms: The Art of John Little, 1940 to 1970.* Chicago: McCormick Gallery, 2008.

Michael Rosenfeld Gallery. Exhibition catalogue. *Alfonso Ossorio: The Creeks—Before, During and After. Watercolors 1932–34 & Photographs 1990.* Edited by Halley K. Harrisburg. New York: Michael Rosenfeld Gallery, 2000.

Miloradovich, Milo. *Hundreds of the Best Recipes from The Art of Fish Cookery.* New York: Doubleday & Company, Inc., 1963.

Montagné, Prosper. *Larousse Gastronomique.* Edited by a Gastronomic Committee chaired by Jöel Robuchon. London: Hamlyn, 2001.

Munro, Eleanor C., *Originals: American Women Artists.* Boston: De Capo Press, 2000.

Myers, John Bernard. *Tracking the Marvelous: A Life in the New York Art World.* New York: Random House, 1983.

Naifeh, Steven and Gregory White Smith. *Jackson Pollock: An American Saga.* Aiken, SC: Woodward/White, Inc., 1989.

O'Connor, Francis V., and Eugene V. Thaw. *Jackson Pollock: A Catalogue Raisonné of Paintings, Drawings and Other Works.* New Haven: Yale University Press, 1978.

Oral history interview with Alfonso Ossorio, November 19, 1968, Archives of American Art, Smithsonian Institution and online: http://www.aaa.si.edu/collections/oralhistories/transcripts/ossori68.htm.

Oral history interview with James Brooks, June 10 and 12, 1965, Archives of American Art, Smithsonian Institution and online: http://www.aaa.si.edu/collections/interviews/oral-history-interview-james-brooks-12719.

Oral history interview with Perle Fine, January 19, 1968, Archives of American Art, Smithsonian Institution and online: http://www.aaa.si.edu/collections/interviews/oral-history-interview-perle-fine-12709.

Oral history interview with Reuben Kadish, April 15, 1992, Archives of American Art, Smithsonian Institution and online: http://www.aaa.si.edu/collections/interviews/oral-history-interview-reuben-kadish-12170.

Oral history interview with Berton Roueché conducted by Jeffrey Potter, 1983. Sourced from the Jeffrey Potter audiotapes in the Oral History Collection, Pollock-Krasner House and Study Center, East Hampton.

Oral history interview with Buffi Johnson conducted by Jeffrey Potter, 1981. Sourced from the Jeffrey Potter audiotapes in the Oral History Collection, Pollock-Krasner House and Study Center, East Hampton.

Oral history interview with Charles Pollock conducted by Jeffrey Potter, 1982. Sourced from the Jeffrey Potter audiotapes in the Oral History Collection, Pollock-Krasner House and Study Center, East Hampton.

Oral history interview with Elizabeth Pollock conducted by Jeffrey Potter, 1982. Sourced from the Jeffrey Potter audiotapes in the Oral History Collection, Pollock-Krasner House and Study Center, East Hampton.

Oral history interview with Elaine de Kooning conducted by Jeffrey Potter, 1980. Sourced from the Jeffrey Potter audiotapes in the Oral History Collection, Pollock-Krasner House and Study Center, East Hampton.

Oral history interview with Helen Phillips Hayter conducted by Jeffrey Potter, 1982. Sourced from the Jeffrey Potter audiotapes in the Oral History Collection, Pollock-Krasner House and Study Center, East Hampton.

Oral history interview with Michael Collins conducted by Jeffrey Potter, 1981. Sourced from the Jeffrey Potter audiotapes in the Oral History Collection, Pollock-Krasner House and Study Center, East Hampton.

Oral history interview with Nina Federico conducted by Jeffrey Potter, 1981. Sourced from the Jeffrey Potter audiotapes in the Oral History Collection, Pollock-Krasner House and Study Center, East Hampton.

Oral history interview with Patsy Southgate conducted by Jeffrey Potter, 1980. Sourced from the Jeffrey Potter audiotapes in the Oral History Collection, Pollock-Krasner House and Study Center, East Hampton.

Oral history interview with Ruben Kadish conducted by Jeffrey Potter, 1981. Sourced from the Jeffrey Potter audiotapes in the Oral History Collection, Pollock-Krasner House and Study Center, East Hampton.

Oral history interview with Stanley William Hayter conducted by Jeffrey Potter, 1983. Sourced from the Jeffrey Potter audiotapes in the Oral History Collection, Pollock-Krasner House and Study Center, East Hampton.

Oral history interview with Willem de Kooning conducted by Jeffrey Potter, 1980. Sourced from the Jeffrey Potter audiotapes in the Oral History Collection, Pollock-Krasner House and Study Center, East Hampton.

Ottmann, Klaus and Dorothy Kosinski. *Angels, Demons, and Savages: Pollock, Ossorio, Dubuffet.* New Haven: Yale University Press, 2013.

Paddleford, Clementine. *How America Eats.* New York: Charles Scribner's Sons, 1960.

Platt, June. *June Platt's Party Cookbook.* Boston: Houghton Mifflin Company, 1936.

Pollock-Krasner House and Study Center. Exhibition catalogue. *Nicolas Carone, The East Hampton Years, Paintings from the 1950s.* East Hampton: Pollock-Krasner House and Study Center, 2013.

Pollock, Sylvia Winter, ed. *American Letters 1927-1947: Jackson Pollock & Family.* Malden: Polity Press, 2011.

Pollock, Sylvia. E-mail interview conducted by Robyn Lea, 2014.

Pollock, Francesca. Personal and e-mail discussions with Robyn Lea in New York, and subsequent e-mail communication including unpublished letters and documents provided to Robyn Lea by Francesca Pollock, 2014.

Pollock, Stella. Unpublished, personal recipe book and scrapbook, courtesy of Jacqueline Pollock de Souza Costa, Sacramento California, July 2014.

Pollock-Leite, Jeri. E-mail interview conducted by Robyn Lea, May 27, 2014.

Potter, Jeffrey. *To a Violent Grave: An Oral Biography of Jackson Pollock.* Wainscott: Puchcart Press, 1987.

Robbins, Ken, and Bill Strachan, eds. *Springs: A Celebration.* East Hampton: Springs Improvement Society, 1984.

Rose, Barbara. "Jackson Pollock at Work: An interview with Lee Krasner." *The Partisan Review,* vol. 47, no. 1, 1980, pp. 82–89.

Roueché, Berton. "Unframed Space." *The New Yorker,* August 5, 1950, p. 16.

Rozzi, Chef Michael. Personal interviews conducted by phone and in person at 1770 House, East Hampton by Robyn Lea, 2014.

Siegfried, Mary Ann, ed. *Fishing: Springs Historical Society.* East Hampton: Springs Historical Society, 2014.

Solomon, Deborah. *Jackson Pollock: A Biography.* New York: Simon and Schuster, 1987.

Spear, Ruth A. *The East Hampton Cookbook of Menus and Recipes.* East Hampton: The Ladies Village Improvement Society of East Hampton, Long Island, Inc., 1975.

Talmage, Ferris G. *The Springs, An Eastern Long Island Town: In The Old Days.* Wainscott: Starch and Press, 1970.

Tooker, Abigail. Personal phone interviews conducted by Robyn Lea, and subsequent unpublished letters and documents provided to Robyn Lea by Abigail Tooker, 2014.

Toulouse-Lautrec, Mapie de. *La Cuisine de France.* Edited and translated by Charlotte Turgeon. New York: Bonanza Books, 1964.

Toynton, Evelyn. *Jackson Pollock.* New Haven: Yale University Press, 2012.

Udall, Sharyn R. *Inside Looking Out: The Life and Art of Gina Knee.* Lubbock: Texas Tech University Press, 1994.

Walker, N. W., and R. D. Pope, M.D. *Raw Vegetable Juices: What's Missing in Your Body.* Reprint. Utah: Norwalk Press, 1949.

Waring Products Corporation. Promotional pamphlet. *340 Recipes for the New Waring Blender.* New York: Waring Products Corporation, 1947.

Various newspaper clippings, newspaper recipe clippings, related documents and ephemera, found in Jackson and Lee's kitchen, were also reviewed extensively. Source: Research Collection at Pollock-Krasner House and Study Center, East Hampton.

Additional recipes and information were provided by Steve Sitton from the Thomas Hart Benton Home & Studio State Historic Site, Kansas City, MO, courtesy of Missouri State Parks.

Additional online or in person research was conducted at:

Archives of American Art New York Research Center, Manhattan, NY

East Hampton Library, East Hampton, NY

Harvard Art Museums, Cambridge, MA

Springs Library, East Hampton, NY

New York Public Library, Manhattan, NY

RECIPE CREDITS

SOUPS & STARTERS

Borscht
Tested by Kylie Balharrie and Kate Mizrahi
Food preparation/styling: Kylie Balharrie and Kate Mizrahi
Props styling: Barbara Marsiletti

Creamy Onion Soup
Tested by Kylie Balharrie and Kate Mizrahi
Food preparation/styling: Kylie Balharrie and Kate Mizrahi
Props styling: Barbara Marsiletti

Eggplant Constantinople
Tested by Chef Michael Rozzi
Food preparation/styling: Chef Michael Rozzi, assisted by Michael Ferran
Props styling: Michelle James

Josephine Little's Hominy Puffs
Tested by Kylie Balharrie, Kate Mizrahi, Heather Chontos, and Lynette Lea
Food preparation/styling: Heather Chontos
Props styling: Heather Chontos

Oven-Baked Stuffed Onions
Tested by Chef Michael Rozzi
Food preparation/styling: Chef Michael Rozzi, assisted by Michael Ferran
Props styling: Michelle James

Spinach Muffins & Spring Greens with Homemade Tomato Chutney
Tested by Chef Kira LePine Williams
Food preparation/styling: Chef Kira LePine Williams
Props styling: Shane Klein

Stella's Potato Pancakes
Tested by Chef Kira LePine Williams
Food preparation/styling: Chef Kira LePine Williams
Props styling: Shane Klein

Swedish Meatballs
Tested by Chef Michael Rozzi
Food preparation/styling: Chef Michael Rozzi, assisted by Michael Ferran
Props styling: Michelle James

MAIN COURSES

Cherrystone Clams with Garlic & Dry Vermouth
Tested by Jackie McKay, Kylie Balharrie and Kate Mizrahi
Food preparation/styling: Kylie Balharrie, assisted by Kate Mizrahi
Props styling: Barbara Marsiletti

Chili con Carne
Tested by Kylie Balharrie, Kate Mizrahi, and Heather Chontos
Props styling: Barbara Marsiletti

Classic Meat Loaf with Mustard Sauce
Tested by Chef Michael Rozzi
Food preparation/styling: Chef Michael Rozzi, assisted by Michael Ferran
Props styling: Michelle James

Creamy Lobster Stew
Tested by Kylie Balharrie and Kate Mizrahi
Food preparation/styling: Kylie Balharrie, assisted by Kate Mizrahi
Props styling: Barbara Marsiletti

Earth-Goddess Stuffed Peppers
Tested by Kylie Balharrie and Kate Mizrahi
Food preparation/styling: Kylie Balharrie, assisted by Kate Mizrahi
Props styling: Barbara Marsiletti

French-Style Roast Chicken with Herb Stuffing
Tested by Kylie Balharrie and Kate Mizrahi
Food preparation/styling: Kylie Balharrie, assisted by Kate Mizrahi
Props styling: Barbara Marsiletti

Heavenly Loving Clam Chowder
Tested by Kylie Balharrie, Kate Mizrahi, Heather Chontos, and Kira LePine Williams
Food preparation/styling: Heather Chontos
Props styling: Heather Chontos

Jackson's Famous Spaghetti Sauce
Tested by Kylie Balharrie and John Young
Food preparation/styling: Kylie Balharrie, assisted by
Kate Mizrahi
Props styling: Barbara Marsiletti

Long Island Clam Pie
Tested by Kylie Balharrie, Kate Mizrahi and
Kira LePine Williams
Food preparation/styling: Kylie Balharrie, assisted by
Kate Mizrahi
Props styling: Barbara Marsiletti

Mussels with White Wine & Fresh Parsley
Tested by Jackie McKay, Kylie Balharrie and
Kate Mizrahi
Food preparation/styling: Kylie Balharrie, assisted by
Kate Mizrahi
Props styling: Barbara Marsiletti

Old-Fashioned Macaroni & Cheese
Tested by Kylie Balharrie, Kate Mizrahi and
Heather Chontos
Food preparation/styling: Kylie Balharrie and
Kate Mizrahi
Props styling: Barbara Marsiletti

Perle Fine's Bouillabaisse
Tested by Kylie Balharrie and Kate Mizrahi
Food preparation/styling: Kylie Balharrie, assisted by
Kate Mizrahi
Props styling: Barbara Marsiletti

Quiche with Forest Mushrooms
Tested by Kate Mizrahi
Food preparation/styling: Kylie Balharrie and
Kate Mizrahi
Props styling: Barbara Marsiletti

Roast Beef with Yorkshire Pudding &
Arloie's Gravy
Tested by Kylie Balharrie and Kate Mizrahi
Roast Beef cooked by Kylie Balharrie, assisted by
Kate Mizrahi
Yorkshire Pudding by Kate Mizrahi, Arloie's Gravy by
Heather Chontos
Props styling: Barbara Marsiletti; gravy props styling:
Heather Chontos

Slow Cooked Pot Roast
Tested by Kylie Balharrie, Kate Mizrahi,
Catherine Malady, and Heather Chontos
Food preparation/styling: Catherine Malady
Props styling: Catherine Malady

MENU: LUCIA WILCOX'S BEACH PICNIC

Baba Ghanoush
Hummus
Kibbee
Stuffed Grape Leaves
Tabbouleh

Kibbee tested by Kate Mizrahi
Baba Ghanoush, Hummus, and Tabbouleh tested by
Renata Radakovic
Food preparation/styling: Kate Mizrahi
Props styling: Barbara Marsiletti

BREADS, LOAVES & PANCAKES

Accabonac Cornmeal Pancakes
Tested by Chef Kira LePine Williams
Food preparation/styling: Chef Kira LePine Williams
Props styling: Shane Klein

Cross-Country Johnny Cakes
Tested by Chef Kira LePine Williams
Food preparation/styling: Chef Kira LePine Williams
Props styling: Shane Klein

Hans Namuth's Bread
Tested by Chef Kira LePine Williams
Food preparation/styling: Kylie Balharrie, assisted by
Kate Mizrahi
Props styling: Barbara Marsiletti

Jackson's Classic Rye Bread
Tested by Chef Kira LePine Williams
Food preparation/styling: Catherine Malady

Jackson's White Bread
Tested by Chef Kira LePine Williams
Food preparation/styling: Catherine Malady
Props styling: Catherine Malady

Sour Cream Griddle Cakes
Tested by Catherine Malady
Food preparation/styling: Catherine Malady
Props styling: Catherine Malady

Southern-Style Corn Bread
Tested by Chef Kira LePine Williams
Food preparation/styling: Chef Kira LePine Williams
Props styling: Shane Klein

VEGETABLES, SALADS & SIDES

Beet Pickles
Tested by Chef Michael Rozzi and Chef Kira
LePine Williams
Food preparation/styling: Chef Michael Rozzi,
assisted by Michael Ferran
Props styling: Michelle James

Elaine de Kooning's Fruit & Grain Salad
Tested by Kylie Balharrie and Kate Mizrahi
Food preparation/styling: Kylie Balharrie, assisted by
Kate Mizrahi
Props styling: Barbara Marsiletti

Pea Salad with Russian Dressing
Tested by Chef Michael Rozzi
Food preparation/styling: Chef Michael Rozzi,
assisted by Michael Ferran
Props styling: Michelle James

Roasted Root Vegetables
with Walnut & Maple Dressing
Tested by Kylie Balharrie and Kate Mizrahi
Food preparation/styling: Kylie Balharrie, assisted by
Kate Mizrahi
Props styling: Barbara Marsiletti

Wild Forest Greens with Anchovy French Dressing
Tested by Kylie Balharrie and Kate Mizrahi
Food preparation/styling: Kylie Balharrie, assisted by
Kate Mizrahi
Props styling: Barbara Marsiletti

DESSERTS & SWEETS

Banana Cream Cake
Tested by Chef Kira LePine Williams
Food preparation/styling: Chef Kira LePine Williams
Props styling: Shane Klein

Blueberry Blintzes
Tested by Chef Kira LePine Williams
Food preparation/styling: Chef Kira LePine Williams
Props styling: Shane Klein

Brandied Peaches with Soft Custard
Tested by Chef Kira LePine Williams
Food preparation/styling: Chef Kira LePine Williams
Props styling: Shane Klein

Chocolate Coconut Blancmange
Tested by Chef Kira LePine Williams
Food preparation/styling: Chef Kira LePine Williams
Props styling: Shane Klein

Cody Cookies
Tested by Chef Michael Rozzi
Food preparation/styling: Chef Michael Rozzi,
assisted by Michael Ferran
Props styling: Michelle James

Francile's Cookies
Tested by Chef Kira LePine Williams
Food preparation/styling: Chef Kira LePine Williams
Props styling: Shane Klein

Gold Cake
Tested by Chef Kira LePine Williams
Food preparation/styling: Chef Kira LePine Williams
Props styling: Shane Klein

Jackson's Prize-Winning Apple Pie
Tested by Chef Kira LePine Williams, Catherine
Malady and Heather Chontos
Food preparation/styling: Chef Kira LePine Williams
Props styling: Shane Klein

Lemon Pudding
Tested by Chef Kira LePine Williams, Catherine
Malady, and Heather Chontos
Food preparation/styling: Chef Kira LePine Williams
Props styling: Shane Klein

Raspberry-Poached Pears with Bavarian Cream
Tested by Chef Kira LePine Williams
Food preparation/styling: Chef Kira LePine Williams
Props styling: Shane Klein

Rita Benton's Pecan Torte with Mocha Frosting
Tested by Chef Kira LePine Williams
Food preparation/styling: Chef Kira LePine Williams
Props styling: Shane Klein

Upside Down Cherry Cake
Tested by Chef Michael Rozzi
Food preparation/styling: Chef Michael Rozzi,
assisted by Michael Ferran
Props styling: Michelle James

Yum Yum Cake
Tested by Chef Michael Rozzi
Food preparation/styling: Chef Michael Rozzi
Props styling: Michelle James

LOCATIONS

Pollock-Krasner House and Study Center, East Hampton · James Huniford's private home, Bridgehampton · 1770 House, East Hampton · Various historic sites, East Hampton · Beaches at Springs, East Hampton, and Montauk · Georgica Pond, East Hampton

PROPS

Pollock-Krasner House and Study Center, East Hampton · Personal collection of James Huniford · Personal collection of Francile Downs · ABC Carpet & Home, New York City · Fishs Eddy, New York City · Whisk, New York City · Nellie's of Amagansett · Huntting House Antiques, East Hampton · R. E. Steele Antiques Inc., East Hampton

LOCAL PRODUCE

Ian Calder-Piedmonte, Balsam Farms, Amagansett

NOTES ON THE RECIPES

In preparing Jackson and Lee's favorite recipes for this book we have tried to stay true to the original wherever possible. Where necessary we have adapted the recipes for the home cook of today and updated the methods for the modern kitchen and appliances. In several recipes we have substituted rarely used ingredients with today's equivalent. On rare occasions, where we know through interviews and research that Lee and Jackson served or enjoyed a certain dish but do not have a matching handwritten recipe, we have sourced them from historic cookbooks in their collection, local historic recipes, or developed recipes based on descriptions from their friends and local food lore. A great majority of the recipes come from Jackson and Lee's own collection, with the addition of others from friends and artists in their circle, including Rita Benton, Elaine de Kooning, Perle Fine, John and Josephine Little, Hans Namuth, Stella Pollock, and Lucia Wilcox.

ACKNOWLEDGMENTS

I would like to thank the contributors and advisors who helped bring this book into the world: My tireless and wonderful producer, Marina Cukeric, who was as thrilled as me with every discovery on this project, big or small, and who organized each shoot with absolute charm, grace, and professionalism. This is our second major book together, and I have never presented Marina with a problem she could not solve beautifully. We have shared countless Pollock-Krasner meals and dishes throughout the project and many long drives to the Hamptons in various seasons, and every day spent working together on this book has been a joy.

Francesca Pollock, who is based in Paris but whom I met in New York on Bleecker Street, has supported and guided me in this project. Through Francesca I was able to see another perspective of the commonly repeated Pollock myths and stories. The daughter of the eldest Pollock brother, the late artist Charles Pollock, Francesca generously offered to share her skills, views, and experience on many occasions. Her e-mails with images, family photos, interviews, and letters would pepper my in-box, and in each e-mail there was another thing to discover, consider, or absorb. Francesca discovered the whereabouts of Stella Pollock's recipe book, and through her introduction to Jacqueline Pollock de Souza Costa, I was able to see and photograph the book, providing me with new and exciting material for the project.

Jackson and Lee's dear friend Francile "Cile" Downs invited Marina and me into her Springs home countless times and patiently contributed to long interviews in person and over the phone. Cile's memories of her friends Lee and Jackson, their entertaining style, their recipes, dinner parties, and lives were fundamental to the development of the text in the book. Cile, a stencil artist and keen cook, was able to detail how Lee cooked certain dishes, and elaborate on stories of the artists in their circle. Cile gave us permission to use one of her recipes, and also the tableware and cookware that she used years ago when entertaining Jackson and Lee and other friends in their circle. These props are woven through the recipe images and add the authentic feel to many of the shots.

Abigail Tooker, daughter of Lee and Jackson's close friends and fellow artists John and Josephine Little, generously mined her late parents' personal archives, including her mother's notebooks, in which she had recorded visits by Jackson, meals shared, and recipes learned. Abigail also offered her own personal childhood recollections of Lee and Jackson, Alfonso Ossorio and Ted Dragon, as well as beautiful and detailed descriptions of her parents' garden, cooking, entertaining style, and way of being. When Abigail's five-page letter, created with an old-style typewriter, arrived in my letter box, I almost cried. Along with the letter were two handwritten recipes, another menu, and a sea of beautiful memories of the family's life in Springs.

Jacqueline Pollock de Souza Costa and her husband, Everardo Mendes, invited me into their wonderful home in California, where I was able to photograph Stella Pollock's precious recipe book from cover to cover. The book was like the missing piece of the puzzle, and provided me with insights and perspective on Stella's extraordinary creativity in the kitchen and endless passion and drive to create stunning dishes. Jackie's warmth and her own incredible skills in the kitchen, coupled with her stories and artwork, ensured the visit was one I will not forget.

Helen Harrison, the Eugene V. and Clare E. Thaw Director at Pollock-Krasner House and Study Center, provided information, direction, and access to source material at every point of our research. Her deep and thorough knowledge of Jackson and Lee and their circle provided us with insights into the stories behind each recipe and their historical context. Through Helen I was able to gain permission to use Lee and Jackson's own tableware and cookware for many of our food shots, as well as to see original papers and photographs including the recipes.

Susan Finesman, my literary agent, who as a passionate foodie herself understood my vision for the book from the outset. Susie's advice, hard work, and enthusiasm provided the fertile ground for this book to flourish.

Multitalented woman Kylie Balharrie and her wonderful assistant cook and friend Kate Mizrahi consulted on a large bulk of the recipes, tackling the first round of testing, and traveling across the world from Australia to help choose ingredients and cook many of the dishes. Their subsequent advice on the recipes was imperative to helping prepare the dishes for publication. The ultimate multitasker, Kylie contributed her abundant food knowledge at the same time as helping manage the Healesville Hotel, K & B Butcher, Harvest Café, and her family in the Yarra Valley in Victoria—no easy feat. Many of the recipes were tested at evening meals on Kylie's husband and children, with others tested on Kate's family in Hawthorn, Victoria. A real team effort: Kate's husband, artist John Young, helped as well by testing Jackson's Famous Spaghetti Sauce.

Gifted interior and furniture designer James "Ford" Huniford was a champion of this project in many ways and generously opened his beautiful Bridgehampton home for me and the crew to cook many of the recipes and stay there. We integrated pieces from his impeccably curated tableware and cookware collection into many of our shots. And the tones, textures, and colors worked in beautifully with the images of the local landscapes.

Barbara Marsiletti, one of the most talented props stylists I have worked with, flew from Italy to join us on one of the main recipe shoots. Barbara's huge heart and creative vision make her a pleasure to work with, and I just loved sharing the Bridgehampton week together.

Chef Rozzi and the warm and professional team from 1770 House in East Hampton brought Stella Pollock's recipes to life. Carol Covell, the hotel manager, and Randye Lordon played important roles in bringing that shoot together. Working with this East Hampton local team added another layer of background information to many of the stories in the book, and Chef Rozzi's endless

food knowledge and passion for ingredients was very helpful to my research into Springs and East Hampton ingredients and food customs. Very much a team effort, local foodie Michael Ferran assisted Chef Rozzi, and his enthusiasm was infectious and very much appreciated.

Michelle James, lighting designer, stylist, and one of the hardest working people I know, styled the East Hampton food shoot. Michelle gathered tableware and props from wonderful local Hamptons stores, including Nellie's of Amagansett, Huntting House Antiques, and R. E. Steele Antiques Inc. in East Hampton. She is a woman of exquisite taste with a wonderful sense of humor, and it was a pleasure to work with Michelle on the shoot.

Chef Kira LePine Williams's three-year Cordon Bleu education made her the perfect person to test, tackle, and help taste the dessert and baking recipes. Watching Kira swirl the frosting on the Banana Cream Cake left no doubt as to her expert touch and wonderful way with food. It has been wonderful working together with this motivated team player with a gentle and kind heart.

Props stylist Shane Klein made visual magic for the dessert and baking shoot, ensuring that the tableware and cookware were absolutely perfect for each shot. A tireless and passionate stylist, Shane helped make not just beautiful shots but also helped create a wonderful, industrious work environment, making the shoot days fly by in a whirl of excitement.

Catherine Malady, blogger, foodie, creator, and friend, was visiting from Australia when the first sixteen recipes were discovered; she volunteered to cook up a feast, which I photographed and which we then ate together with Marina and my family. Cathy made Jackson's white bread as well as the pot roast, and both were absolutely delicious. This meal helped me realize that these recipes were not only interesting historical documents but also very special indeed.

Sylvia Pollock kindly shared her memories of Stella Pollock and her late husband, Charles Pollock, and provided useful background information that aided my understanding of the family.

Marissa Eller was instrumental in getting this project off the ground. My friend and neighbor in Scarsdale, Marissa has supported my work in ways big and small and provided me with critical advice and referrals whenever needed. A generous spirit and one of life's great enthusiasts, Marissa touches the lives of many people with her thoughtfulness.

Jeri Pollock-Leite shared her stories of Grandma Pollock's recipes and dishes. These firsthand accounts were invaluable to my research and helped build a basis for understanding the recipes and the Pollock family.

My parents, Lynette and Richard Lea, patiently assisted me with manuscript advice and guidance. When they arrived in New York to visit me from Australia, they enthusiastically volunteered to help me with more research and even helped test some of the recipes.

Gigia Marchiori, from GMAimages, and fashion designer Lauren Sara urged me to consider turning the recipes into a book from the very beginning. It was with their support and encouragement that I decided to make this book, and their belief in the project is deeply appreciated.

Ruth Applehof, director at Guild Hall, East Hampton, provided fascinating insights into Lee Krasner's cooking style and approach as a hostess, having lived with Lee for a summer while writing her dissertation on the artist.

New York photo agent Elyse Connolly and her marvelous crew encouraged my early efforts to get the project off the ground.

Other wonderful supporters of, or contributors to, the project include: Karina Aguilar, Stefano Antoniazzi, Rebecca Ascher, Margaret Z. Atkins (Smithsonian), Maddy Berezov, Loring Bolger (Ashawagh Hall), Annie Bullock (ABC), Heather Chontos, Connie Dankmyer, Rudy DeSanti Sr., Rudy DeSanti Jr., Laurence Dunst, Clay Fried, Alisa Greenspan, Linda Honan, Alexander Kabbaz, Ellen Landau, Julia Lea, Jim Levis, Lucas Matthiessen, Jason McCoy, Brook McManus, Rebecca Molinaro, Peter Namuth, Elizabeth Petit, Mary Rodgers, Mark Schlesinger, Megan Schwenke, Steve Sitton (Thomas Hart Benton Home Museum, Missouri State Parks), Russ Steele, Christina Mossaides Strassfield (Guild Hall museum director), and Joan Washburn.

To my husband, Tim Hunt, and our children, Issy and Freddie, thank you for taking this journey with me and for your interest and enthusiasm for the art and food of Jackson Pollock.

Esther Kremer, vice president and editorial director at Assouline, allowed me full creative freedom on this book and encouraged me to follow my heart and dreams. The resulting journey has been nourishing, exciting, and rewarding. I feel deeply privileged to have worked with this material, to have discovered a new side of Jackson Pollock, and to have worked with Esther and Assouline.

∽

Assouline would like to thank Robyn Lea, Marina Cukeric, and the entire team at Robyn Lea Creative for their gracious collaboration, and Helen A. Harrison at the Pollock-Krasner House and Study Center for her kind assistance. Special thanks also to Lindsey Tulloch for her assistance on this project.

PHOTO CREDITS